THE ELEMENTS
OF DRAWING

Illustrated edition with notes
by Bernard Dunstan

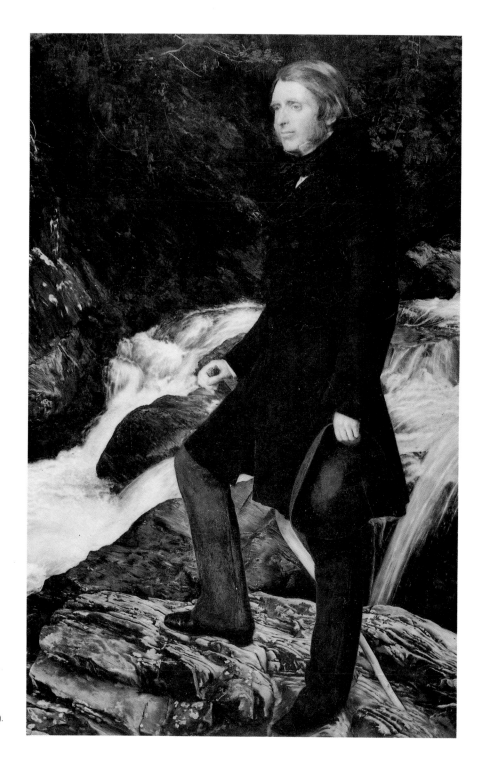

J. E. Millais *John Ruskin* 1854 (detail).
Private Collection

John Ruskin

THE ELEMENTS OF DRAWING

ILLUSTRATED EDITION
with notes by Bernard Dunstan

Watson-Guptill Publications/New York

Copyright © 1991 The Herbert Press Ltd
Copyright in the commentary and notes © 1991 Bernard Dunstan
Copyright under the Berne Convention

First published in the United States in 1997 by
Watson-Guptill Publications, a division
of BPI Communications, Inc.,
1515 Broadway, New York, NY 10036

Reprinted 1997

Designed by Pauline Harrison
Typeset in Century Schoolbook and Helvetica by
Nene Phototypesetters Ltd, Northampton
Printed and bound in Hong Kong by
South China Printing Co. (1988) Ltd

Library of Congress Cataloging-in-Publication Data
Ruskin, John. 1819–1900.
 The elements of drawing / John Ruskin. — Illustrated ed. / with
notes by Bernard Dunstan.
 p. cm.
 Includes index.
 ISBN 0–8230–1602–1
 1. Drawing. I. Dunstan, Bernard. 1920– . II. Title.
NC710.R8 1997
741—dc21 96–49063
 CIP

JACKET FRONT
John Ruskin *Vineyard Walk at Lucca* 1874 (detail).
The Ruskin Galleries, Bembridge School, Isle of Wight

Contents

Acknowledgements

My thanks are due to those owners who have allowed their drawings and paintings to be reproduced. In a few cases it has proved impossible to trace owners to ask their permission, and I hope they will forgive any apparent discourtesy in my use of existing photographic material.

 I would also like to thank Alison Winter at Agnew's, and Nick Savage and Helen Valentine at the Royal Academy Library, for their invaluable help; my wife, for contributing many of the illustrations, including some of Ruskin's most testing exercises; and finally, David and Brenda Herbert for their encouragement.

BERNARD DUNSTAN

Introduction

Since 1857, when *The Elements of Drawing* first appeared, there has been only one period when it was allowed to go out of print, at a time in Ruskin's career when his mind had turned largely to economic and social problems; and it is almost certainly the only book of its kind that has continued to be read for so long. One reason for its continued relevance is that Ruskin, unlike almost all authors of 'how to do it' books, is not in the least interested in teaching one style or another or in making an amateur's work look professional by the use of this or that set of tricks. All through the book he stresses the importance of direct observation, and he believes passionately in the value of drawing as a part of an educational whole. He says, 'I believe that the sight is a more important thing than the drawing; and I would rather teach drawing that my pupils may learn to love nature, than teach the looking at nature that they may learn to draw.' It is not the end result that concerns him. He is not interested in training professional artists, but in the sharpening of the vision, the precision of the touch, the increased ability to appreciate both natural forms and works of art.

In this respect, *The Elements of Drawing* is particularly relevant to our time. The amateur artist today is swamped with attractively produced books, almost all of which are concerned with the end-product – the professional-looking article, to be hung on the wall and admired. There is no doubt that this is what very many amateur painters want; but the continued sale, since its first appearance, of *The Elements of Drawing* must show that there are many students for whom this is not enough.

Ruskin's approach is exactly defined by the title of the book. He reduces the art of drawing to its simplest elements – the making of marks, the perception of silhouettes and shapes – before going on to greater complexities. With his genius for simplification he announces that 'all good drawing consists merely in dirtying the paper delicately. All touch and dexterous trick is barbarism.'

What other writer could have come up with such a surprising – yet totally apt – definition of drawing as 'dirtying the paper delicately'?

Anyone who was at art school during the sixties will recognise a strong link between Ruskin's method – of going first to the basics and developing from them by means of successively more complex exercises – and the doctrine of Basic Design as taught then; and this is another aspect that makes *The Elements of Drawing* such a timeless work. Basic Design, as originated by Thubron, de Sausmarez and others and elaborated in countless Foundation Course classrooms, could be described as an abstract painter's development of Ruskin's method, in that it started with basic marks, shapes and directions and led the student through many an ingenious exercise towards an understanding of the abstract and expressive qualities of picture-making. This last word – 'picture-making' – points to the essential difference: Ruskin's method, with the exception of the first few exercises, was always directed towards natural forms and the student's observation of them; towards seeing, rather than the production of pictures. Both methods, however, assume that a graduated course of study – rather as in music, where the beginner plays simple exercises to begin with – makes more sense than the academic teaching of, for instance, the Royal Academy Schools in Ruskin's day or the London Slade School in ours. It can be argued that drawing is not music; and that the principle of graduated study does not necessarily apply. And we must remember, in any case, that Ruskin was not aiming at the would-be professional student; he always said that the Royal Academy Schools were the place for such study.

The book is the result of quite considerable teaching experience, which Ruskin somehow managed to fit in with his numerous other commitments. He had been giving informal lessons by letter to friends for some time, for he could never resist giving advice; and he had also taught more formal classes at the Working Men's College, a duty he shared with Rossetti. It was as a sort of distillation of all this experience that *The Elements of Drawing* was born; and also from his own development as a draughtsman. Since his early youth he had drawn obsessively, a discipline that he not only kept up right through the production of his great literary works, but which was essential to them.

His books *Modern Painters* and *Stones of Venice* are full of his expressive diagrams and more elaborate drawings. He had

gone through the hands of successive drawing masters, and by the time he was twenty-two had acquired a proficiency in the conventions of Harding and Prout, doing skilful work which depended a great deal on imitation of the masters' handling of the pencil. He was, in fact, seeing through other men's eyes; until, as he described it later in *Praeterita*, he began to realise that drawing is not a question of manner but of individual observation and that natural forms compose themselves if only we can see them clearly and without preconception: 'Languidly, but not idly, I began to draw it; and as I drew, the languor passed away; the beautiful lines insisted on being traced – without weariness. More and more beautiful they became, as each rose out of the rest, and took its place in the air. With wonder increasing every instant, I saw that they "composed" themselves, by finer laws than any known to men. At last, the tree was there, and everything that I had thought before about trees, nowhere.' It is this sense of discovery, and this humility – a humility on the part of a man who was by no means inclined naturally to be humble – that makes Ruskin's teaching so important, to us as well as to his contemporaries.

Obviously, though, we are going to read *The Elements of Drawing* with a set of ideas about drawing very different from those of his readers in the mid nineteenth century. We have, inevitably, experience of so many violent upheavals and changes, beginning with the Impressionist period; how can the Ruskinian method still have meaning for us? The answer, I think, may be that we are always inclined to exaggerate the sweeping effect of such changes on the art of drawing, the most direct and personal of the means of communication or expression, which yet retains a remarkable continuity. Look at drawings by, say, Millet, Rossetti, Keene, Pissarro, Vuillard, Sickert and Balthus – a range which covers the century from 1850 to 1950. They are all of the family of good European figure drawing, which has altered remarkably little under all the stylistic changes of the period. Someone setting out to draw a leaf or a leg with the intention of finding out about its structure, or to discover how to express as clearly as possible that structure within the limits of a flat sheet of paper and a pencil, is not going to set about it so very differently if he is a fifteenth-century Florentine, a nineteenth-century Londoner, or someone of our own period. The important thing, of course, is that it continues to be something worth doing – something which can be re-discovered by each individual in the way that Ruskin discovered it in 1842.

So there is little that is 'old fashioned' in Ruskin's approach and a great deal that cannot date, particularly in his remarks about natural structure, colour changes in landscape, and so on. And his analysis of compositional organization has, in my opinion, never been bettered. But inevitably there are some things which belong essentially to his age and are of less importance to us. Some of the early exercises need not, I think, be taken too seriously; the laborious hatching with a pen to make an even tone, for instance, or the gradations in a watercolour wash. And of course there are changes in the use or nomenclature of materials. Ruskin several times mentions rubbing a cake of watercolour on a saucer with water, whereas we would use the colour in pans, soft enough to be taken off with the brush. But such matters can be readily understood and allowed for by any reader. A more questionable subject is Ruskin's attitude to photography, and the copying of photographs. Here we have to remember that photography was a comparatively new technique in the 1850s. Ruskin would have been familiar with it through the medium of the daguerrotype, and he makes many references in his works to the beauty and delicacy of these images, many of which, of Venetian buildings, he had taken for his own use. What attracted him, as well as the delicacy of their detail, was probably the subtlety of tonal gradation, for the daguerrotype has a closer range of tone than the modern photograph, a range of delicate greys. It is this that he recommends copying, as a means of giving the student some help in his understanding of tonal relations. Today the situation vis-à-vis photography is very different. We are flooded with images, and the student may well be tempted to use them as a substitute for direct observation: indeed, he is even encouraged to by some teachers and manuals. I am quite sure that Ruskin himself would have vigorously disapproved of this and would have been in agreement with Delacroix's condemnation of a painter who relied too heavily on the camera as 'a machine copying another machine'.

My policy throughout, however, has been to cut as little as possible in making this edition, confining myself to references which no longer have any meaning to the reader, and some notes in Ruskin's Appendix.

On the other hand, there are the additions. Obviously the *raison d'être* of this edition is the greatly increased number of illustrations. The editions I had known were frustratingly under-illustrated, with only Ruskin's own diagrams and a few plates. He so often refers to particular pictures in the text, and

whenever possible I have included a reproduction or a detail; where this has not been possible, because of the difficulty of getting a photograph, I have included a drawing after the particular painting.

The notes and references form the other enlargement of the book. Here it is essential to note that this edition represents a version not only of Ruskin's work but also that of Cook and Wedderburn, his indefatigable editors, the creators of the superb Library Edition of 1904. This carries footnotes on many pages referring the reader to passages in other works by Ruskin, particularly *Modern Painters*, which help to elucidate or enlarge on matters touched on in the text. As few readers are likely to have a set of the Library Edition handy to look up the quotations, I have in many cases added them to my own notes. Many of Ruskin's own footnotes or Appendix notes have also been incorporated into the text (indicated by the use of square brackets) or into the notes. All Ruskin's own drawings and diagrams (Figs. 1–48) reproduced here, except for a few which have been redrawn, are in the form of wood engravings made from his original drawings for the purposes of reproduction. I have retained the numbering of Ruskin's illustrations, and all additional illustrations have been left unnumbered.

The physical shape of the book arose from the need to place these quotations, and my own comments, alongside Ruskin's text in such a way as to cause the least possible inconvenience or frustration to the reader, and also to place the illustrations as near as possible to the relevant passage of text.

It goes without saying that I would hope that the reader who is not familiar with Ruskin will be stimulated to explore further in his vast and many-sided production, beginning, perhaps, with *Modern Painters*. Many people are still under the vague impression that Ruskin was a wordy, unreadable and self-contradictory preacher, whose marital misfortunes are more interesting than his works. In fact he is never unreadable, and often very entertaining. It is possible to open *Modern Painters* or *Stones of Venice* at any page and find oneself reading on, engrossed. Any difficulty comes from the way his mind throws off a profusion of ideas, each one liable to branch off into other trains of thought; this is not so evident in *The Elements of Drawing*, which makes it a good introduction to his writing, with its easy, conversational style and vigour of expression.

BERNARD DUNSTAN

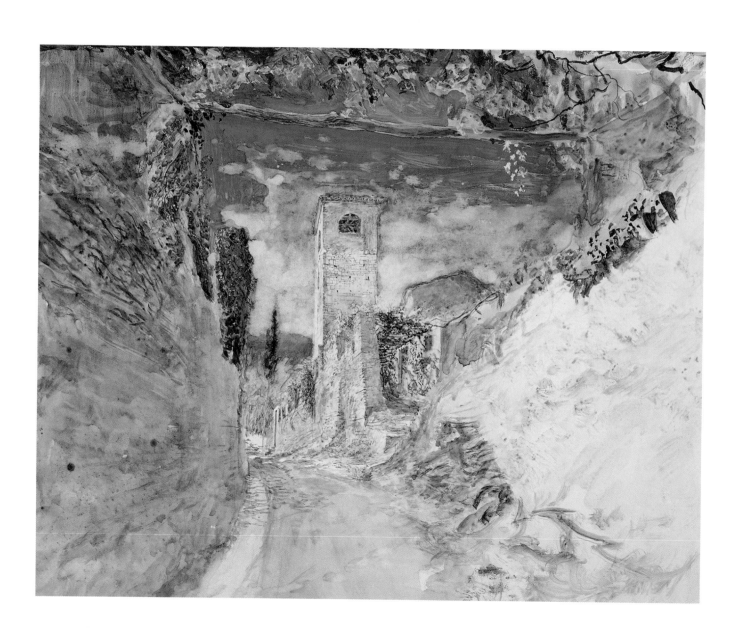

Preface
[1857]

I have retained such parts of Ruskin's Preface, which fills eleven pages of the Library Edition, as seem to have relevance to a modern reader.

IT MAY PERHAPS be thought, that in prefacing a manual of drawing, I ought to expatiate on the reasons why drawing should be learned; but those reasons appear to me so many and so weighty, that I cannot quickly state or enforce them. With the reader's permission, as this volume is too large already, I will waive all discussion respecting the importance of the subject, and touch only on those points which may appear questionable in the method of its treatment.

. . .

The manuals at present published on the subject of drawing are all directed, as far as I know, to one or other of two objects. Either they propose to give the student a power of dexterous sketching with pencil or water-colour, so as to emulate (at considerable distance) the slighter work of our second-rate artists; or they propose to give him such accurate command of mathematical forms as may afterwards enable him to design rapidly and cheaply for manufactures.

. . .

I believe that (irrespective of differences in individual temper and character) the excellence of an artist, as such, depends wholly on refinement of perception, and that it is this, mainly, which a master or a school can teach; so that while powers of invention distinguish man from man, powers of perception distinguish school from school. All great schools enforce delicacy of drawing and subtlety of sight: and the only rule which I have, as yet, found to be without exception respecting art, is that all great art is delicate.

Therefore, the chief aim and bent of the following system is to obtain, first, a perfectly patient, and, to the utmost of the

Left: John Ruskin *Vineyard Walk at Lucca* 1874. The Ruskin Galleries, Bembridge School, Isle of Wight. A detail of this painting is reproduced on the front of the jacket.

pupil's power, a delicate method of work, such as may ensure his seeing truly. For I am nearly convinced that, when once we see keenly enough, there is very little difficulty in drawing what we see; but, even supposing that this difficulty be still great, I believe that the sight is a more important thing than the drawing; and I would rather teach drawing that my pupils may learn to love Nature, than teach the looking at Nature that they may learn to draw. It is surely also a more important thing, for young people and unprofessional students, to know how to appreciate the art of others, than to gain much power in art themselves. Now the modes of sketching ordinarily taught are inconsistent with this power of judgement. No person trained to the superficial execution of modern water-colour painting, can understand the work of Titian or Leonardo; they must for ever remain blind to the refinement of such men's pencilling, and the precision of their thinking. But, however slight a degree of manipulative power the student may reach by pursuing the mode recommended to him in these letters, I will answer for it that he cannot go once through the advised exercises without beginning to understand what masterly work means; and, by the time he has gained some proficiency in them, he will have a pleasure in looking at the painting of the great schools, and a new perception of the exquisiteness of natural scenery, such as would repay him for much more labour than I have asked him to undergo.

That labour is, nevertheless, sufficiently irksome, nor is it possible that it should be otherwise, so long as the pupil works unassisted by a master.

· · ·

One principle ... I consider the most important and special of all that are involved in my teaching: namely, the attaching its full importance, from the first, to local colour. I believe that the endeavour to separate, in the course of instruction, the observation of light and shade from that of local colour, has always been, and must always be, destructive of the student's power of accurate sight, and that it corrupts his taste as much as it retards his progress. I will not occupy the reader's time by any discussion of the principle here, but I wish him to note it as the only distinctive one in my system, so far as it *is* a system. For the recommendation to the pupil to copy faithfully, and without alteration, whatever natural object he chooses to study, is serviceable, among other

reasons, just because it gets rid of systematic rules altogether, and teaches people to draw, as country lads learn to ride, without saddle or stirrups; my main object being, at first, not to get my pupils to hold their reins prettily, but to 'sit like a jackanapes, never off.'

In these written instructions, therefore, it has always been with regret that I have seen myself forced to advise anything like monotonous or formal discipline. But, to the unassisted student, such formalities are indispensable, and I am not without hope that the sense of secure advancement, and the pleasure of independent effort, may render the following out of even the more tedious exercises here proposed, possible to the solitary learner, without weariness. But if it should be otherwise, and he finds the first steps painfully irksome, I can only desire him to consider whether the acquirement of so great a power as that of pictorial expression of thought be not worth some toil; or whether it is likely, in the natural order of matters in this working world, that so great a gift should be attainable by those who will give no price for it.

. . .

Of figure drawing, nothing is said in the following pages, because I do not think figures, as chief subjects, can be drawn to any good purpose by an amateur. As accessaries in landscape, they are just to be drawn on the same principles as anything else.

. . .

I have good hope, however, that enough guidance is given in this work to prevent the occurrence of any serious embarrassment; and I believe that the student who obeys its directions will find, on the whole, that the best answerer of questions is perseverance; and the best drawing-masters are the woods and hills.

LETTER I

On First Practice

MY DEAR READER – whether this book is to be of use to you or not, depends wholly on your reason for wishing to learn to draw. If you desire only to possess a graceful accomplishment, to be able to converse in a fluent manner about drawing, or to amuse yourself listlessly in listless hours, I cannot help you: but if you wish to learn drawing that you may be able to set down clearly, and usefully, records of such things as cannot be described in words, either to assist your own memory of them, or to convey distinct ideas of them to other people; if you wish to obtain quicker perceptions of the beauty of the natural world, and to preserve something like a true image of beautiful things that pass away, or which you must yourself leave; if, also, you wish to understand the minds of great painters, and to be able to appreciate their work sincerely, seeing it for yourself, and loving it, not merely taking up the thoughts of other people about it; then I *can* help you, or, which is better, show you how to help yourself.

Only you must understand, first of all, that these powers, which indeed are noble and desirable, cannot be got without work. It is much easier to learn to draw well, than it is to learn to play well on any musical instrument; but you know that it takes three or four years of practice, giving three or four hours a day, to acquire even ordinary command over the keys of a piano; and you must not think that a masterly command of your pencil, and the knowledge of what may be done with it, can be acquired without painstaking, or in a *very* short time. The kind of drawing which is taught, or supposed to be taught, in our schools, in a term or two, perhaps at the rate of an hour's practice a week, is not drawing at all. It is only the performance of a few dexterous (not always even that) evolutions on paper with a black-lead pencil; profitless alike to performer and beholder, unless as a matter of vanity, and that the smallest possible vanity. If any young person, after being taught what is, in polite circles,

The first part of The Elements of Drawing, called 'On first practice', takes the student through a series of exercises designed to help him do two things: to master his materials, and to develop his perception. His hand, and his eye: these are the two faculties that every elementary art training must develop.

How far, though, can they be separated, as Ruskin separates them in these first pages? Most people nowadays would disagree with Ruskin's emphasis on the hand, on purely technical exercises.

Teachers who believe in the value of direct objective drawing and painting have usually taken for granted that all the manual dexterity that an artist requires can be gained during the course of making studies from nature, and Ruskin's 'hand' exercises only come, in fact, at the very beginning of his course. They are always related clearly to an 'eye', or perception, lesson. Thus an exercise in making gradated tones will be followed by the advice to try to paint a small section of sky.

Another feature of Ruskin's teaching that will seem anachronistic is the use he makes of copying. The present-day art student is often told that he must never copy; he must always interpret or translate (though he is seldom discouraged from an imitation of *style*). Worse still, from this point of view, is the way Ruskin suggests copying from actual two-dimensional images such as a portion of an engraving, or even a capital letter A. Yet his attitude to copying would have been understood – even taken for granted – by any other culture but our own. In China, in Renaissance Italy, in Cotman's England, the beginner would naturally be given examples of his master's work to copy.

The point of copying is to learn control. Precise control over the medium is necessary, whatever you are going to do with it; and the advantage of a certain amount of quite humble copying (no one, least of all Ruskin, suggests doing too much of it) is that the student can see for himself exactly where he has gone wrong. If he has made a crude or imprecise statement in the limited, but very important, area of accurate judgement of size, shape and angle, it will be obvious. This comparative clarity of aim is important for a beginner with very little in the way of judgement or experience, who may well find the onus of 'interpretation' too much.

A portion of a drawing by Charles Keene, engraved on wood for reproduction in *Punch*. The wood-engravers of the 1860s were highly skilled at translating the artists' drawings into their own medium, and, as Ruskin comments, were usually working against time. Keene's drawings could not have been easy to work from, as they often made very little concession to the engraver.

called 'drawing,' will try to copy the commonest piece of real work – suppose a lithograph on the title-page of a new opera air, or a woodcut in the cheapest illustrated newspaper of the day – they will find themselves entirely beaten. And yet that common lithograph was drawn with coarse chalk, much more difficult to manage than the pencil of which an accomplished young lady is supposed to have command; and that woodcut was drawn in urgent haste, and half spoiled in the cutting afterwards; and both were done by people whom nobody thinks of as artists, or praises for their power; both were done for daily bread, with no more artist's pride than any simple handicraftsmen feel in the work they live by.

Do not, therefore, think that you can learn drawing, any more than a new language, without some hard and disagreeable labour. But do not, on the other hand, if you are ready and willing to pay this price, fear that you may be unable to get on for want of special talent. It is indeed true that the persons who have peculiar talent for art, draw instinctively, and get on almost without teaching; though never without toil. It is true, also, that of inferior talent for drawing there are many degrees: it will take one person a much longer time

John Ruskin *Piazza delle Erbe*. Watercolour. Private Collection

In a letter to Charles Eliot Norton in 1884, Ruskin commented on his drawing classes at the Working Men's College:

'I'm giving them dreadful elementary exercises at Oxford which they mew and howl over, and are forced to do, nevertheless . . .'

Ruskin gave out this notice to his class:

'The teacher of landscape painting wishes it to be generally understood by all his pupils, that the instruction given in his classes is not intended to fit them for becoming artists, or in any direct manner, to advance their skill in the occupations that they follow. They are taught drawing, primarily in order to direct their attention accurately to the beauty of God's work in the material universe; and secondly, that they may be enabled to record with some degree of truth, the forms and colour of objects, when such recording is likely to be useful.'

William Morris said on the subject of drawing:

'I think undoubtedly everyone ought to be taught to draw, just as much as everybody ought to be taught to read and write.'

than another to attain the same results, and the results thus painfully attained are never quite so satisfactory as those got with greater ease when the faculties are naturally adapted to the study. But I have never yet, in the experiments I have made, met with a person who could not learn to draw at all; and, in general, there is a satisfactory and available power in every one to learn drawing if he wishes, just as nearly all persons have the power of learning French, Latin, or arithmetic, in a decent and useful degree, if their lot in life requires them to possess such knowledge.

Supposing then that you are ready to take a certain amount of pains, and to bear a little irksomeness and a few disappointments bravely, I can promise you that an hour's practice a day for six months, or an hour's practice every other day for twelve months, or, disposed in whatever way you find convenient, some hundred and fifty hours' practice, will give you sufficient power of drawing faithfully whatever you want to draw, and a good judgment, up to a certain point, of other people's work: of which hours if you have one to spare at present, we may as well begin at once.

EXERCISE I Everything that you can see in the world around you, presents itself to your eyes only as an arrangement of patches of different colours variously shaded. [The perception of solid Form is entirely a matter of experience. We *see* nothing but flat colours; and it is only by a series of experiments that we find out that a stain of black or grey indicates the dark side of a solid substance, or that a faint hue indicates that the object in which it appears is far away. The whole technical power of painting depends on our recovery of what may be called the *innocence of the eye*; that is to say, of a sort of childish perception of these flat stains of colour, merely as such, without consciousness of what they signify – as a blind man would see them if suddenly gifted with sight.

For instance: when grass is lighted strongly by the sun in certain directions, it is turned from green into a peculiar and somewhat dusty-looking yellow. If we had been born blind, and were suddenly endowed with sight on a piece of grass thus lighted in some parts by the sun, it would appear to us that part of the grass was green, and part a dusty yellow (very nearly of the colour of primroses); and, if there were primroses near, we should think that the sunlighted grass was another mass of plants of the same sulphur-yellow

colour. We should try to gather some of them, and then find that the colour went away from the grass when we stood between it and the sun, but not from the primroses; and by a series of experiments we should find out that the sun was really the cause of the colour in the one – not in the other. We go through such processes of experiment unconsciously in childhood; and having once come to conclusions touching the signification of certain colours, we always suppose that we *see* what we only know, and have hardly any consciousness of the real aspect of the signs we have learned to interpret. Very few people have any idea that sunlighted grass is yellow.

Now, a highly accomplished artist has always reduced himself as nearly as possible to this condition of infantine sight. He sees the colours of nature exactly as they are, and therefore perceives at once in the sunlighted grass the precise relation between the two colours that form its shade and light. To him it does not seem shade and light, but bluish green barred with gold.

Strive, therefore, first of all, to convince yourself of this great fact about sight. This, in your hand, which you know by experience and touch to be a book, is to your eye nothing but a patch of white, variously gradated and spotted; this other thing near you, which by experience you know to be a table, is to your eye only a patch of brown, variously darkened and veined; and so on: and the whole art of Painting consists merely in perceiving the shape and depth of these patches of colour, and putting patches of the same size, depth, and shape on canvas. The only obstacle to the success of painting is, that many of the real colours are brighter and paler than it is possible to put on canvas: we must put darker ones to represent them.] Some of these patches of colour have an appearance of lines or texture within them, as a piece of cloth or silk has of threads, or an animal's skin shows texture of hairs: but whether this be the case or not, the first broad aspect of the thing is that of a patch of some definite colour; and the first thing to be learned is, how to produce extents of smooth colour, without texture.

This can only be done properly with a brush; but a brush, being soft at the point, causes so much uncertainty in the touch of an unpractised hand, that it is hardly possible to learn to draw first with it, and it is better to take, in early practice, some instrument with a hard and fine point, both that we may give some support to the hand, and that by working over the subject with so delicate a point, the atten-

Ruskin's advice may be compared with remarks made by Monet and Pissarro. Monet said:

'When you go out to paint, try to forget what objects you have in front of you, a tree, a field . . . merely think, here is a little square of blue, here an oblong of pink, here a streak of yellow, and paint it just as it looks to you, the exact colour and shape, until it gives your own naive impression of the scene.'

Pissarro's advice to a young painter was to 'paint everything at once by placing tones everywhere, with brush-strokes of the right colour and value, while noticing what is alongside. Use small strokes and try to put down your perceptions immediately. The eye should not be fixed on one point, but should take in everything, while observing the reflections which the colours produce on their surroundings . . . Don't be timid in front of nature; one must be bold, at the risk of being deceived and making mistakes. One must have only one master – nature; she is the one always to be consulted.'

tion may be properly directed to all the most minute parts of it. Even the best artists need occasionally to study subjects with a pointed instrument, in order thus to discipline their attention: and a beginner must be content to do so for a considerable period.

Also, observe that before we trouble ourselves about differences of colour, we must be able to lay on *one* colour properly, in whatever gradations of depth and whatever shapes we want. We will try, therefore, first to lay on tints or patches of grey, of whatever depth we want, with a pointed instrument. Take any finely pointed steel pen (one of Gillott's lithographic crowquills is best), and a piece of quite smooth, but not shining, note-paper, cream laid, and get some ink that has stood already some time in the inkstand, so as to be quite black, and as thick as it can be without clogging the pen. Take a rule, and draw four straight lines, so as to enclose a square, or nearly a square, about as large as *a*, FIG. 1. I say nearly a square, because it does not in the least matter whether it is quite square or not, the object being merely to get a space enclosed by straight lines.

Now, try to fill in that square space with crossed lines, as completely and evenly that it shall look like a square patch of grey silk or cloth, cut out and laid on the white paper, as at *b*. Cover it quickly, first with straightish lines, in any direction you like, not troubling yourself to draw them much closer or neater than those in the square *a*. Let them quite dry before retouching them. (If you draw three or four squares side by side, you may always be going on with one while the others are drying.) Then cover these lines with others in a different direction, and let those dry; then in another direction still, and let those dry. Always wait long enough to run no risk of blotting, and then draw the lines as quickly as you can. Each ought to be laid on as swiftly as the dash of the pen of a good writer; but if you try to reach this great speed at first, you will go over the edge of the square, which is a fault in this exercise. Yet it is better to do so now and then than to draw the lines very slowly; for if you do, the pen leaves a little dot of ink at the end of each line, and these dots spoil your work. So draw each line quickly, stopping always as nearly as you can at the edge of the square. The ends of lines which go over the edge are afterwards to be removed with the penknife, but not till you have done the whole work, otherwise you roughen the paper, and the next line that goes over the edge makes a blot.

FIG. 1

a *b*

Ruskin comments later that 'this exercise in shading is very tiresome'. Any student who attempts it will agree with him. In fact I would be inclined to say that it is the least necessary of his exercises. Evenness of pen hatching hardly seems a very useful accomplishment: nevertheless it will do no harm to have a shot at it, as I have done here.

Pen nibs of the sort described by Ruskin are still to be found at specialist dealers. However, an ordinary ballpoint pen can be used, as in my example here.

When you have gone over the whole three or four times, you will find some parts of the square look darker than other parts. Now try to make the lighter parts as dark as the rest, so that the whole may be of equal depth or darkness. You will find, on examining the work, that where it looks darkest the lines are closest, or there are some much darker lines than elsewhere; therefore you must put in other lines, or little scratches and dots, *between* the lines in the paler parts; and where there are any very conspicuous dark lines, scratch them out lightly with the penknife, for the eye must not be attracted by any line in particular. The more carefully and delicately you fill in the little gaps and holes, the better; you will get on faster by doing two or three squares perfectly than a great many badly. As the tint gets closer and begins to look even, work with very little ink in your pen, so as hardly to make any mark on the paper; and at last, where it is too dark, use the edge of your penknife very lightly, and for some time, to wear it softly into an even tone. You will find that the greatest difficulty consists in getting evenness: one bit will always look darker than another bit of your square; or there will be a granulated and sandy look over the whole. When you find your paper quite rough and in a mess, give it up and begin another square, but do not rest satisfied till you have done your best with every square. The tint at last ought at least to be as close and even as that in *b*, FIG. 1. You will find, however, that it is very difficult to get a pale tint; because, naturally, the ink lines necessary to produce a close tint at all, blacken the paper more than you want. You must get over this difficulty not so much by leaving the lines wide apart as by trying to draw them excessively fine, lightly and swiftly; being very cautious in filling in; and, at last, passing the penknife over the whole.* By keeping several squares in progress at one time, and reserving your pen for the light one just when the ink is nearly exhausted, you may get on better. The paper ought, at last, to look lightly and evenly toned all over, with no lines distinctly visible.

EXERCISE II As this exercise in shading is very tiresome, it will be well to vary it by proceeding with another at the same time. The power of shading rightly depends mainly on lightness of hand and keenness of sight; but there are other qualities required in drawing, dependent not merely on lightness, but steadiness of hand; and the eye, to be perfect in

*Using the penknife to 'pass over the drawing', to lighten it, is a method that I had never heard of anywhere else. Given the right sort of paper – rather heavy and with a good 'tooth' – it can be made to work.

Copy in progress

*Ruskin's advice to lay tracing paper over the drawing, to compare with the original, implies that you are copying exactly the same size. This in itself is not as easy as might be expected. Again, the student will find that there are more rewarding exercises later; but there is no harm in following Ruskin's instructions to the letter. Some students may be surprised at the difficulty in achieving a reasonable result.

its power, must be made accurate as well as keen, and not only see shrewdly, but measure justly.

Possess yourself therefore of any cheap work on botany containing *outline* plates of leaves and flowers, it does not matter whether bad or good ... Copy any of the simplest outlines, first with a soft pencil, following it, by the eye, as nearly as you can; if it does not look right in proportions, rub out and correct it, always by the eye, till you think it is right: when you have got it to your mind, lay tracing-paper on the book;* on this paper trace the outline you have been copying, and apply it to your own; and having thus ascertained the faults, correct them all patiently, till you have got it as nearly accurate as may be. Work with a very soft pencil, and do not rub out so hard as to spoil the surface of your paper;* never mind how dirty the paper gets, but do not roughen it; and let the false outlines alone where they do not really interfere with the true one. It is a good thing to accustom yourself to hew and shape your drawing out of a dirty piece of paper. When you have got it as right as you can, take a quill pen, not very fine at the point; rest your hand on a book about an inch and a half thick, so as to hold the pen long; and go over your pencil outline with ink, raising your pen point as seldom as possible, and never leaning more heavily on one part of the line than on another. In most outline drawings of the present day, parts of the curves are thickened to give an effect of shade; all such outlines are bad, but they will serve well enough for your exercises, provided you do not imitate this character: it is better, however, if you can, to choose a book of pure outlines. It does not in the least matter whether your pen outline be thin or thick; but it matters greatly that it should be *equal*, not heavier in one place than in another. The power to be obtained is that of drawing an even line slowly and in any direction; all dashing lines, or approximations to penmanship, are bad. The pen should, as it were, walk slowly over the ground, and you should be able at any moment to stop it, or to turn it in any other direction, like a well-managed horse.

As soon as you can copy every curve *slowly* and accurately, you have made satisfactory progress; but you will find the difficulty is in the slowness. It is easy to draw what appears to be a good line with a sweep of the hand, or with what is called freedom; the real difficulty and masterliness is in never letting the hand *be* free, but keeping it under entire control at every part of the line.* [What is usually so much

*Ruskin comments in a footnote: 'Stale crumb of bread is better, if you are making a delicate drawing, than India-rubber, for it disturbs the surface of the paper less: but it crumbles about the room and makes a mess; and, besides, you waste the good bread, which is wrong; and your drawing will not for a long while be worth the crumbs. So use India-rubber very lightly; or, if heavily, pressing it only, not passing it over the paper, and leave what pencil marks will not come away so, without minding them. In a finished drawing the uneffaced pencilling is often serviceable, helping the general tone, and enabling you to take out little bright lights.'

*This seems to me to be one of the most important statements in the whole book, even if Ruskin originally relegated the following passage to a footnote. Nowadays 'freedom' is even more admired than in 1856, particularly by amateur painters. How many times have teachers heard the phrase, 'I would like my painting to become more free' or 'to loosen up'?

sought after under the term 'freedom' is the character of the drawing of a great master in a hurry, whose hand is so thoroughly disciplined, that when pressed for time he can let it fly as it will, and it will not go far wrong. But the hand of a great master at real *work* is *never* free: its swiftest dash is under perfect government. Paul Veronese or Tintoret could pause within a hair's-breadth of any appointed mark, in their fastest touches; and follow, within a hair's breadth, the previously intended curve. You must never, therefore, aim at freedom. It is not required of your drawing that it should be free, but that it should be right; in time you will be able to do right easily, and then your work will be free in the best sense; but there is no merit in doing wrong easily.

These remarks, however, do not apply to the lines used in shading, which, it will be remembered, are to be made as quickly as possible. The reason of this is, that the quicker a line is drawn, the lighter it is at the ends, and therefore the more easily joined with other lines, and concealed by them; the object in perfect shading being to conceal the lines as much as possible.

And observe, in this exercise, the object is more to get firmness of hand than accuracy of eye for outline; for there are no outlines in Nature, and the ordinary student is sure to draw them falsely if he draws them at all. Do not, therefore, be discouraged if you find mistakes continue to occur in your outlines; be content at present if you find your hand gaining command over the curves.]

EXERCISE III Meantime, you are always to be going on with your shaded squares, and chiefly with these, the outline exercises being taken up only for rest.

As soon as you find you have some command of the pen as a shading instrument, and can lay a pale or dark tint as you choose, try to produce gradated spaces like FIG. 2, the dark tint passing gradually into the lighter ones. Nearly all expression of form, in drawing, depends on your power of gradating delicately; and the gradation is always most skilful which passes from one tint into another very little paler.

FIG. 2

Draw, therefore, two parallel lines for limits to your work, as in FIG. 2, and try to gradate the shade evenly from white to

black, passing over the greatest possible distance, yet so that every part of the band may have visible change in it. The perception of gradation is very deficient in all beginners (not to say, in many artists), and you will probably, for some time, think your gradation skilful enough, when it is quite patchy and imperfect. By getting a piece of grey shaded riband, and comparing it with your drawing, you may arrive, in early stages of your work, at a wholesome dissatisfaction with it. Widen your band little by little as you get more skilful, so as to give the gradation more lateral space, and accustom yourself at the same time to look for gradated spaces in Nature. The sky is the largest and the most beautiful; watch it at twilight, after the sun is down, and try to consider each pane of glass in the window you look through as a piece of paper coloured blue, or grey, or purple, as it happens to be, and observe how quietly and continuously the gradation extends over the space in the window, of one or two feet square. Observe the shades on the outside and inside of a common white cup or bowl, which make it look round and hollow; [If you can get any pieces of dead white porcelain, not glazed, they will be useful models.] and then on folds of white drapery; and thus gradually you will be led to observe the more subtle transitions of the light as it increases or declines on flat surfaces. At last, when your eye gets keen and true, you will see gradation on everything in Nature.

But it will not be in your power yet awhile to draw from any objects in which the gradations are varied and complicated; nor will it be a bad omen for your future progress, and for the use that art is to be made of by you, if the first thing at which you aim should be a little bit of sky. So take any narrow space of evening sky, that you can usually see, between the boughs of a tree, or between two chimneys, or through the corner of a pane in the window you like best to sit at, and try to gradate a little space of white paper as evenly as that is gradated – as *tenderly*, you cannot gradate it without colour, no, nor with colour either; but you may do it as evenly; or, if you get impatient with your spots and lines of ink, when you look at the beauty of the sky, the sense you will have gained of that beauty is something to be thankful for. But you ought not to be impatient with your pen and ink; for all great painters, however delicate their perception of colour, are fond of the peculiar effect of light which may be got in a pen-and-ink sketch, and in a woodcut, by the gleaming of

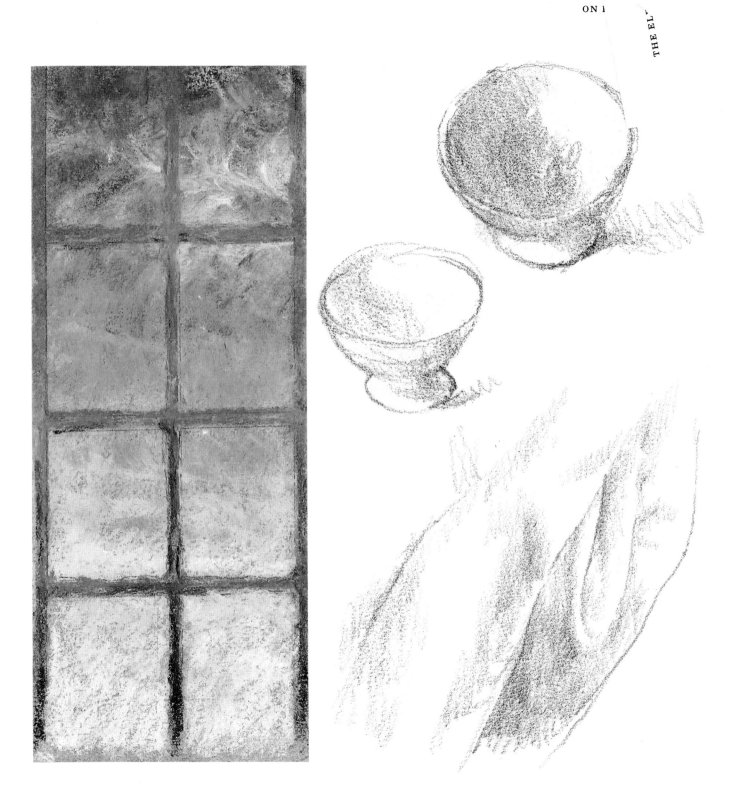

Sickert's etchings, and some pen drawings by him, are a modern equivalent that comes to mind.

the white paper between the black lines; and if you cannot gradate well with pure black lines, you will never gradate well with pale ones. By looking at any common woodcuts, in the cheap publications of the day, you may see how gradation is given to the sky by leaving the lines farther and farther apart; but you must make your lines as fine as you can, as well as far apart, towards the light; and do not try to make them long or straight, but let them cross irregularly in any direction easy to your hand, depending on nothing but their gradation for your effect. On this point of direction of lines, however, I shall have to tell you more, presently; in the meantime, do not trouble yourself about it.

EXERCISE IV As soon as you find you can gradate tolerably with the pen, take an H or HH pencil, using its point to produce shade, from the darkest possible to the palest, in exactly the same manner as the pen, lightening, however, now with India-rubber instead of the penknife. You will find that all *pale* tints of shade are thus easily producible with great precision and tenderness, but that you cannot get the same dark power as with the pen and ink, and that the surface of the shade is apt to become glossy and metallic, or dirty-looking, or sandy. Persevere, however, in trying to bring it to evenness with the fine point, removing any single speck or line that may be too black, with the *point* of the knife: you must not scratch the whole with the knife as you do the ink. If you find the texture very speckled-looking, lighten it all over with India-rubber, and recover it again with sharp, and excessively fine touches of the pencil point, bringing the parts that are too pale to perfect evenness with the darker spots.

You cannot use the point too delicately or cunningly in doing this; work with it as if you were drawing the down on a butterfly's wing.

At this stage of your progress, if not before, you may be assured that some clever friend will come in, and hold up his hands in mocking amazement, and ask you who could set you to that 'niggling'; and if you persevere in it, you will have to sustain considerable persecution from your artistical acquaintances generally, who will tell you that all good drawing depends on 'boldness.' But never mind them. You do not hear them tell a child, beginning music, to lay its little hand with a crash among the keys, in imitation of the great

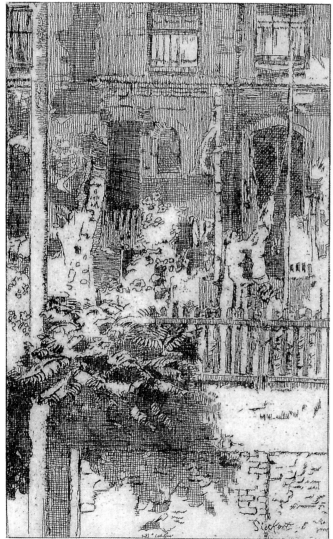

W. R. Sickert *The Hanging Gardens of Islington*. Etching

masters: yet they might, as reasonably as they may tell you to be bold in the present state of your knowledge. Bold, in the sense of being undaunted, yes; but bold in the sense of being careless, confident, or exhibitory – no – no, and a thousand times no; for, even if you were not a beginner, it would be bad advice that made you bold. Mischief may easily be done quickly, but good and beautiful work is generally done slowly; you will find no boldness in the way a flower or a bird's wing is painted; and if Nature is not bold at her work, do you think you ought to be at yours? So never mind what people say, but work with your pencil point very patiently; and if you can trust me in anything, trust me when I tell you, that though there are all kinds and ways of art – large work for large places, small work for narrow places, slow work for people who can wait, and quick work for people who cannot – there is one quality, and, I think, only one, in which all great and good art agrees – it is all delicate art. Coarse art is always bad art. You cannot understand this at present, because you do not know yet how much tender thought, and subtle care, the great painters put into touches that at first look coarse; but, believe me, it is true, and you will find it is so in due time.

You will be perhaps also troubled, in these first essays at pencil drawing, by noticing that more delicate gradations are got in an instant by a chance touch of the India-rubber, than by an hour's labour with the point; and you may wonder why I tell you to produce tints so painfully, which might, it appears, be obtained with ease. But there are two reasons: the first, that when you come to draw forms, you must be able to gradate with absolute precision, in whatever place and direction you wish; not in any wise vaguely, as the India-rubber does it: and, secondly, that all natural shadows are more or less mingled with gleams of light. In the darkness of ground there is the light of the little pebbles or dust; in the darkness of foliage, the glitter of the leaves; in the darkness of flesh, transparency; in that of a stone, granulation: in every case there is some mingling of light, which cannot be represented by the leaden tone which you get by rubbing, or by an instrument known to artists as the 'stump.' When you can manage the point properly, you will indeed be able to do much also with this instrument, or with your fingers; but then you will have to retouch the flat tints afterwards, so as to put life and light into them, and that can only be done with the point. Labour on, therefore, courageously, with that only.

Leonardo in his *Treatise* warns: 'Accuracy ought to be learnt before despatch in the execution.'

Sickert's remarks on Eugène Carrière are applicable here:

'Sound drawing and painting proceeds by accumulations, by addition; decadence sets in when subtraction plays a large part. An interesting example in the history of art has been the undoubted decadence of water-colour painting from the date when it was found the colour could be erased or scratched out, as well as put on. In the fine period of water-colour a thin bough was drawn by an outline. In the decadent period it began to be formed by scratching out a light line from a darker ground. I remember a portrait of Verlaine by Carrière in which a white tuft of moustache is got by wiping out, and leaving a visible wipe to do the work of a certain tone knowingly concocted to a nuance decided on by himself.' (Walter Richard Sickert. *A Free House* ed. Osbert Sitwell)

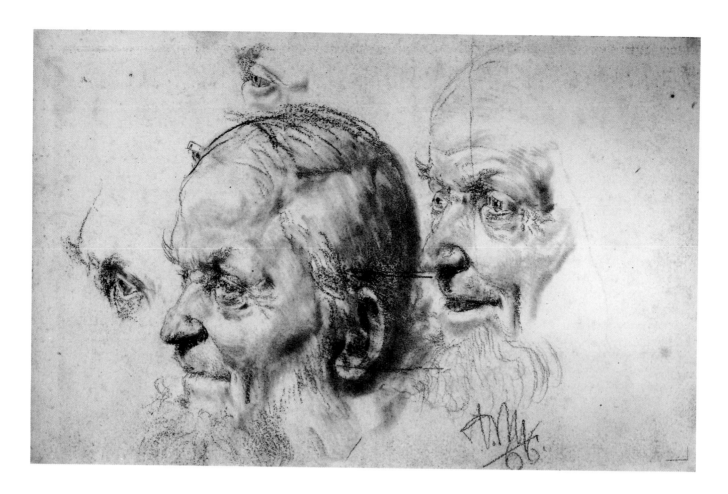

EXERCISE V When you can manage to tint and gradate tenderly with the pencil point, get a good large alphabet, and try to *tint* the letters into shape with the pencil point. Do not outline them first, but measure their height and extreme breadth with the compasses, as *a b, a c,* FIG. 3, and then scratch in their shapes gradually; the letter A, enclosed within the lines, being in what Turner would have called a 'state of forwardness.' Then, when you are satisfied with the shape of the letter, draw pen-and-ink lines firmly round the tint, as at *d,* and remove any touches outside the limit, first with the India-rubber, and then with the penknife, so that all may look clear and right. If you rub out any of the pencil inside the outline of the letter, retouch it, closing it up to the inked line. The straight lines of the outline are all to be ruled, but the curved lines are to be drawn by the eye and hand; and you will soon find what good practice there is in getting the curved letters, such as Bs, Cs, etc., to stand quite straight, and come into accurate form.

A fine drawing by Adolf von Menzel, the great nineteenth-century German artist: it is easy to see the distinction between tone rubbed with the stump, and the crisper touches made with the chalk. (Kunstmuseum, Düsseldorf)

As to the use of a ruler, Ruskin comments in a footnote:

'Artists who glance at this book may be surprised at this permission. My chief reason is, that I think it more necessary that the pupil's eye should be trained to accurate perception of the relations of curve and right lines, by having the latter absolutely true, than that he should practise drawing straight lines. But also, I believe, though I am not quite sure of this, that he never *ought* to be able to draw a straight line. I do not believe a perfectly trained hand ever can draw a line without some curvature in it, or some variety of direction. Prout could draw a straight line, but I do not believe Raphael could, nor Tintoret. A great draughtsman can, as far as I have observed, draw every line *but* a straight one.'

FIG. 3

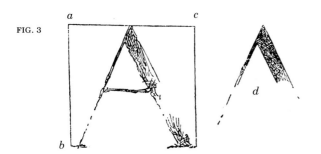

All these exercises are very irksome, and they are not to be persisted in alone; neither is it necessary to acquire perfect power in any of them. An entire master of the pencil or brush ought, indeed, to be able to draw any form at once, as Giotto his circle;* but such skill as this is only to be expected of the consummate master, having pencil in hand all his life, and all day long – hence the force of Giotto's proof of his skill; and it is quite possible to draw very beautifully, without attaining even an approximation to such a power; the main point being, not that every line should be precisely what we intend or wish, but that the line which we intended or wished to draw should be right. If we always see rightly and mean rightly, we shall get on, though the hand may stagger a little; but if we mean wrongly, or mean nothing, it does not matter how firm the hand is. Do not therefore torment yourself because you cannot do as well as you would like; but work patiently, sure that every square and letter will give you a certain increase of power; and as soon as you can draw your letters pretty well, here is a more amusing exercise for you.

EXERCISE VI Choose any tree that you think pretty, which is nearly bare of leaves, and which you can see against the sky, or against a pale wall, or other light ground: it must not be against strong light, or you will find the looking at it hurt your eyes; nor must it be in sunshine, or you will be puzzled by the lights on the boughs. But the tree must be in shade; and the sky blue, or grey, or dull white. A wholly grey or rainy day is the best for this practice.

You will see that all the boughs of the tree are dark against the sky. Consider them as so many dark rivers, to be laid down in a map with absolute accuracy; and, without the least thought about the roundness of the stems, map them all out in flat shade, scrawling them in with pencil, just as you did the limbs of your letters; then correct and alter them, rubbing out and out again, never minding how much your paper is

*This reference is to the well-known story of Giotto drawing a perfect circle freehand, as a demonstration of his ability to be sent to the Pope.

Negative shapes (x) in a drawing

This might be a good place to insert a comment by Sickert on drawing: an over-simplification, but one which contains a truth which Ruskin would have approved of:

'And now I will tell you what drawing is . . . All lines in nature, if you come to reflect on it, are located somewhere in radiants, within the 360 degrees of four right angles. All straight lines absolutely, and all curves, can be considered as tangents to such lines. In other words, there is no line in nature which does not go in the direction of one of the little ticks that mark the minutes on the face of a watch. Given the limits of exactness needed for aesthetic purposes, if you could put on paper by sight the place, that is to say the minute of every line you see, you could draw.' (from *A Free House*)

dirtied (only not destroying its surface), until every bough is exactly, or as near as your utmost power can bring it, right in curvature and in thickness. Look at the white interstices* between them with as much scrupulousness as if they were little estates which you had to survey, and draw maps of, for some important lawsuit, involving heavy penalties if you cut the least bit of a corner off any of them, or give the hedge anywhere too deep a curve; and try continually to fancy the whole tree nothing but a flat ramification on a white ground. Do not take any trouble about the little twigs, which look like a confused network or mist; leave them all out, [or, if you feel able to do so, scratch them in with confused quick touches, indicating the general shape of the cloud or mist of twigs round the main branches; but do not take much trouble about them,] drawing only the main branches as far as you can see them distinctly, your object at present being not to draw a tree, but to learn how to do so. When you have got the thing as nearly right as you can – and it is better to make a good study, than twenty left unnecessarily inaccurate – take your pen, and put a fine outline to all the boughs, as you did to your letter, taking care, as far as possible, to put the outline within the edge of the shade, so as not to make the boughs thicker: the main use of the outline is to affirm the whole more clearly; to do away with little accidental roughnesses and excrescences, and especially to mark where boughs cross, or come in front of each other, as at such points their arrangement in this kind of sketch is unintelligible without the outline. It may perfectly well happen that in Nature it should be less distinct than your outline will make it; but it is better in this kind of sketch to mark the facts clearly. The temptation is always to be slovenly and careless, and the outline is like a bridle, and forces our indolence into attention and precision. The outline should be about the thickness of that in FIG. 4, which represents the ramification of a small stone pine, only I have not endeavoured to represent the pencil shading within the outline, as I could not easily express it in a woodcut; and you have nothing to do at present with the indication of foliage above, of which in another place. You may also draw your trees as much larger than this figure as you like; only, however large they may be, keep the outline as delicate, and draw the branches far enough into their outer sprays to give quite as slender ramification as you have in this figure, otherwise you do not get good enough practice out of them.

*This is another instance where Ruskin's advice is in tune with much later practice (and, in fact, with that of his antagonist Whistler). Sickert and his followers laid great emphasis on the 'negative shapes'.

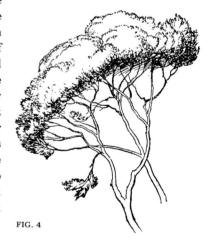

FIG. 4

30

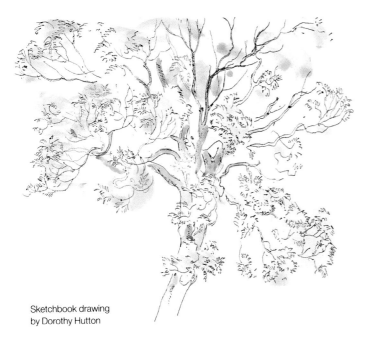

Sketchbook drawing
by Dorothy Hutton

Leslie Worth RWS:
'The wash is the basis of the traditional method of transparent watercolour technique. Applied with the correct balance of water/pigment content, flat, graduated, broken or overlapped, it is the foundation on which nearly every watercolour painting is laid.' (from *Working with Watercolour*, Search Press)

*The modern equivalent of 'a shilling cake of Prussian blue' would be a pan – or a half-pan – of watercolour; it is soft enough for a wet brush to take the colour off. The same colour can, of course, also be bought in a tube. The only colour nowadays available that needs to be rubbed on a dish with water is Chinese ink.

Any good watercolour paper would be perfectly satisfactory for these exercises.

You cannot do too many studies of this kind: every one will give you some new notion about trees. But when you are tired of tree boughs, take any forms whatever which are drawn in flat colour, one upon another; as patterns on any kind of cloth, or flat china (tiles, for instance), executed in two colours only; and practise drawing them of the right shape and size by the eye, and filling them in with shade of the depth required.

In doing this, you will first have to meet the difficulty of representing depth of colour by depth of shade. Thus a pattern of ultramarine blue will have to be represented by a darker tint of grey than a pattern of yellow.

And now it is both time for you to begin to learn the mechanical use of the brush; and necessary for you to do so in order to provide yourself with the gradated scale of colour which you will want. If you can, by any means, get acquainted with any ordinary skilful water-colour painter, and prevail on him to show you how to lay on tints with a brush, by all means do so; not that you are yet, nor for a long while yet, to begin to colour, but because the brush is often more convenient than the pencil for laying on masses or tints of shade, and the sooner you know how to manage it as an instrument the better. If, however, you have no opportunity of seeing how water-colour is laid on by a workman of any kind, the following directions will help you:

EXERCISE VII Get a shilling cake of Prussian blue.* Dip the end of it in water so as to take up a drop, and rub it in a white saucer till you cannot rub much more, and the colour gets dark, thick, and oily-looking. Put two teaspoonfuls of water to the colour you have rubbed down, and mix it well up with a camel's-hair brush about three-quarters of an inch long.

Then take a piece of smooth, but not glossy, Bristol board or pasteboard; divide it, with your pencil and rule, into squares as large as those of the very largest chessboard: they need not be perfect squares, only as nearly so as you can quickly guess. Rest the pasteboard on something sloping as much as an ordinary desk; then, dipping your brush into the colour you have mixed, and taking up as much of the liquid as it will carry, begin at the top of one of the squares, and lay a pond or runlet of colour along the top edge. Lead this pond of colour gradually downwards, not faster at one place than another, but as if you were adding a row of bricks to a building, all along (only building down instead of up), dipping

the brush frequently so as to keep the colour as full in that, and in as great quantity on the paper, as you can, so only that it does not run down anywhere in a little stream. But if it should, never mind; go on quietly with your square till you have covered it all in. When you get to the bottom, the colour will lodge there in a great wave. Have ready a piece of blotting-paper; dry your brush on it, and with the dry brush take up the superfluous colour as you would with a sponge, till it all looks even.

In leading the colour down, you will find your brush continually go over the edge of the square, or leave little gaps within it. Do not endeavour to retouch these, nor take much care about them; the great thing is to get the colour to lie smoothly where it reaches, not in alternate blots and pale patches; try, therefore, to lead it over the square as fast as possible, with such attention to your limit as you are able to give. The use of the exercise is, indeed, to enable you finally to strike the colour up to the limit with perfect accuracy; but the first thing is to get it even – the power of rightly striking the edge comes only by time and practice: even the greatest artists rarely can do this quite perfectly.

When you have done one square, proceed to do another which does not communicate with it. When you have thus done all the alternate squares, as on a chessboard, turn the pasteboard upside down, begin again with the first, and put another coat over it, and so on over all the others. The use of turning the paper upside down is to neutralise the increase of darkness towards the bottom of the squares, which would otherwise take place from the ponding of the colour.

Be resolved to use blotting-paper, or a piece of rag, instead of your lips, to dry the brush. The habit of doing so, once acquired, will save you from much partial poisoning. Take care, however, always to draw the brush from root to point, otherwise you will spoil it. You may even wipe it as you would a pen when you want it very dry, without doing harm, provided you do not crush it upwards. Get a good brush at first, and cherish it; it will serve you longer and better than many bad ones.

When you have done the squares all over again, do them a third time, always trying to keep your edges as neat as possible. When your colour is exhausted, mix more in the same proportions, two teaspoonfuls to as much as you can grind with a drop; and when you have done the alternate squares three times over, as the paper will be getting very

damp, and dry more slowly, begin on the white squares, and bring them up to the same tint in the same way. The amount of jagged dark line which then will mark the limits of the squares will be the exact measure of your unskilfulness.

As soon as you tire of squares draw circles (with compasses); and then draw straight lines irregularly across circles, and fill up the spaces so produced between the straight line and the circumference; and then draw any simple shapes of leaves, according to the exercise NO. II, and fill up those, until you can lay on colour quite evenly in any shape you want.

You will find in the course of this practice, as you cannot always put exactly the same quantity of water to the colour, that the darker the colour is, the more difficult it becomes to lay it on evenly. Therefore, when you have gained some definite degree of power, try to fill in the forms required with a full brush, and a dark tint, at once, instead of laying several coats one over another; always taking care that the tint, however dark, be quite liquid; and that, after being laid on, so much of it is absorbed as to prevent its forming a black line at the edge as it dries. A little experience will teach you how apt the colour is to do this, and how to prevent it; not that it needs always to be prevented, for a great master in water-colours will sometimes draw a firm outline, when he *wants* one, simply by letting the colour dry in this way at the edge.

When, however, you begin to cover complicated forms with the darker colour, no rapidity will prevent the tint from drying irregularly as it is led on from part to part. You will then find the following method useful. Lay in the colour very pale and liquid; so pale, indeed, that you can only just see where it is on the paper. Lead it up to all the outlines, and make it precise in form, keeping it thoroughly wet every-where. Then, when it is all in shape, take the darker colour, and lay some of it *into* the middle of the liquid colour. It will spread gradually in a branchy kind of way, and you may now lead it up to the outlines already determined, and play it with the brush till if fills its place well; then let it dry, and it will be as flat and pure as a single dash, yet defining all the complicated forms accurately.

Having thus obtained the power of laying on a tolerably flat tint, you must try to lay on a gradated one. Prepare the colour with three or four teaspoonfuls of water; then, when it is mixed, pour away about two thirds of it, keeping a teaspoonful of pale colour. Sloping your paper as before, draw

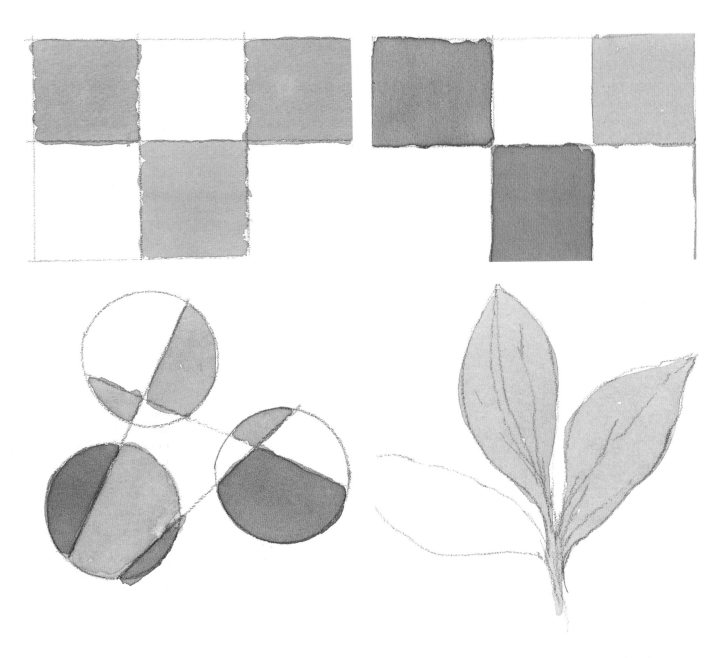

two pencil lines all the way down, leaving a space between them of the width of a square on your chess-board. Begin at the top of your paper, between the lines; and having struck on the first brushful of colour, and led it down a little, dip your brush deep in water, and mix up the colour on the plate quickly with as much more water as the brush takes up at that one dip: then, with this paler colour, lead the tint farther down. Dip in water again, mix the colour again, and thus lead down the tint, always dipping in water once between each replenishing of the brush, and stirring the colour on the plate

33

Gradated colour

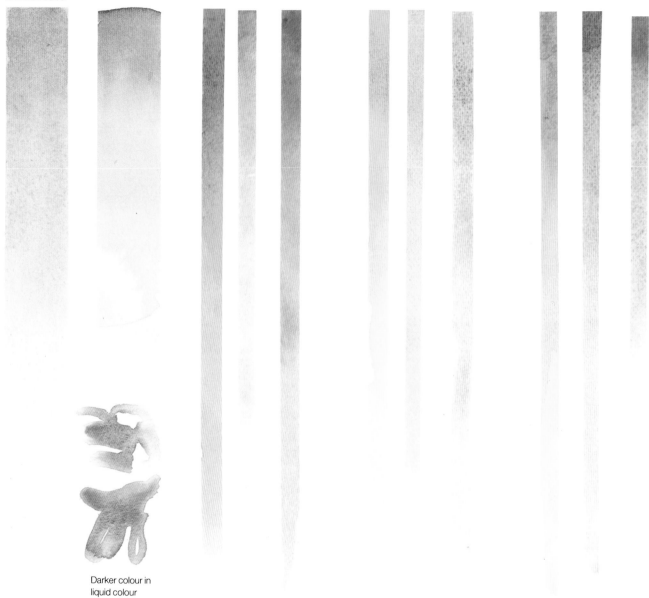

Darker colour in
liquid colour

well, but as quickly as you can. Go on until the colour has become so pale that you cannot see it; then wash your brush thoroughly in water, and carry the wave down a little farther with that, and then absorb it with the dry brush, and leave it to dry.

If you get to the bottom of your paper before your colour gets pale, you may either take longer paper, or begin, with the tint as it was when you left off, on another sheet; but be sure to exhaust it to pure whiteness at last. When all is quite dry, recommence at the top with another similar mixture of colour, and go down in the same way. Then again, and then again, and so continually until the colour at the top of the paper is as dark as your cake of Prussian blue, and passes down into pure white paper at the end of your column, with a perfectly smooth gradation from one into the other.

You will find at first that the paper gets mottled or wavy, instead of evenly gradated; this is because at some places you have taken up more water in your brush than at others, or not mixed it thoroughly on the plate, or led one tint too far before replenishing with the next. Practice only will enable you to do it well; the best artists cannot always get gradations of this kind quite to their minds; nor do they ever leave them on their pictures without after-touching.

As you get more power, and can strike the colour more quickly down, you will be able to gradate in less compass; beginning with a small quantity of colour, and adding a drop of water, instead of a brushful; with finer brushes, also, you may gradate to a less scale. But slight skill will enable you to test the relations of colour to shade as far as is necessary for your immediate progress, which is to be done thus:

Take cakes of lake, of gamboge, of sepia, of blue-black, of cobalt, and vermilion; and prepare gradated columns (exactly as you have done with the Prussian blue) of the lake and blue-black. [Of course, all the columns of colour are to be of equal length.] Cut a narrow slip, all the way down, of each gradated colour, and set the three slips side by side; fasten them down, and rule lines at equal distances across all the three, so as to divide them into fifty degrees, and number the degrees of each, from light to dark, 1, 2, 3, etc. If you have gradated them rightly, the darkest part either of the red or blue will be nearly equal in power to the darkest part of the blue-black, and any degree of the black slip will also, accurately enough for our purpose, balance in weight the degree similarly numbered in the red or the blue slip. Then, when you are drawing from objects of a crimson or blue colour, if you can match their colour by any compartment of the crimson or blue in your scales, the grey in the compartment of the grey scale marked with the same number is the grey which must represent that crimson or blue in your light and shade drawing.

Next, prepare scales with gamboge, cobalt, and vermilion. You will find that you cannot darken these beyond a certain point; for yellow and scarlet, so long as they remain yellow and scarlet, cannot approach to black; we cannot have, properly speaking, a dark yellow or dark scarlet. [The degree of darkness you can reach with the given colour is always indicated by the colour of the solid cake in the box.] Make your scales of full yellow, blue, and scarlet, half-way down; passing *then* gradually to white. Afterwards use lake to darken the upper half of the vermilion and gamboge; and Prussian blue to darken the cobalt. You will thus have three more scales, passing from white nearly to black, through yellow and orange, through sky-blue, and through scarlet. By mixing the gamboge and Prussian blue you may make another with green; mixing the cobalt and lake, another with violet; the sepia alone will make a forcible brown one; and so on, until you have as many scales as you like, passing from black to white through different colours. Then, supposing your scales properly gradated and equally divided, the compartment or degree NO. 1 of the grey will represent in chiaroscuro the NO. 1 of all the other colours; NO. 2 of grey the NO. 2 of the other colours, and so on.

It is only necessary, however, in this matter that you should understand the principle; for it would never be possible for you to gradate your scales so truly as to make them practically accurate and serviceable; and even if you could, unless you had about ten thousand scales, and were able to change them faster than ever juggler changed cards, you could not in a day measure the tints on so much as one side of a frost-bitten apple. But when once you fully understand the principle, and see how all colours contain as it were a certain quantity of darkness, or power of dark relief from white – some more, some less; and how this pitch or power of each may be represented by equivalent values of grey, you will soon be able to arrive shrewdly at an approximation by a glance of the eye, without any measuring scale at all.

You must now go on, again with the pen, drawing patterns, and any shapes of shade that you think pretty, as veinings in

marble or tortoiseshell, spots in surfaces of shells, etc., as tenderly as you can, in the darknesses that correspond to their colours; and when you find you can do this successfully, it is time to begin rounding.

EXERCISE VIII Go out into your garden, or into the road, and pick up the first round or oval stone you can find, not very white, nor very dark; and the smoother it is the better, only it must not *shine*. Draw your table near the window, and put the stone, which I will suppose is about the size of *a* in FIG. 5 (it had better not be much larger), on a piece of not very white paper, on the table in front of you. Sit so that the light may come from your left, else the shadow of the pencil point interferes with your sight of your work. You must not let the *sun* fall on the stone, but only ordinary light: therefore choose a window which the sun does not come in at. If you can shut the shutters of the other windows in the room it will be all the better; but this is not of much consequence.

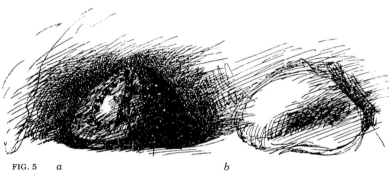

FIG. 5 *a* *b*

Now if you can draw that stone, you can draw anything; I mean, anything that is drawable. Many things (sea foam, for instance) cannot be drawn at all, only the idea of them more or less suggested; but if you can draw the stone *rightly*, everything within reach of art is also within yours.

For all drawing depends, primarily, on your power of representing *Roundness*. If you can once do that, all the rest is easy and straightforward; if you cannot do that, nothing else that you may be able to do will be of any use. For Nature is all made up of roundnesses; not the roundness of perfect globes, but of variously curved surfaces. Boughs are rounded, leaves are rounded, stones are rounded, clouds are rounded, cheeks are rounded, and curls are rounded: there is no more flatness in the natural world than there is vacancy. The

Compare Leonardo's advice: 'To paint well from nature, your window should be to the north, that the lights may not vary. If it be to the south, you must have paper blinds, that the sun, in going round, may not alter the shadows. The situation of the light should be such as to produce upon the ground a shadow from your model as long as that is high.'

In *Modern Painters*, Ruskin has this to say about the drawing of stones:

'Here is an instance, from Titian, of stones in the bed of a torrent, expressing in its writhed and variously broken lines far more of real structure than the common water-colour dash of the moderns. Observe, especially, how Titian has understood that the fracture of the stone more or less depends on the undulating grain of its crystalline structure, following the cavity of the largest stone in the middle of the figure, with concentric lines . . .

'I give one more example from the lower part of the same print . . . in which a stone with an eddy round it, is nearly as well drawn as it can be in the simple method of the early wood engraving. Perhaps the reader will feel its truth better by contrast with a fragment or two of modern Idealism. Here, for instance, is a group of stones, highly entertaining in their variety of form. Next . . . is another poetical conception, one of Flaxman's . . .' (*Modern Painters* vol. VI, p.370)

'Modern Idealism', drawn by Ruskin after Flaxman

produce the appearance of the object and its ground. The best draughtsmen – Titian and Paul Veronese themselves – could do no more than this; and you will soon be able to get some power of doing it in an inferior way, if you once understand the exceeding simplicity of what is to be done. Suppose you have a brown book on a white sheet of paper, on a red tablecloth. You have nothing to do but to put on spaces of red, white, and brown, in the same shape, and gradated from dark to light in the same degrees, and your drawing is done. If you will not look at what you see, if you try to put on

Two drawings by Ruskin after Titian

world itself is round, and so is all that is in it, more or less, except human work, which is often very flat indeed.

Therefore, set yourself steadily to conquer that round stone, and you have won the battle.

Look your stone antagonist boldly in the face. You will see that the side of it next to the window is lighter than most of the paper; that the side of it farthest from the window is darker than the paper; and that the light passes into the dark gradually, while a shadow is thrown to the right on the paper itself by the stone: the general appearance of things being more or less as in *a* FIG. 5, the spots on the stone excepted, of which more presently.

Now, remember always what was stated in the outset, that everything you can see in Nature is seen only so far as it is lighter or darker than the things about it, or of a different colour from them. It is either seen as a patch of one colour on a ground of another; or as a pale thing relieved from a dark thing, or a dark thing from a pale thing. And if you can put on patches of colour or shade of exactly the same size, shape, and gradations as those on the object and its ground, you will

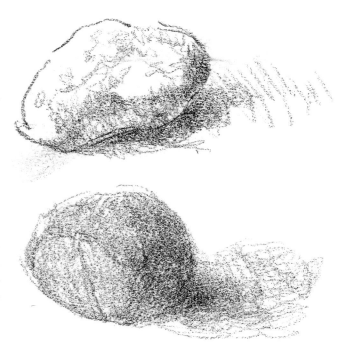

brighter or duller colours than are there, if you try to put them on with a dash or a blot, or to cover your paper with 'vigorous' lines, or to produce anything, in fact, but the plain, unaffected, and finished tranquillity of the thing before you, you need not hope to get on. Nature will show you nothing if you set yourself up for her master. But forget yourself, and try to obey her, and you will find obedience easier and happier than you think.

The real difficulties are to get the refinement of the forms and the evenness of the gradations. You may depend upon it, when you are dissatisfied with your work, it is always too coarse or too uneven. It may not be wrong – in all probability is not wrong, in any (so-called) great point. But its edges are not true enough in outline; and its shades are in blotches, or scratches, or full of white holes. Get it more tender and more true, and you will find it is more powerful.*

Do not, therefore, think your drawing must be weak because you have a finely pointed pen in your hand. Till you can draw with that, you can draw with nothing; when you can draw with that, you can draw with a log of wood charred at the end. True boldness and power are only to be gained by care. Even in fencing and dancing, all ultimate ease depends on early precision in the commencement; much more in singing or drawing.

Now I do not want you to copy my sketch in FIG. 5, but to copy the stone before you in the way that my sketch is done. To which end, first measure the extreme length of the stone with compasses, and mark that length on your paper; then, between the points marked, leave something like the form of the stone in light, scrawling the paper all over, round it; *b*, in FIG. 5, is a beginning of this kind. Rather leave too much room for the high light, than too little; and then more cautiously fill in the shade, shutting the light gradually up, and putting in the dark slowly on the dark side. You need not plague yourself about accuracy of shape, because, till you have practised a great deal, it is impossible for you to draw the shape of the stone quite truly, and you must gradually gain correctness by means of these various exercises: what you have mainly to do at present is, to get the stone to look solid and round, not much minding what its exact contour is – only draw it as nearly right as you can without vexation; and you will get it more right by thus feeling your way to it in shade, than if you tried to draw the outline at first. For you can *see* no outline; what you see is only a certain space of gradated

*Cook and Wedderburn added a footnote here in the Library Edition:

'Leonardo says: "Take care that the shadows and lights be united, or lost in each other; without any hard strokes or lines; as smoke loses itself in the air, so are your lights and shadows to pass from the one to the other, without any apparent separation." '

In a letter to John Lewis of 1858 Ruskin expresses with great vigour the essential difficulty of 'getting things right':

'I never in my life did such a spell of painting . . . and I am surprised to find the terrible difficulty of putting things in their places, even approximately. Surely painters have not enough explained yet to their pupils the infinite way in which everything alters everything else: how what looked too short in outline will look too long in shade, and how a line which seems to slope too much on Wednesday, will slope too little on Thursday, merely because a greater slope has been put beside it. Quite three quarters of my work is placing, and altering things placed.'

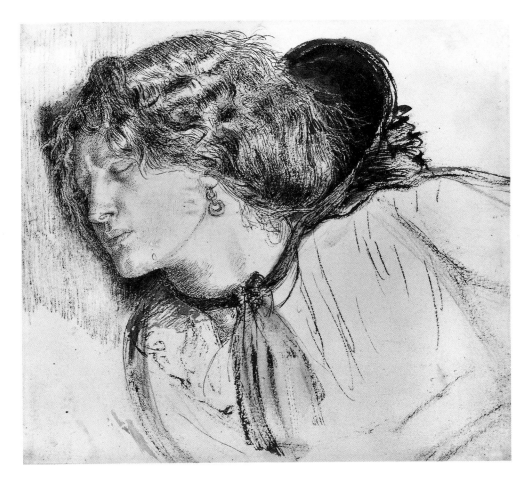

shade, with other such spaces about it; and those pieces of shade you are to imitate as nearly as you can, by scrawling the paper over till you get them to the right shape, with the same gradations which they have in Nature. And this is really more likely to be done well, if you have to fight your way through a little confusion in the sketch, than if you have an accurately traced outline. For instance, having sketched the fossil sea-urchin at *a*, in FIG. 5, whose form, though irregular, required more care in following than that of a common stone, I was going to draw it also under another effect; reflected light bringing its dark side out from the background: but when I had laid on the first few touches I thought it would be better to stop, and let you see how I had begun it, at *b*. In which beginning it will be observed that nothing is so determined but that I can more or less modify,

D. G. Rossetti. Drawing for *Found*. City Museum and Art Gallery, Birmingham

Ruskin nowhere in his book mentions drawing human subjects. However, this beautiful drawing by Rossetti sums up so much of Ruskin's advice that it seems a suitable illustration here. The form is modelled with fine pen strokes using diluted ink. Wash is also used.

and add to or diminish the contour as I work on, the lines which suggest the outline being blended with the others if I do not want them; and the having to fill up the vacancies and conquer the irregularities of such a sketch will probably secure a higher completion at last, than if half an hour had been spent in getting a true outline before beginning.

In doing this, however, take care not to get the drawing too dark. In order to ascertain what the shades of it really are, cut a round hole, about half the size of a pea, in a piece of white paper the colour of that you use to draw on. Hold this bit of paper with the hole in it, between you and your stone; and pass the paper backwards and forwards, so as to see the different portions of the stone (or other subject) through the hole. You will find that, thus, the circular hole looks like one of the patches of colour you have been accustomed to match, only changing in depth as it lets different pieces of the stone be seen through it. You will be able thus actually to *match* the colour of the stone at any part of it, by tinting the paper beside the circular opening. And you will find that this opening never looks quite *black*, but that all the roundings of the stone are given by subdued greys. [The figure *a*, FIG. 5, is very dark, but this is to give an example of all kinds of depths of tint, without repeated figures.]

You will probably find, also, that some parts of the stone or of the paper it lies on, look luminous through the opening; so that the little circle then tells as a light spot instead of a dark spot. When this is so, you cannot imitate it, for you have no means of getting light brighter than white paper: but by holding the paper more sloped towards the light, you will find that many parts of the stone, which before looked light through the hole, then look dark through it; and if you can place the paper in such a position that every part of the stone looks slightly dark, the little hole will tell always as a spot of shade, and if your drawing is put in the same light, you can imitate or match every gradation. You will be amazed to find, under these circumstances, how slight the differences of tint are, by which, through infinite delicacy of gradation, Nature can express form.

If any part of your subject will obstinately show itself as a light through the hole, that part you need not hope to imitate. Leave it white; you can do no more.

When you have done the best you can to get the general form, proceed to finish, by imitating the texture and all the cracks and stains of the stone as closely as you can; and note,

Leonardo says: 'Reverberations are produced by all bodies of a bright nature, that have a smooth and tolerably hard surface, which, repelling the light it receives, makes it rebound like a football [*balzo della palla*] against the first object opposed to it.'

in doing this, that cracks or fissures of any kind, whether between stones in walls, or in the grain of timber or rocks, or in any of the thousand other conditions they present, are never expressible by single black lines, or lines of simple shadow. A crack must always have its complete system of light and shade, however small its scale. It is in reality a little ravine, with a dark or shady side, and light or sunny side, and, usually, shadow in the bottom. This is one of the instances in which it may be as well to understand the reason of the appearance; it is not often so in drawing, for the aspects of things are so subtle and confused that they cannot in general be explained; and in the endeavour to explain some, we are sure to lose sight of others, while the natural over-estimate of the importance of those on which the attention is fixed causes us to exaggerate them, so that merely scientific draughtsmen caricature a third part of Nature, and miss two thirds. The best scholar is he whose eye is so keen as to see at once how the thing looks, and who need not therefore trouble himself with any reasons why it looks so: but few people have this acuteness of perception; and to those who are destitute of it, a little pointing out of rule and reason will be a help, especially when a master is not near them. I never allow my own pupils to ask the reason of anything, because, as I watch their work, I can always show them how the thing IS, and what appearance they are missing in it; but when a master is not by to direct the sight, science may, here and there, be allowed to do so in his stead.

Generally, then, every solid illumined object – for instance, the stone you are drawing – has a light side turned towards the light, a dark side turned away from the light, and a shadow, which is cast on something else (as by the stone on the paper it is set upon). You may sometimes be placed so as to see only the light side and shadow, sometimes only the dark side and shadow, and sometimes both or either without the shadow; but in most positions solid objects will show all the three, as the stone does here.

Hold up your hand with the edge of it towards you, as you sit now with your side to the window, so that the flat of your hand is turned to the window. You will see one side of your hand distinctly lighted, the other distinctly in shade. Here are light side and dark side, with no seen shadow; the shadow being detached, perhaps on the table, perhaps on the other side of the room; you need not look for it at present.

Take a sheet of note-paper, and holding it edgewise, as you

This fine drawing of a stone is taken from *Modern Painters*, vol. IV.

*These passages are further examples of Ruskin's advice anticipating what we have come to think of as the colour theory of the Impressionists. Notice, also, how he emphasizes the need to look for oneself and never to rely on preconceptions.

Ruskin had this to say about the subject in *Modern Painters*:

'. . . the great splendour of the Venetian school arises from their having seen and held from the beginning this great fact – that shadow is as much colour as light, often much more. In Titian's fullest red the lights are pale rose-colour, passing into white – the shadows deep warm crimson. In Veronese's most splendid orange, the lights are pale, the shadows crocus colour: and so on.'

hold your hand, wave it up and down past the side of your hand which is turned from the light, the paper being of course farther from the window. You will see, as it passes, a strong gleam of light strike on your hand, and light it considerably on its dark side. This light is *reflected* light. It is thrown back from the paper (on which it strikes first in coming from the window) to the surface of your hand, just as a ball would be if somebody threw it through the window at the wall and you caught it at the rebound.

Next, instead of the note-paper, take a red book, or a piece of scarlet cloth. You will see that the gleam of light falling on your hand, as you wave the book, is now reddened. Take a blue book, and you will find the gleam is blue. Thus every object will cast some of its own colour back in the light that it reflects.

Now it is not only these books or papers that reflect light to your hand: every object in the room on that side of it reflects some, but more feebly, and the colours mixing all together form a neutral light, which lets the colour of your hand itself be more distinctly seen than that of any object which reflects light to it; but if there were no reflected light, that side of your hand would look as black as a coal.

Objects are seen therefore, in general, partly by direct light, and partly by light reflected from the objects around them, or from the atmosphere and clouds. The colour of their light sides depends much on that of the direct light, and that of the dark sides on the colours of the objects near them. It is therefore impossible to say beforehand what colour an object will have at any point of its surface, that colour depending partly on its own tint, and partly on infinite combinations of rays reflected from other things. The only certain fact about dark sides is, that their colour will be changeful, and that a picture which gives them merely darker shades of the colour of the light sides must assuredly be bad.*

Now, lay your hand flat on the white paper you are drawing on. You will see one side of each finger lighted, one side dark, and the shadow of your hand on the paper. Here, therefore, are the three divisions of shade seen at once. And although the paper is white, and your hand of a rosy colour somewhat darker than white, yet you will see that the shadow all along, just under the finger which casts it, is darker than the flesh, and is of a very deep grey. The reason of this is, that much light is reflected from the paper to the dark side of your finger, but very little is reflected from other

things to the paper itself in that chink under your finger.

In general, for this reason, a shadow, or, at any rate, the part of the shadow nearest the object, is darker than the dark side of the object. I say in general, because a thousand accidents may interfere to prevent its being so. Take a little bit of glass, as a wine-glass, or the ink-bottle, and play it about a little on the side of your hand farthest from the window; you will presently find you are throwing gleams of light all over the dark side of your hand, and in some positions of the glass the reflection from it will annihilate the shadow altogether, and you will see your hand dark on the white paper. Now a stupid painter would represent, for instance, a drinking-glass beside the hand of one of his figures, and because he had been taught by rule that 'shadow was darker than the dark side,' he would never think of the reflection from the glass, but paint a dark grey under the hand, just as if no glass were there. But a great painter would be sure to think of the true effect, and paint it; and then comes the stupid critic, and wonders why the hand is so light on its dark side.

Thus it is always dangerous to assert anything as a *rule* in matters of art; yet it is useful for you to remember that, in a general way, a shadow is darker than the dark side of the thing that casts it, supposing the colours otherwise the same; that is to say, when a white object casts a shadow on a white surface, or a dark object on a dark surface: the rule will not hold if the colours are different, the shadow of a black object on a white surface being, of course, not so dark, usually, as the black thing casting it. The only way to ascertain the ultimate truth in such matters is to *look* for it; but, in the meantime, you will be helped by noticing that the cracks in the stone are little ravines, on one side of which the light strikes sharply, while the other is in shade. This dark side usually casts a little darker shadow at the bottom of the crack; and the general tone of the stone surface is not so bright as the light bank of the ravine. And, therefore, if you get the surface of the object of a uniform tint, more or less indicative of shade, and then scratch out a white spot or streak in it of any shape; by putting a dark touch beside this white one, you may turn it, as you choose, into either a ridge or an incision, into either a boss or a cavity. If you put the dark touch on the side of it nearest the sun, or rather, nearest the place that the light comes from, you will make it a cut or cavity; if you put it on the opposite side, you will make it a

A white cup will serve the purpose of this example much better than the glass suggested by Ruskin, which does not have nearly as much reflective power.

43

ridge or mound; and the complete success of the effect depends less on depth of shade than on the rightness of the drawing; that is to say, on the evident correspondence of the form of the shadow with the form that casts it. In drawing rocks, or wood, or anything irregularly shaped, you will gain far more by a little patience in following the forms carefully, though with slight touches, than by laboured finishing of texture of surface and transparencies of shadow.

When you have got the whole well into shape, proceed to lay on the stains and spots with great care, quite as much as you gave to the forms. Very often, spots or bars of local colour do more to express form than even the light and shade, and they are always interesting as the means by which Nature carries light into her shadows, and shade into her lights; an art of which we shall have more to say hereafter, in speaking of composition. *a*, in FIG. 5, is a rough sketch of a fossil sea-urchin, in which the projections of the shell are of black flint, coming through a chalky surface. These projections form dark spots in the light; and their sides, rising out of the shadow, form smaller whiter spots in the dark. You may take such scattered lights as these out with the penknife, provided you are just as careful to place them rightly as if you got them by a more laborious process.

When you have once got the feeling of the way in which gradation expresses roundness and projection, you may try your strength on anything natural or artificial that happens to take your fancy, provided it be not too complicated in form. I have asked you to draw a stone first, because any irregularities and failures in your shading will be less offensive to you, as being partly characteristic of the rough stone surface, than they would be in a more delicate subject; and you may as well go on drawing rounded stones of different shapes for a little while, till you find you can really shade delicately. You may then take up folds of thick white drapery, a napkin or towel thrown carelessly on the table is as good as anything, and try to express them in the same way; only now you will find that your shades must be wrought with perfect unity and tenderness, or you will lose the flow of the folds. Always remember that a little bit perfected is worth more than many scrawls;

John Ruskin, drawing of Naples. Private Collection

I leave out here a sentence in which Ruskin suggests that the student should copy a photograph of drapery (from sculpture at Chartres, for example).

As I mentioned before, photography at Ruskin's period was still a new and exiciting way of image making: a copy from a photograph would have quite a different connotation. It would not necessarily seem a 'short cut' as it does today – at least, to anyone who takes drawing seriously.

whenever you feel yourself inclined to scrawl, give up work resolutely, and do not go back to it till next day. Of course your towel or napkin must be put on something that may be locked up, so that its folds shall not be disturbed till you have finished ... Probably for some time you will find yourself failing painfully ... for drapery is very difficult to follow in its sweeps; but do not lose courage, for the greater the difficulty, the greater the gain in the effort. If your eye is more just in measurement of form than delicate in perception of tint, a pattern on the folded surface will help you. Try whether it does or not: and if the patterned drapery confuses you, keep for a time to the simple white one; but if it helps you, continue to choose patterned stuffs (tartans and simple chequered designs are better at first than flowered ones), and even though it should confuse you, begin pretty soon to use a pattern occasionally, copying all the distortions and perspective modifications of it among the folds with scrupulous care.

Neither must you suppose yourself condescending in doing this. The greatest masters are always fond of drawing patterns; and the greater they are, the more pains they take to do it truly. Nor can there be better practice at any time, as introductory to the nobler complication of natural detail. For when you can draw the spots which follow the folds of a printed stuff, you will have some chance of following the spots which fall into the folds of the skin of a leopard as he leaps; but if you cannot draw the manufacture, assuredly you will never be able to draw the creature. So the cloudings on a piece of wood, carefully drawn, will be the best introduction to the drawing of the clouds of the sky, or the waves of the sea; and the dead leaf-patterns on a damask drapery, well rendered, will enable you to disentangle masterfully the living leaf-patterns of a thorn thicket or a violet bank.

Observe, however, in drawing any stuffs, or bindings of books, or other finely textured substances, do not trouble yourself, as yet, much about the woolliness or gauziness of the thing; but get it right in shade and fold, and true in pattern. We shall see, in the course of after-practice, how the penned lines may be made indicative of texture; but at present attend only to the light and shade and pattern. You will be puzzled at first by *lustrous* surfaces, but a little attention will show you that the expression of these depends merely on the right drawing of their light and shade, and reflections. Put a small black japanned tray on the table in front of some books; and you will see it reflects the objects

Ruskin wrote in a letter to Anna Blunden, one of his young disciples:

'If you were my pupil . . . I should at once forbid all sentiment for a couple of years and set you to paint, first, – a plain white cambric pocket handkerchief – or linen napkin, thrown at random on the table, and *kept there* – till finished – taking about a week's hard work to said pocket-handkerchief. Then a coloured one, with a simple pattern. Then an apple. Then a child's cheek – perhaps two inches of it – if you were very good – I would give you a bit of lip – as much as would take half a smile. Then a curl or two of golden hair – putting you back to bricks the moment I saw you getting sentimental. If you won't do this I can't help you.'

beyond it as in a little black rippled pond; its own colour mingling always with that of the reflected objects. Draw these reflections of the books properly, making them dark and distorted, as you will see that they are, and you will find that this gives the lustre to your tray. It is not well, however, to draw polished objects in general practice; only you should do one or two in order to understand the aspect of any lustrous portion of other things, such as you cannot avoid; the gold, for instance, on the edges of books, or the shining of silk and damask, in which lies a great part of the expression of their folds. Observe also that there are very few things which are totally without lustre; you will frequently find a light which puzzles you, on some apparently dull surface, to be the dim image of another object.

And now, as soon as you can conscientiously assure me that with the point of the pen or pencil you can lay on any form and shade you like, I give you leave to use the brush with one colour – sepia, or blue black, or mixed cobalt and blue black, or neutral tint; and this will much facilitate your study, and refresh you. But, preliminarily, you must do one or two more exercises in tinting.

EXERCISE IX Prepare your colour as directed for Exercise VII. Take a brush full of it, and strike it on the paper in any irregular shape; as the brush gets dry, sweep the surface of the paper with it as if you were dusting the paper very lightly; every such sweep of the brush will leave a number of more or less minute interstices in the colour. The lighter and faster every dash the better. Then leave the whole to dry; and, as soon as it is dry, with little colour in your brush, so that you can bring it to a fine point, fill up all the little interstices one by one, so as to make the whole as even as you can, and fill in the larger gaps with more colour, always trying to let the edges of the first and of the newly applied colour exactly meet, and not lap over each other. When your new colour dries, you will find it in places a little paler than the first. Retouch it therefore, trying to get the whole to look quite one piece. A very small bit of colour thus filled up with your very best care, and brought to look as if it had been quite even from the first, will give you better practice and more skill than a great deal filled in carelessly; so do it with your best patience, not leaving the most minute spot of white; and do not fill in the large pieces first and then go to the small, but quietly and steadily cover in the whole up to a marked

limit; then advance a little farther, and so on; thus always seeing distinctly what is done and what undone.

EXERCISE X Lay a coat of the blue, prepared as usual, over a whole square of paper. Let it dry. Then another coat over four fifths of the square, or thereabouts, leaving the edge rather irregular than straight, and let it dry. Then another coat over three fifths; another over two fifths; and the last over one fifth; so that the square may present the appearance of gradual increase in darkness in five bands, each darker than the one beyond it. Then, with the brush rather dry, (as in the former exercise, when filling up the interstices), try, with small touches, like those used in the pen etching, only a little broader, to add shade delicately beyond each edge, so as to lead the darker tints into the paler ones imperceptibly. By touching the paper very lightly, and putting a multitude of little touches, crossing and recrossing in every direction, you will gradually be able to work up to the darker tints, outside of each, so as quite to efface their edges, and unite them tenderly with the next tint. The whole square, when done, should look evenly shaded from dark to pale, with no bars, only a crossing texture of touches, something like chopped straw, over the whole. [The use of acquiring this habit of execution is that you may be able, when you begin to colour, to let one hue be seen in minute portions, gleaming between the touches of another.] see page 51

Next, take your rounded pebble; arrange it in any light and shade you like; outline it very loosely with the pencil. Put on a wash of colour, prepared *very* pale, quite flat over all of it, except the highest light, leaving the edge of your colour quite sharp. Then another wash, extending only over the darker parts, leaving the edge of that sharp also, as in tinting the square. Then another wash over the still darker parts, and another over the darkest, leaving each edge to dry sharp. Then, with the small touches, efface the edges, reinforce the darks, and work the whole delicately together as you would with the pen, till you have got it to the likeness of the true light and shade. You will find that the tint underneath is a great help, and that you can now get effects much more subtle and complete than with the pen merely. see page 51

The use of leaving the edges always sharp is that you may not trouble or vex the colour, but let it lie as it falls suddenly on the paper: colour looks much more lovely when it has been laid on with a dash of the brush, and left to dry in its own

way, than when it has been dragged about and disturbed; so that it is always better to let the edges and forms be a little wrong, even if one cannot correct them afterwards, than to lose this fresh quality of the tint. Very great masters in water colour can lay on the true forms at once with a dash, and bad masters in water colour lay on grossly false forms with a dash, and leave them false; for people in general, not knowing false from true, are as much pleased with the appearance of power in the irregular blot as with the presence of power in the determined one; but *we*, in our beginnings, must do as much as we can with the broad dash, and then correct with the point, till we are quite right. We must take care to be right, at whatever cost of pains; and then gradually we shall find we can be right with freedom.

I have hitherto limited you to colour mixed with two or three teaspoonfuls of water; but, in finishing your light and shade from the stone, you may, as you efface the edge of the palest coat towards the light, use the colour for the small touches with more and more water, till it is so pale as not to be perceptible. Thus you may obtain a perfect gradation to the light. And in reinforcing the darks, when they are very dark, you may use less and less water. If you take the colour tolerably dark on your brush, only always liquid (not pasty), and dash away the superflous colour on blotting paper, you will find that, touching the paper very lightly with the dry brush, you can, by repeated touches, produce a dusty kind of bloom, very valuable in giving depth to shadow; but it requires great patience and delicacy of hand to do this properly. You will find much of this kind of work in the grounds and shadows of William Hunt's drawings. see page 52

As you get used to the brush and colour, you will gradually find out their ways for yourself, and get the management of them. And you will often save yourself much discouragement by remembering what I have so often asserted – that if anything goes wrong, it is nearly sure to be refinement that is wanting, not force; and connexion, not alteration. If you dislike the state your drawing is in, do not lose patience with it, nor dash at it, nor alter its plan, nor rub it desperately out, at the place you think wrong; but look if there are no shadows you can gradate more perfectly; no little gaps and rents you can fill; no forms you can more delicately define: and do not *rush* at any of the errors or incompletions thus discerned, but efface or supply slowly, and you will soon find your drawing take another look. A very useful expedient in

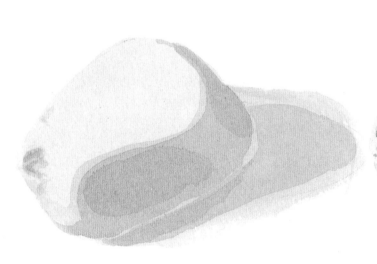

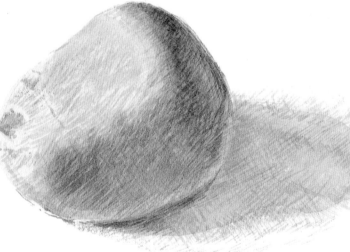

William Henry Hunt *Oyster Shell and Onion*. Watercolour. Private Collection

Sickert on William Hunt:

'I was looking at the exquisite examples of his work at Agnew's the other day, and thinking how he had anticipated the Impressionist technique, in his multitude of small touches, building up a sensitive whole. I was thinking of this, and of Pissarro, and of how the extreme division into small touches in each case brought about this desirable result. The more touches, provided they are dictated by sensation and observation, the more frequent is the revision. Hence the juster sum . . .' (*A Free House*)

He described the methods of Hunt's watercolours as 'pure colour over pure colour', while Ruskin characterized them as 'a broken execution by detached and sharply defined touches'.

producing some effects, is to wet the paper, and then lay the colour on it, more or less wet, according to the effect you want. You will soon see how prettily it gradates itself as it dries; when dry, you can reinforce it with delicate stippling when you want it darker. Also, while the colour is still damp on the paper, by drying your brush thoroughly, and touching the colour with the brush so dried, you may take out soft lights with great tenderness and precision. Try all sorts of experiments of this kind, noticing how the colour behaves; but remembering always that your final results must be obtained, and can only be obtained, by pure work with the point, as much as in the pen drawing.

You will find also, as you deal with more and more complicated subjects, that Nature's resources in light and shade are so much richer than yours, that you cannot possibly get all, or anything like all, the gradations of shadow in any given group. When this is the case, determine first to keep the broad masses of things distinct: if, for instance, there is a green book, and a white piece of paper, and a black inkstand in the group, be sure to keep the white paper as a light mass, the green book as a middle tint mass, the black inkstand as a dark mass; and do not shade the folds in the paper, or corners of the book, so as to equal in depth the darkness of the inkstand. The great difference between the masters of light and shade, and imperfect artists, is the power of the former to draw so delicately as to express form in a dark-coloured object with little light, and in a light-coloured object with little darkness; and it is better even to leave the forms here and there unsatisfactorily rendered than to lose the general relations of the great masses. And this, observe, not because masses are grand or desirable things in your composition (for with composition at present you have nothing whatever to do), but because it is a fact that things do so present themselves to the eyes of men, and that we see paper, book, and inkstand as three separate things, before we see the wrinkles, or chinks, or corners of any of the three. Understand, therefore, at once, that no detail can be as strongly expressed in drawing as it is in reality; and strive to keep all your shadows and marks and minor markings on the masses, lighter than they appear to be in Nature; you are sure otherwise to get them too dark. You will in doing this find that you cannot get the projection of things sufficiently shown; but never mind that; there is no need that they should appear to project, but great need that their relations

of shade to each other should be preserved. All deceptive projection is obtained by partial exaggeration of shadow; and whenever you see it, you may be sure the drawing is more or less bad: a thoroughly fine drawing or painting will always show a slight tendency towards flatness.*

Observe, on the other hand, that, however white an object may be, there is always some small point of it whiter than the rest. You must therefore have a slight tone of grey over everything in your picture except on the extreme high lights; even the piece of white paper, in your subject, must be toned slightly down, unless (and there are thousand chances against its being so) it should all be turned so as fully to front the light. By examining the treatment of the white objects in any pictures accessible to you by Paul Veronese or Titian, you will soon understand this.

As soon as you feel yourself capable of expressing with the brush the undulations of surfaces and the relations of masses, you may proceed to draw more complicated and beautiful things. And first, the boughs of trees, now not in mere dark relief, but in full rounding. Take the first bit of branch or stump that comes to hand, with a fork in it; cut off the ends of the forking branches, so as to leave the whole only about a foot in length; get a piece of paper the same size, fix your bit of branch in some place where its position will not be altered, and draw it thoroughly, in all its light and shade, full size; striving, above all things, to get an accurate expression of its structure at the fork of the branch. When once you have mastered the tree at its *armpits*, you will have little more trouble with it.

Always draw whatever the background happens to be, exactly as you see it. Wherever you have fastened the bough, you must draw whatever is behind it, ugly or not, else you will never know whether the light and shade are right; they may appear quite wrong to you, only for want of the background. And this general law is to be observed in all your studies: whatever you draw, draw completely and unalteringly, else you never know if what you have done is right, or whether you *could* have done it rightly had you tried. There is nothing *visible* out of which you may not get useful practice.

Next, to put the leaves on your boughs. Gather a small twig with four or five leaves on it, put it into water, put a sheet of light-coloured or white paper behind it, so that all the leaves may be relieved in dark from the white field; then sketch in

*In other words, under-modelling rather than over-modelling. Students have a quite natural tendency to try to make things 'look round' or to 'stand out', and this shows itself in the exaggeration of tone between the dark and light side of a form. Ruskin hardly ever mentions the drawing of heads; but it is here that the tendency to over-modelling usually shows itself, and may be counteracted by a study of, for instance, heads by Titian, Gainsborough, Renoir, Goya – all of whom preferred to paint a head in a relatively frontal light, with only slight and subtle changes of tone within the form. Manet's *Olympia* was criticized at the time for being 'as flat as a playing card' (it was exhibited in the Salon eight years after the publication of *The Elements of Drawing*).

'There is always some part of it whiter than the rest.' Perhaps Ruskin exaggerates here. The point – that most surfaces gradate to some extent, and the eye has to be trained to perceive this – is worth making, however.

'Always draw whatever the background happens to be, exactly as you see it.' This – considering its period – is one of the most surprisingly 'modern' statements in *The Elements of Drawing*, and shows how unacademic is Ruskin's whole approach. In all academic drawing based on the Italian Renaissance models, the tendency is always to leave out any background and consider the figure or object as an isolated form. This applies equally to drawing as taught in Ruskin's own time and to the 'Slade Tradition' of the early years of this century. So that the students would automatically comply to this norm, the model or object was arranged as far as possible in front of a plain background. To the best of my knowledge, it was not until the methods of Sickert (deriving from Whistler and Keene) were introduced into English art school training via the Euston Road School and Camberwell, that 'drawing the background shapes' became accepted practice.

Sickert mentions the advice to use the background shapes as being used in teaching by Solomon J. Solomon, the Victorian portrait painter. I have never come across it at any earlier date, except in this instance.

It is useful advice to anyone aiming at precision in objective drawing. A vertical or horizontal behind the object being drawn will connect parts of it and help to relate them accurately together. A shape made by the background (see sketch) can be looked at dispassionately, as an abstract shape about which one can have no preconceptions, and may tell one something important about the object it comes up against. Besides, a drawing is more likely to attain a sense of reality if it describes a relation between an object and its environment; and it will have more relationship with painting, where the background is inevitably being dealt with at the same time as the object.

Left: background shapes used in a study for composition, from a sketchbook

their dark shape carefully with pencil as you did the complicated boughs, in order to be sure that all their masses and interstices are right in shape before you begin shading, and complete as far as you can with pen and ink, in the manner of FIG. 6, which is a young shoot of lilac.

You will probably, in spite of all your pattern drawings, be at first puzzled by leaf foreshortening; especially because the look of retirement or projection depends not so much on the perspective of the leaves themselves as on the double sight of the two eyes. Now there are certain artifices by which good painters can partly conquer this difficulty; as slight exaggerations of force or colour in the nearer parts, and of obscurity in the more distant ones; but you must not attempt

FIG. 6

*'Shut one of your eyes': Anyone who has tried to draw a plant from close up knows the difficulties caused by focusing two eyes on a form which one is drawing in relation to others behind it.

We don't only see one contour of, for instance, a cheek or an apple, but two, for one eye sees further round the object than the other. Slight and continual natural movements of the head increase this tendency to 'see round the edge'. The multiple contours in many late Cézanne drawings may well derive from this physical fact. They are unlikely to be, as we might assume, mere 'shots' at getting the contour right. Cézanne was a highly skilled draughtsman.

'. . . if you have got two eyes there is never an edge anyway, as you are always looking round it. If there is an edge it is two edges, but you do not keep your head still anyway.' (Sir Thomas Monnington, PRA)

anything of this kind. When you are first sketching the leaves, shut one of your eyes,* fix a point in the background, to bring the point of one of the leaves against; and so sketch the whole bough as you see it in a fixed position, looking with one eye only. Your drawing never can be made to look like the object itself, as you see that object with *both* eyes, but it can be made perfectly like the object seen with one, and you must be content when you have got a resemblance on these terms.

In order to get clearly at the notion of the thing to be done, take a single long leaf, hold it with its point towards you, and as flat as you can, so as to see nothing of it but its thinness, as if you wanted to know how thin it was; outline it so. Then slope it down gradually towards you, and watch it as it lengthens out to its full length, held perpendicularly down before you. Draw it in three or four different positions between these extremes, with its ribs as they appear in each position, and you will soon find out how it must be.

Draw first only two or three of the leaves; then larger clusters; and practise, in this way, more and more complicated pieces of bough and leafage, till you find you can master the most difficult arrangements, not consisting of more than ten or twelve leaves. You will find as you do this, if you have an opportunity of visiting any gallery of pictures, that you take a much more lively interest than before in the work of the great masters; you will see that very often their best backgrounds are composed of little more than a few sprays of leafage, carefully studied, brought against the distant sky; and that another wreath or two form the chief interest of their foregrounds. If you live in London you may test your progress *accurately* by the degree of admiration you feel for the leaves of vine round the head of the Bacchus, in Titian's Bacchus and Ariadne. All this, however, will not enable you to draw a mass of foliage. You will find, on looking at any rich piece of vegetation, that it is only one or two of the nearer clusters that you can by any possibility draw in this complete manner. The mass is too vast, and too intricate, to be thus dealt with.

You must now therefore have recourse to some confused mode of execution, capable of expressing the confusion of Nature. And, first, you must understand what the character of that confusion is. If you look carefully at the outer sprays of any tree at twenty or thirty yards' distance, you will see them defined against the sky in masses, which, at first, look quite definite; but if you examine them, you will see, mingled with

'. . . the leaves which crown the Bacchus, and the little dancing faun, in Titian's *Bacchus and Ariadne*, in which every turn of the most subtle perspective, and every gradation of colour, is given with the colossal ease and power of the consummate master.' (Ruskin, *Academy Notes* 1855)

Head of Bacchus, detail, after Titian *Bacchus and Ariadne* (in the National Gallery, London)

the real shapes of leaves, many indistinct lines, which are, some of them, stalks of leaves, and some, leaves seen with the edge turned towards you, and coming into sight in a broken way; for, supposing the real leaf shape to be as at *a*, FIG. 7, this, when removed some yards from the eye, will appear dark against the sky, as at *b*; then, when removed some yards farther still, the stalk and point disappear altogether, the middle of the leaf becomes little more than a line; and the result is the condition at *c*, only with this farther subtlety in the look of it, inexpressible in the woodcut, that the stalk and point of the leaf, though they have disappeared to the eye, have yet some influence in *checking the light* at the places where they exist, and cause a slight dimness about the part of the leaf which remains visible, so that its perfect effect could only be rendered by two layers of colour, one subduing the sky tone a little, the next drawing the broken portions of the leaf, as at *c*, and carefully indicating the greater darkness of the spot in the middle, where the under side of the leaf is.

This is the perfect theory of the matter. In practice we cannot reach such accuracy; but we shall be able to render the general look of the foliage satisfactorily by the following mode of practice.

Gather a spray of any tree, about a foot or eighteen inches long. Fix it firmly by the stem in anything that will support it steadily; put it about eight feet away from you, or ten if you are far-sighted. Put a sheet of not very white paper behind it, as usual. Then draw very carefully, first placing them with pencil, and then filling them up with ink, every leaf-mass and stalk of it in simple black profile, as you see them against the paper: FIG. 8 is a bough of Phillyrea so drawn. Do not be afraid of running the leaves into a black mass when they come together; this exercise is only to teach you what the actual shapes of such masses are when seen against the sky.

Make two careful studies of this kind of one bough of every common tree – oak, ash, elm, birch, beech, etc.; in fact, if you are good, and industrious, you will make one such study carefully at least three times a week, until you have examples of every sort of tree and shrub you can get branches of. You are to make two studies of each bough, for this reason – all masses of foliage have an upper and under surface, and the side view of them, or profile, shows a wholly different organisation of branches from that seen in the view from above. They are generally seen more or less in profile, as you look at the whole tree, and Nature puts her best composition

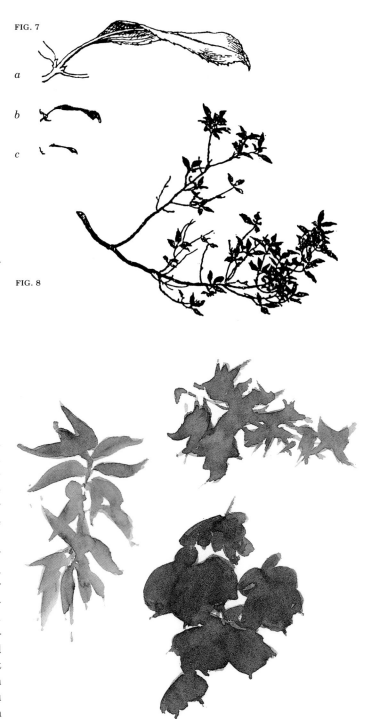

FIG. 7

a

b

c

FIG. 8

Geraniums. Drawing by Diana Armfield.
Private Collection

into the profile arrangement. But the view from above or below occurs not unfrequently, also, and it is quite necessary you should draw it if you wish to understand the anatomy of the tree. The difference between the two views is often far greater than you could easily conceive. For instance, in FIG. 9, *a* is the upper view and *b* the profile, of a single spray of Phillyrea. FIG. 8 is an intermediate view of a larger bough; seen from beneath, but at some lateral distance also.

When you have done a few branches in this manner, take one of the drawings you have made, and put it first a yard away from you, then a yard and a half, then two yards; observe how the thinner stalks and leaves gradually disappear, leaving only a vague and slight darkness where they were; and make another study of the effect at each distance, taking care to draw nothing more than you really see, for in this consists all the difference between what would be merely a miniature drawing of the leaves seen near, and a full-size drawing of the same leaves at a distance. By full size, I mean the size which they would really appear of if their outline were traced through a pane of glass held at the same distance from the eye at which you mean to hold your drawing.* You can always ascertain this full size of any object by holding your paper upright before you, at the distance from your eye at which you wish your drawing to be seen. Bring its edge across the object you have to draw, and mark upon this edge the points where the outline of the object crosses, or goes behind, the edge of the paper. You will always find it, thus measured, smaller than you supposed.

When you have made a few careful experiments of this kind on your own drawings, (which are better for practice, at first, than the real trees, because the black profile in the drawing is quite stable, and does not shake, and is not confused by sparkles of lustre on the leaves,) you may try the extremities of the real trees, only not doing much at a time, for the brightness of the sky will dazzle and perplex your sight. And this brightness causes, I believe, some loss of the outline itself; at least the chemical action of the light in a photograph extends much within the edges of the leaves, and, as it were, eats them away, so that no tree extremity, stand it ever so still, nor any other form coming against bright sky, is truly drawn by a photograph; and if you once succeed in drawing a few sprays rightly, you will find the result much more lovely and interesting than any photograph can be.

*This has become known as working 'sight-size', and is another example of Ruskin's advice corresponding with much later practice, as well as with Leonardo's advice to 'take a glass as large as your paper, fasten it well between your eyes and the object you mean to draw . . .'

The usual practice in Ruskin's day, on the other hand, was to 'fill the paper', whatever one's distance from, for instance, the model in a life-class.

FIG. 9

a

b

All this difficulty, however, attaches to the rendering merely the dark form of the sprays as they come against the sky. Within those sprays, and in the heart of the tree, there is a complexity of a much more embarrassing kind; for nearly all leaves have some lustre, and all are more or less translucent (letting light through them); therefore, in any given leaf, besides the intricacies of its own proper shadows and foreshortenings, there are three series of circumstances which alter or hide its forms. First, shadows cast on it by other leaves – often very forcibly. Secondly, light reflected from its lustrous surface, sometimes the blue of the sky, sometimes the white of clouds, or the sun itself flashing like a star. Thirdly, forms and shadows of other leaves, seen as darknesses through the translucent parts of the leaf; a most important element of foliage effect, but wholly neglected by landscape artists in general.

The consequence of all this is, that except now and then by chance, the form of a complete leaf is never seen; but a marvellous and quaint confusion, very definite, indeed, in its evidence of direction of growth, and unity of action, but wholly indefinable and inextricable, part by part, by any amount of patience. You cannot possibly work it out in facsimile, though you took a twelvemonth's time to a tree; and you must therefore try to discover some mode of execution which will more or less imitate, by its own variety and mystery, the variety and mystery of Nature, without absolute delineation of detail.

Now I have led you to this conclusion by observation of tree form only, because in that the thing to be proved is clearest. But no natural object exists which does not involve in some part or parts of it this inimitableness, this mystery of quantity, which needs peculiarity of handling and trick of touch to express it completely. If leaves are intricate, so is moss, so is foam, so is rock cleavage, so are fur and hair, and texture of drapery, and of clouds. And although methods and dexterities of handling are wholly useless if you have not gained first the thorough knowledge of the form of the thing; so that if you cannot draw a branch perfectly, then much less a tree; and if not a wreath of mist perfectly, much less a flock of clouds; and if not a single grass blade perfectly, much less a grass bank; yet having once got this power over decisive form, you may safely – and must, in order to [achieve] perfection of work – carry out your knowledge by every aid of method and dexterity of hand.

But, in order to find out what method can do, you must now look at Art as well as Nature, and see what means painters and engravers have actually employed for the expression of these subtleties ... It is a general truth, that the enjoyment derivable from art cannot be increased in quantity, beyond a certain point, by quantity of possession; it is only spread, as it were, over a larger surface, and very often dulled by finding ideas repeated in different works. Now, for a beginner, it is always better that his attention should be concentrated on one or two good things, and all his enjoyment founded on them, than that he should look at many, with divided thoughts. He has much to discover; and his best way of discovering it is to think long over few things, and watch them earnestly. It is one of the worst errors of this age to try to know and to see too much: the men who seem to know everything, never in reality know anything rightly. Beware of *handbook* knowledge.

Engravings are, in general, more for you to look at than to copy; and they will be of more use to you when we come to talk of composition, than they are at present; still, it will do you a great deal of good, sometimes to try how far you can get their delicate texture, or gradations of tone: as your pen-and-ink drawing will be apt to incline too much to a scratchy and broken kind of shade ...

You need not copy touch for touch, but try to get the same effect. And if you feel discouraged by the delicacy required, and begin to think that engraving is not drawing, and that copying it cannot help you to draw, remember that it differs from common drawing only by the difficulties it has to encounter. You perhaps have got into a careless habit of thinking that engraving is a mere business, easy enough when one has got into the knack of it. On the contrary, it is a form of drawing more difficult than common drawing, by exactly so much as it is more difficult to cut steel than to move the pencil over paper. It is true that there are certain mechanical aids and methods which reduce it at certain stages either to pure machine work, or to more or less a habit of hand and arm; but this is not so in the foliage you are trying to copy, of which the best and prettiest parts are always etched – that is, drawn with a fine steel point and free hand: only the line made is white instead of black, which renders it much more difficult to judge of what you are about. And the trying to copy these plates will be good for you, because it will awaken you to the real labour and skill of the

This section, in which Ruskin discusses and lists the engravings after Turner that the student should study and copy, presents some difficulty to the present-day reader, who will be far less likely than Ruskin's contemporaries to be able to get hold of them; and in any case will be quite unaccustomed to the idea of copying engravings, or indeed of copying at all. I have therefore regarded these passages as among the few parts of Ruskin's text that can be cut.

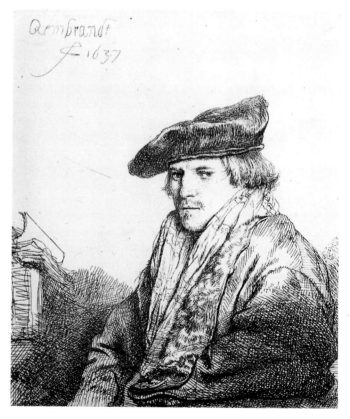

Rembrandt *Ferdinand Bol*. Etching. Royal Academy of Arts Library, London

engraver, and make you understand a little how people must work, in this world, who have really to *do* anything in it ...

Besides these line engravings, and to protect you from what harm there is in their influence, you are to provide yourself, if possible, with a Rembrandt etching, or a photograph of one (of figures, not landscape). It does not matter of what subject, or whether a sketchy or finished one, but the sketchy ones are generally cheapest, and will teach you most. Copy it as well as you can, noticing especially that Rembrandt's most rapid lines have steady purpose; and that they are laid with almost inconceivable precision when the object becomes at all interesting. The 'Prodigal Son,' 'Death of the Virgin,' 'Abraham and Isaac,' and such others, containing incident and character rather than chiaroscuro, will be the most instructive ... Whenever you have an opportunity of examining his work at museums, etc., do so with the greatest care, not looking at *many* things, but a long time at each. You must also provide yourself, if possible, with an engraving of Albert Dürer's. This you will not be able to copy; but you must keep it beside you, and refer to it as a standard of precision in line. If you can get one with a *wing* in it, it will be best. The crest with the cock, that with the skull and satyr, and the 'Melancholy,' are the best you could have, but any will do. Perfection in chiaroscuro drawing lies between these two masters, Rembrandt and Dürer. Rembrandt is often too loose and vague; and Dürer has little or no effect of mist or uncertainty. If you can see anywhere a drawing by Leonardo, you will find it balanced between the two characters; but there are no engravings which present this perfection, and your style will be best formed, therefore, by alternate study of Rembrandt and Dürer. Lean rather to Dürer; it is better, for amateurs, to err on the side of precision than on that of vagueness: and though, as I have just said, you cannot copy a Dürer, yet try every now and then a quarter of an inch square or so, and see how much nearer you can come; you cannot possibly try to draw the leafy crown of the 'Melancholia' too often ...

When either the material (as the copper or wood) or the time of an artist does not permit him to make a perfect drawing – that is to say, one in which no lines shall be prominently visible – and he is reduced to show the black lines, either drawn by the pen, or on the wood, it is better to make these lines help, as far as may be, the expression of texture and form. You will thus find many textures, as of

Dürer *The Four Horsemen of the Apocalypse* (detail). Royal Academy of Arts Library, London

John Leech (1817–64): English illustrator and caricaturist.

Alfred Rethel (1816–59): German draughtsman and painter in fresco.

Ludwig Richter (1803–84): German illustrator.

cloth or grass or flesh, and many subtle effects of light, expressed by Leech with zigzag or crossed or curiously broken lines; and you will see that Alfred Rethel and Richter constantly express the direction and rounding of surfaces by the direction of the lines which shade them. All these various means of expression will be useful to you, as far as you can learn them, provided you remember that they are merely a kind of shorthand; telling certain facts not in quite the right way, but in the only possible way under the conditions: and provided in any after use of such means, you never try to show your own dexterity; but only to get as much record of the object as you can in a given time; and that you continually make efforts to go beyond such shorthand, and draw portions of the objects rightly.

And touching this question of direction of lines as indicating that of surface, observe these few points:

If lines are to be distinctly shown, it is better that, so far as they *can* indicate anything by their direction, they should explain rather than oppose the general character of the object. Thus, in the piece of woodcut from Titian, FIG. 10, the lines are serviceable by expressing, not only the shade of the trunk, but partly also its roundness, and the flow of its grain.

FIG. 10

And Albert Dürer, whose work was chiefly engraving, sets himself always thus to make his lines as *valuable* as possible; telling much by them, both of shade and direction of surface: and if you were always to be limited to engraving on copper (and did not want to express effects of mist or darkness, as well as delicate forms), Albert Dürer's way of work would be the best example for you. But, inasmuch as the perfect way of drawing is by shade without lines, and the great painters

always conceive their subject as complete, even when they are sketching it most rapidly, you will find that, when they are not limited in means, they do not much trust to direction of line, but will often scratch in the shade of a rounded surface with nearly straight lines, that is to say, with the easiest and quickest lines possible to themselves. When the hand is free, the easiest line for it to draw is one inclining from the left upwards to the right, or *vice versâ*, from the right downwards to the left; and when done very quickly, the line is hooked a little at the end by the effort at return to the next. Hence, you will always find the pencil, chalk, or pen sketch of a *very* great master full of these kind of lines; and even if he draws carefully, you will find him using simple straight lines from left to right, when an inferior master would have used curved ones. FIG. 11 is a fairer facsimile of part of a sketch of Raphael's, which exhibits these characters very distinctly. Even the careful drawings of Leonardo da Vinci are shaded most commonly with straight lines; and you may always assume it as a point increasing the probability of a drawing being by a great master if you find rounded surfaces, such as those of cheeks or lips, shaded with straight lines.

FIG. 11

But you will also now understand how easy it must be for dishonest dealers to forge or imitate scrawled sketches like FIG. 11, and pass them for the work of great masters; and how the power of determining the genuineness of a drawing depends entirely on your knowing the facts of the objects drawn, and perceiving whether the hasty handling is *all* conducive to the expression of those truths. In a great man's work, at its fastest, no line is thrown away, and it is not by the rapidity, but the *economy* of the execution that you know him to be great. Now to judge of this economy, you must know exactly what he meant to do, otherwise you cannot of course discern how far he has done it; that is, you must know the beauty and nature of the thing he was drawing. All judgment of art thus finally founds itself on knowledge of Nature.

But farther observe, that this scrawled, or economic, or impetuous execution is never affectedly impetuous. If a great man is not in a hurry, he never pretends to be; if he has no eagerness in his heart, he puts none into his hand; if he thinks his effect would be better got with *two* lines, he never, to show his dexterity, tries to do it with one. Be assured, therefore (and this is a matter of great importance), that you will never produce a great drawing by imitating the execu-

tion of a great master. Acquire his knowledge and share his feelings, and the easy execution will fall from your hand as it did from his: but if you merely scrawl because he scrawled, or blot because he blotted, you will not only never advance in power, but every able draughtsman, and every judge whose opinion is worth having, will know you for a cheat, and despise you accordingly.

Again, observe respecting the use of outline:

All merely outlined drawings are bad, for the simple reason, that an artist of any power can always do more, and tell more, by quitting his outlines occasionally, and scratching in a few lines for shade, than he can by restricting himself to outline only. Hence the fact of his so restricting himself, whatever may be the occasion, shows him to be a bad draughtsman, and not to know how to apply his power economically. This hard law, however, bears only on drawings meant to remain in the state in which you see them; not on those which were meant to be proceeded with, or for some mechanical use. It is sometimes necessary to draw pure outlines, as an incipient arrangement of a composition, to be filled up afterwards with colour, or to be pricked through and used as patterns or tracings; but if, with no such ultimate object, making the drawing wholly for its own sake, and meaning it to remain in the state he leaves it, an artist restricts himself to outline, he is a bad draughtsman, and his work is bad. There is no exception to this law. A good artist habitually sees masses, not edges, and can in every case make his drawing more expressive (with any given quantity of work) by rapid shade than by contours; so that all good work whatever is more or less touched with shade, and more or less interrupted as outline.

Hence ... all outline engravings from pictures, are bad work, and only serve to corrupt the public taste. And of such outlines, the worst are those which are darkened in some part of their course by way of expressing the dark side, as Flaxman's from Dante,* and such others; because an outline can only be true so long as it accurately represents the form of the given object with *one* of its edges. Thus, the outline *a* and the outline *b*, FIG. 12, are both *true* outlines of a ball; because, however thick the line may be, whether we take the interior or exterior edge of it, that edge of it always draws a true circle. But *c* is a false outline of a ball, because either the inner or outer edge of the black line must be an untrue circle, else the line could not be thicker in one place than another.

*John Flaxman (1755–1826) published in 1802 a set of engraved illustrations of Dante which won international acclaim.

FIG. 12

Hence all 'force,' as it is called, is gained by falsification of the contours; so that no artist whose eye is true and fine could endure to look at it. It does indeed often happen that a painter, sketching rapidly, and trying again and again for some line which he cannot quite strike, blackens or loads the first line by setting others beside and across it; and then a careless observer supposes it has been thickened on purpose: or, sometimes also, at a place where shade is afterwards to enclose the form, the painter will strike a broad dash of this shade beside his outline at once, looking as if he meant to thicken the outline; whereas this broad line is only the first instalment of the future shadow, and the outline is really drawn with its inner edge. And thus, far from good draughtsmen darkening the lines which turn away from the light, the *tendency* with them is rather to darken them towards the light, for it is there in general that shade will ultimately enclose them. The best example of this treatment that I know is Raphael's sketch, in the Louvre, of the head of the angel pursuing Heliodorus, the one that shows part of the left eye; where the dark strong lines which terminate the nose and forehead towards the light are opposed to tender and light ones behind the ear, and in other places towards the shade. You will see in FIG. 11 the same principle variously exemplified; the principal dark lines, in the head and drapery of the arms, being on the side turned to the light.

All these refinements and ultimate principles, however, do not affect your drawing for the present. You must try to make your outlines as *equal* as possible; and employ pure outline only for the two following purposes: either (1) to steady your hand, as in EXERCISE II, for if you cannot draw the line itself, you will never be able to terminate your shadow in the precise shape required, when the line is absent; or (2) to give you shorthand memoranda of forms, when you are pressed for time. Thus the forms of distant trees in groups are defined, for the most part, by the light edge of the rounded mass of the nearer one being shown against the darker part of the rounded mass of a more distant one; and to draw this properly, nearly as much work is required to round each tree as to round the stone in FIG. 5. Of course you cannot often get time to do this; but if you mark the terminal line of each tree as is done by Dürer in FIG. 13, you will get a most useful memorandum of their arrangement, and a very interesting drawing. Only observe in doing this, you must not, because the procedure is a quick one, hurry that procedure itself. You

FIG. 13

will find, on copying that bit of Dürer, that every one of his lines is firm, deliberate, and accurately descriptive as far as it goes. It means a bush of such a size and such a shape, definitely observed and set down; it contains a true 'signalement' of every nut-tree, and apple-tree, and higher bit of hedge, all round that village. If you have not time to draw thus carefully, do not draw at all – you are merely wasting your work and spoiling your taste. When you have had four or five years' practice you may be able to make useful memoranda at a rapid rate, but not yet; except sometimes of light and shade, in a way of which I will tell you presently. And this use of outline, note farther, is wholly confined to objects which have edges or limits. You can outline a tree or a stone, when it rises against another tree or stone; but you cannot outline folds in drapery, or waves in water; if these are to be expressed at all, it must be by some sort of shade, and therefore the rule that no good drawing can consist throughout of pure outline remains absolute. You see, in that woodcut of Dürer's, his reason for even limiting himself so much to outline as he has, in those distant woods and plains, is that he may leave them in bright light, to be thrown out still more by the dark sky and the dark village spire: and the scene becomes real and sunny only by the addition of these shades.

Understanding, then, thus much of the use of outline, we will go back to our question about tree-drawing left un-answered at page 59.

We were, you remember, in pursuit of mystery among the leaves. Now, it is quite easy to obtain mystery and disorder, to any extent; but the difficulty is to keep organization in the midst of mystery. And you will never succeed in doing this unless you lean always to the definite side, and allow yourself rarely to become quite vague, at least through all your early practice. So, after your single groups of leaves, your first step must be to conditions like FIGS. 14 and 15, which are careful facsimiles of two portions of a beautiful woodcut of Dürer's, the 'Flight into Egypt.' Copy these carefully – never mind how little at a time, but thoroughly; then trace the Dürer, and apply it to your drawing, and do not be content till the one fits the other, else your eye is not true enough to carry you safely through meshes of real leaves. And in the course of doing this, you will find that not a line nor dot of Dürer's can be displaced without harm; that all add to the effect, and either express something, or illumine something, or relieve something. If, afterwards, you copy any of the pieces of modern tree-drawing, of which so many rich examples are given constantly in our cheap illustrated periodicals,* . . . you will see that, though good· and forcible general effect is produced, the lines are thrown in by thousands without special intention, and might just as well go one way as another, so only that there be enough of them to produce all together a well-shaped effect of intricacy: and you will find that a little careless scratching about with your pen will bring you very near the same result without an effort; but that no scratching of pen, nor any fortunate chance, nor anything but downright skill and thought, will imitate so much as one leaf of Dürer's. Yet there is considerable intricacy and glittering confusion in the interstices of those vine leaves of his, as well as of the grass.

When you have got familiarised to his firm manner, you may draw from Nature as much as you like in the same way; and when you are tired of the intense care required for this, you may fall into a little more easy massing of the leaves, as in FIG. 10 (p. 62). This is facsimiled from an engraving after Titian, but an engraving not quite first-rate in manner, the leaves being a little too formal; still, it is a good enough model for your times of rest; and when you cannot carry the thing even so far as this, you may sketch the forms of the masses,

FIG. 14

FIG. 15

*Ruskin gives as an example the *Illustrated Times Weekly Newspaper* (1855–72)

as in FIG. 16, taking care always to have thorough command over your hand; that is, not to let the mass take a free shape because your hand ran glibly over the paper, but because in Nature it has actually a free and noble shape, and you have faithfully followed the same. [This sketch is not of a tree standing on its head, though it looks like it. You will find it explained presently.]

FIG. 16

And now that we have come to questions of noble shape, as well as true shape, and that we are going to draw from Nature at our pleasure, other considerations enter into the business, which are by no means confined to first practice, but extend to all practice; these (as this letter is long enough, I should think, to satisfy even the most exacting of correspondents) I will arrange in a second letter; praying you only to excuse the tiresomeness of this first one – tiresomeness inseparable from directions touching the beginning of any art – and to believe me, even though I am trying to set you to dull and hard work,

Very faithfully yours,
J. RUSKIN

LETTER II

Sketching from Nature

MY DEAR READER – The work we have already gone through together has, I hope, enabled you to draw with fair success either rounded and simple masses, like stones, or complicated arrangements of form, like those of leaves; provided only these masses or complexities will stay quiet for you to copy, and do not extend into quantity so great as to baffle your patience. But if we are now to go out to the fields, and to draw anything like a complete landscape, neither of these conditions will any more be observed for us. The clouds will not wait while we copy their heaps or clefts; the shadows will escape from us as we try to shape them, each, in its stealthy minute march, still leaving light where its tremulous edge had rested the moment before, and involving in eclipse objects that had seemed safe from its influence; and instead of the small clusters of leaves which we could reckon point by point, embarrassing enough even though numerable, we have now leaves as little to be counted as the sands of the sea, and restless, perhaps, as its foam.

In all that we have to do now, therefore, direct imitation becomes more or less impossible. It is always to be aimed at so far as it *is* possible; and when you have time and opportunity, some portions of a landscape may, as you gain greater skill, be rendered with an approximation almost to mirrored portraiture. Still, whatever skill you may reach, there will always be need of judgment to choose, and of speed to seize, certain things that are principal or fugitive; and you must give more and more effort daily to the observance of characteristic points, and the attainment of concise methods.

I have directed your attention early to foliage for two reasons. First, that it is always accessible as a study; and secondly, that its modes of growth present simple examples of the importance of leading or governing lines.* It is by seizing these leading lines, when we cannot seize all, that likeness and expression are given to a portrait, and grace and a kind of vital truth to the rendering of every natural form. I

'. . . I call these the leading lines or governing lines, not because they are the first which strike the eye, but because, like those of the grain of the wood in a tree-trunk, they rule the swell and fall and change of all the mass. In Nature, or in a photograph, a careless observer will by no means be struck with them, any more than he would by the curves of the tree; and an ordinary artist would draw rather the cragginess and granulation of the surfaces, just as he would rather draw the bark and moss of the trunk. Nor can anyone be more steadfastly adverse than I to every substitution of anatomical knowledge for outward and apparent fact; but it is, that, as an artist increases in acuteness of perception, the facts which *become* outward and apparent to him are those which bear upon the growth or make of the thing.' (*Modern Painters* IV)

call it vital truth, because these chief lines are always expressive of the past history and present action of the thing. They show in a mountain, first, how it was built or heaped up; and secondly, how it is now being worn away, and from what quarter the wildest storms strike it. In a tree, they show what kind of fortune it has had to endure from its childhood: how troublesome trees have come in its way, and pushed it aside, and tried to strangle or starve it; where and when kind trees have sheltered it, and grown up lovingly together with it, bending as it bent; what winds torment it most; what boughs of it behave best, and bear most fruit; and so on. In a wave or cloud, these leading lines show the run of the tide and of the wind, and the sort of change which the water or vapour is at any moment enduring in its form, as it meets shore, or counter-wave, or melting sunshine. Now remember, nothing distinguishes great men from inferior men more than their always, whether in life or in art, *knowing the way things are going*. Your dunce thinks they are standing still, and draws them all fixed; your wise man sees the change or changing in them, and draws them so — the animal in its motion, the tree in its growth, the cloud in its course, the mountain in its wearing away. Try always, whenever you look at a form, to see the lines in it which have had power over its past fate and will have power over its futurity. Those are its *awful* lines; see that you seize on those, whatever else you miss. Thus, the leafage in FIG. 16 (page 68) grew round the root of a stone pine, on the brow of a crag at Sestri near Genoa, and all the sprays of it are thrust away in their first budding by the great rude root, and spring out in every direction round it, as water splashes when a heavy stone is thrown into it. Then, when they have got clear of the root, they begin to bend up again; some of them, being little stone pines themselves, have a great notion of growing upright, if they can; and this struggle of theirs to recover their straight road towards the sky, after being obliged to grow sideways in their early years, is the effort that will mainly influence their future destiny, and determine if they are to be crabbed, forky pines, striking from that rock of Sestri, whose clefts nourish them, with bared red lightning of angry arms towards the sea; or if they are to be goodly and solemn pines, with trunks like pillars of temples, and the purple burning of their branches sheathed in deep globes of cloudy green. Those, then, are their fateful lines; see that you give that spring and resilience, whatever you leave ungiven:

Gerard Manley Hopkins's conception of 'inscape' as the characteristic shape or pattern of a natural form, is relevant here.

'Awful' is used here, of course, in its original meaning: 'worthy of, or commanding, profound respect or reverential fear'. (*OED*)

depend upon it, their chief beauty is in these.

So in trees in general, and bushes, large or small, you will notice that, though the boughs spring irregularly and at various angles, there is a tendency in all to stoop less and less as they near the top of the tree. This structure, typified in the simplest possible terms at *c*, FIG. 17, is common to all trees that I know of, and it gives them a certain plumy character, and aspect of unity in the hearts of their branches, which are essential to their beauty. The stem does not merely send off a wild branch here and there to take its own way, but all the branches share in one great fountain-like impulse; each has a curve and a path to take, which fills a definite place, and each terminates all its minor branches at its outer extremity, so as to form a great outer curve, whose character and proportion are peculiar for each species. That is to say, the general type or idea of a tree is not as *a*, FIG. 17, but as *b*, in which, observe, the boughs all carry their minor divisions right out to the bounding curve; not but that smaller branches, by thousands, terminate in the heart of the tree, but the idea and main purpose in every branch are to carry all its child branches well out to the air and light, and let each of them, however small, take its part in filling the united flow of the bounding curve, so that the type of each separate bough is again not *a*, but *b*, FIG. 18; approximating, that is to say, so far to the structure of a plant of broccoli as to throw the great mass of spray and leafage out to a rounded surface. Therefore beware of getting into a careless habit of drawing boughs with successive sweeps of the pen or brush, one hanging to the other, as in FIG. 19. If you look at the tree-boughs in any painting of Wilson's* you will see this structure, and nearly every other that is to be avoided, in their intensest types. You will also notice that Wilson never conceives a tree as a round mass, but flat, as if it had been pressed and dried. Most people in drawing pines seem to fancy, in the same way, that the boughs come out only on two sides of the trunk, instead of all round it: always, therefore, take more pains in trying to draw the boughs of trees that grow *towards* you than those that go off to the sides; anybody can draw the latter, but the fore-shortened ones are not so easy. It will help you in drawing them to observe that in most trees the ramification of each branch, though not of the tree itself, is more or less flattened, and approximates, in its position, to the look of a hand held out to receive something, or shelter something. If you take a looking-glass, and hold your hand before it slightly

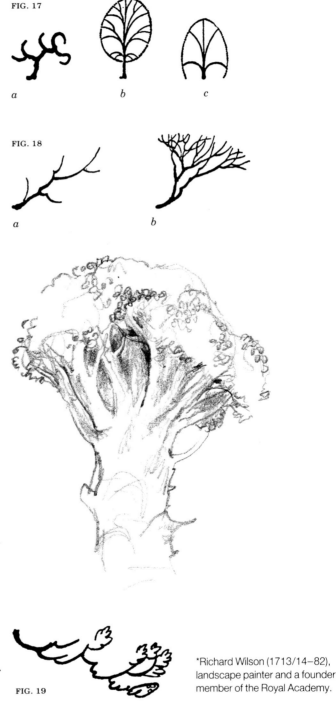

FIG. 17

a *b* *c*

FIG. 18

a *b*

FIG. 19

*Richard Wilson (1713/14–82), landscape painter and a founder member of the Royal Academy.

71

hollowed, with the palm upwards, and the fingers open, as if you were going to support the base of some great bowl, larger than you could easily hold; and sketch your hand as you see it in the glass with the points of the fingers towards you; it will materially help you in understanding the way trees generally hold out their hands: and if then you will turn yours with its palm downwards, as if you were going to try to hide something, but with the fingers expanded, you will get a good type of the action of the lower boughs in cedars and such other spreading trees.

FIG. 20 will give you a good idea of the simplest way in which these and other such facts can be rapidly expressed; if you copy it carefully, you will be surprised to find how the touches all group together, in expressing the plumy toss of the tree branches, and the springing of the bushes out of the

Fig. 20 was drawn by Ruskin from a detail of *Sheep-washing: Windsor from Slough*, an unpublished plate for *Liber Studiorum*.

FIG. 20

Samuel Palmer *A Cow Lodge with a Mossy Roof* *c.*1829. Yale Center for British Art, Paul Mellon Collection

bank, and the undulation of the ground: note the careful drawing of the footsteps made by the climbers of the little mound on the left. It is facsimiled from an etching of Turner's, and is as good an example as you can have of the use of pure and firm lines; it will also show you how the particular action in foliage, or anything else to which you wish to direct attention, may be intensified by the adjuncts. The tall and upright trees are made to look more tall and upright still, because their line is continued below by the figure of the farmer with his stick; and the rounded bushes on the bank are made to look more rounded because their line is continued in one broad sweep by the black dog and the boy climbing the wall. These figures are placed entirely with this object, as we shall see more fully hereafter when we come to talk about composition; but, if you please, we will not talk about that yet awhile. What I have been telling you about the beautiful lines and action of foliage has nothing to do with composition, but only with fact, and the brief and expressive representation of fact. But there will be no harm in your looking forward, if you like to do so, to the account, in Letter III, of the 'Law of Radiation,' and reading what is said there about tree growth: indeed it would in some respects have

been better to have said it here than there, only it would have broken up the account of the principles of composition somewhat awkwardly.

Now, although the lines indicative of action are not always quite so manifest in other things as in trees, a little attention will soon enable you to see that there are such lines in everything. In an old house roof, a bad observer and bad draughtsman will only see and draw the spotty irregularity of tiles or slates all over; but a good draughtsman will see all the bends of the under timbers, where they are weakest and the weight is telling on them most, and the tracks of the run of the water in time of rain, where it runs off fastest, and where it lies long and feeds the moss; and he will be careful, however few slates he draws, to mark the way they bend together towards those hollows (which have the future fate of the roof in them), and crowd gradually at the top of the gable, partly diminishing in perspective, partly perhaps, diminished on purpose (they are so in most English old houses) by the slate-layer. So in ground, there is always the direction of the run of the water to be noticed, which rounds the earth and cuts it into hollows; and, generally, in any bank or height worth drawing, a trace of bedded or other internal structure

besides. FIG. 20 will give you some idea of the way in which such facts may be expressed by a few lines. Do you not feel the depression in the ground all down the hill where the footsteps are, and how the people always turn to the left at the top, losing breath a little, and then how the water runs down in that other hollow towards the valley, behind the roots of the trees?

Now, I want you in your first sketches from Nature to aim exclusively at understanding and representing these vital facts of form; using the pen – not now the steel, but the quill* – firmly and steadily, never scrawling with it, but saying to yourself before you lay on a single touch – 'that leaf is the main one, that bough is the guiding one, and this touch, so long, so broad, means that part of it' – point or side or knot, as the case may be. Resolve always, as you look at the thing, what you will take, and what miss of it, and never let your hand run away with you, or get into any habit or method of touch. If you want a continuous line, your hand should pass calmly from one end of it to the other without a tremor; if you want a shaking and broken line, your hand should shake, or break off, as easily as a musician's finger shakes or stops on a note: only remember this, that there is no general way of doing any thing; no recipe can be given you for so much as the drawing of a cluster of grass. The grass may be ragged and stiff, or tender and flowing; sunburnt and sheep-bitten, or rank and languid; fresh or dry; lustrous or dull: look at it, and try to draw it as it is, and don't think how somebody 'told you to do grass.' So a stone may be round or angular, polished or rough, cracked all over like an ill-glazed teacup, or as united and broad as the breast of Hercules. It may be as flaky as a wafer, as powdery as a field puffball; it may be knotted like a ship's hawser, or kneaded like hammered iron, or knit like a Damascus sabre, or fused like a glass bottle, or crystallised like hoar-frost, or veined like a forest leaf: look at it, and don't try to remember how anybody told you to 'do a stone.'

As soon as you find that your hand obeys you thoroughly, and that you can render any form with a firmness and truth approaching that of Turner's or Dürer's work, you must add a simple but equally careful light and shade to your pen drawing, so as to make each study as complete as possible; for which you must prepare yourself thus. Get, if you can, a good impression of one plate of Turner's Liber Studiorum. ... You will see that it is composed of a firm etching in line, with mezzotint shadow laid over it. You must first copy the etched

*There is no reason why the student should not occasionally use a quill pen, even though more convenient tools are to hand. The quill is a very sensitive instrument, capable of great variety of touch; the use of it will give greater insight into, for instance, Rembrandt's drawings. Quills can be bought from specialist dealers in art materials.

Ruskin adds a note here: 'I do not mean that you can approach Turner or Dürer in their strength, that is to say, in their imagination or power of design. But you may approach them, by perseverance, in truth of manner.'

Here Ruskin gives a list of Turner's Liber Studiorum plates which he recommends for copying (plus another list of those which are 'quite useless'). From these I reproduce Ben Arthur, opposite.

Another 'outline' from a Liber Studiorum plate (unpublished) is shown on page 72.

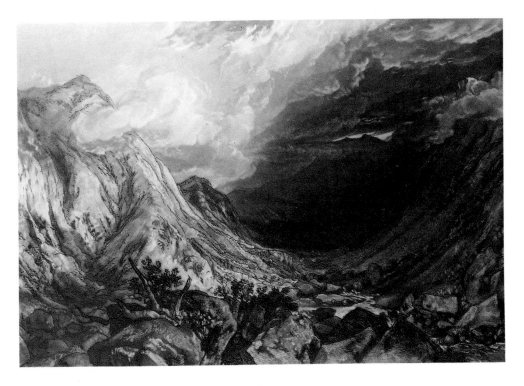

J. M. W. Turner *Ben Arthur*. Engraving from *Liber Studiorum*. Royal Academy of Arts Library, London

part of it accurately; to which end put the print against the window, and trace slowly with the greatest care every black line; retrace this on smooth drawing-paper; and, finally, go over the whole with your pen, looking at the original plate always, so that if you err at all, it may be on the right side, not making a line which is too curved or too straight already in the tracing, more curved or more straight, as you go over it. And in doing this, never work after you are tired, nor to 'get the thing done,' for if it is badly done, it will be of no use to you. The true zeal and patience of a quarter of an hour are better than the sulky and inattentive labour of a whole day. If you have not made the touches right at the first going over with the pen, retouch them delicately, with little ink in your pen, thickening or reinforcing them as they need: you cannot give too much care to the facsimile. Then keep this etched outline by you in order to study at your ease the way in which Turner uses his line as preparatory for the subsequent shadow; it is only in getting the two separate that you will be able to reason on this. Next, copy once more, though for the fourth time, any part of this etching which you like, and put on the light and shade with the brush, working it with the

point of the brush as delicately as if you were drawing with pencil, and dotting and cross-hatching as lightly as you can touch the paper, till you get the gradations of Turner's engraving.

In this exercise, as in the former one, a quarter of an inch worked to close resemblance of the copy is worth more than the whole subject carelessly done. Not that in drawing afterwards from Nature you are to be obliged to finish every gradation in this way, but that, once having fully accomplished the drawing *something* rightly, you will thenceforward feel and aim at a higher perfection than you could otherwise have conceived, and the brush will obey you, and bring out quickly and clearly the loveliest results, with a submissiveness which it would have wholly refused if you had not put it to severest work. Nothing is more strange in art than the way that chance and materials seem to favour you, when once you have thoroughly conquered them. Make yourself quite independent of chance, get your result in spite of it, and from that day forward all things will somehow fall as you would have them. Show the camel's hair, and the colour in it, that no bending nor blotting is of any use to escape your will; that the touch and the shade *shall* finally be right, if it costs you a year's toil; and from that hour of corrective conviction, said camel's hair will bend itself to all your wishes, and no blot will dare to transgress its appointed border ... You will find that a few well-put pen lines, with a tint dashed over or under them, get more expression of facts than you could reach in any other way, by the same expenditure of time. The use of the Liber Studiorum print to you is chiefly as an example of the simplest shorthand of this kind, a shorthand which is yet capable of dealing with the most subtle natural effects; for the firm etching gets at the expression of complicated details, as leaves, masonry, textures of ground, etc., while the overlaid tint enables you to express the most tender distances of sky, and forms of playing light, mist, or cloud. Most of the best drawings by the old masters are executed on this principle, the touches of the pen being useful also to give a look of transparency to shadows, which could not otherwise be attained but by great finish of tinting; and if you have access to any ordinarily good public gallery ... you will not be at a loss to find some example of this unity of pen with tinting ...

And now at last, when you can copy a piece of Liber Studiorum, or its photographic substitute, faithfully, you

D. G. Rossetti, *Tennyson reading 'Maud'*. City Museum and Art Gallery, Birmingham. '. . . a few well-put lines, with a tint dashed over or under them.'

I have cut a couple of long passages here in which Ruskin suggests that the student, if he cannot get hold of the Turner prints, should copy from photographs. I have explained elsewhere how the photograph in Ruskin's day was a new and exciting image; and how different our attitude to it is likely to be.

He recommends the use of photography only to those students who are unable, because of where they live, to have access to galleries or printsellers. This can no longer apply in this age of universally available books and reproductions.

have the complete means in your power of working from Nature on all subjects that interest you, which you should do in four different ways.

First. When you have full time, and your subject is one that will stay quiet for you, make perfect light and shade studies, or as nearly perfect as you can, with grey or brown colour of any kind, reinforced and defined with the pen.

Secondly. When your time is short, or the subject is so rich in detail that you feel you cannot complete it intelligibly in light and shade, make a hasty study of the effect, and give the rest of the time to a Düreresque expression of the details. If the subject seems to you interesting, and there are points about it which you cannot understand, try to get five spare minutes to go close up to it, and make a nearer memorandum; not that you are ever to bring the details of this nearer sketch into the farther one, but that you may thus perfect your experience of the aspect of things, and know that such and such a look of a tower or cottage at five hundred yards off means *that* sort of tower or cottage near; while, also, this nearer sketch will be useful to prevent any future misinterpretation of your own work. If you have time, however far your light and shade study in the distance may have been carried, it is always well, for these reasons, to make also your Düreresque and your near memoranda; for if your light and shade drawing be good, much of the interesting detail must be lost in it, or disguised.

Your hasty study of effect may be made most easily and quickly with a soft pencil, dashed over when done with one tolerably deep tone of grey, which will fix the pencil. While this fixing colour is wet, take out the higher lights with the dry brush; and, when it is quite dry, scratch out the highest lights with the penknife. Five minutes, carefully applied, will do much by these means. Of course the paper is to be white. I do not like studies on grey paper so well; for you can get more gradation by the taking off your wet tint, and laying it on cunningly a little darker here and there, than you can with body-colour white, unless you are consummately skilful. There is no objection to your making your Düreresque memoranda on grey or yellow paper, and touching or relieving them with white; only, do not depend much on your white touches, nor make the sketch for their sake.

Thirdly. When you have neither time for careful study nor for Düreresque detail, sketch the outline with pencil, then dash in the shadows with the brush boldly, trying to do as

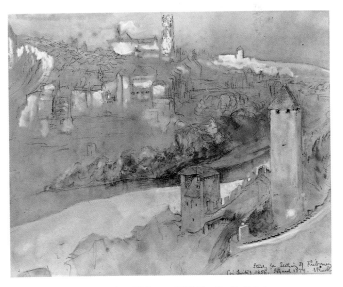

John Ruskin. Study for etching of Fribourg, 1856. The Ruskin Galleries, Bembridge School, Isle of Wight

White touches: this always seems good advice. Whether the white is put on in chalk or in body colour, it should be a sort of final emphasis given to a form which is still expressive without it.

much as you possibly can at once, and to get a habit of expedition and decision; laying more colour again and again into the tints as they dry, using every expedient which your practice has suggested to you of carrying out your chiaroscuro in the manageable and moist material, taking the colour off here with the dry brush, scratching out lights in it there with the wooden handle of the brush, rubbing it in with your fingers, drying it off with your sponge, etc. Then, when the colour is in, take your pen and mark the outline characters vigorously, in the manner of the Liber Studiorum. This kind of study is very convenient for carrying away pieces of effect which depend not so much on refinement as on complexity, strange shapes of involved shadows, sudden effects of sky, etc.; and it is most useful as a safeguard against any too servile or slow habits which the minute copying may induce in you; for although the endeavour to obtain velocity merely for velocity's sake, and dash for display's sake, is as baneful as it is despicable; there *are* a velocity and a dash which not only are compatible with perfect drawing, but obtain certain results which cannot be had otherwise. And it is perfectly safe for you to study occasionally for speed and decision, while your continual course of practice is such as to ensure your retaining an accurate judgment and a tender touch. Speed, under such circumstances, is rather fatiguing than tempting; and you will find yourself always beguiled rather into elaboration than negligence.

Fourthly. You will find it of great use, whatever kind of landscape scenery you are passing through, to get into the habit of making memoranda of the shapes of shadows. You will find that many objects of no essential interest in themselves, and neither deserving a finished study, nor a Düreresque one, may yet become of singular value in consequence of the fantastic shapes of their shadows; for it happens often, in distant effect, that the shadow is by much a more important element than the substance. Thus, in the Alpine bridge, FIG. 21, seen within a few yards of it, as in the figure, the arrangement of timbers to which the shadows are owing is perceptible; but at half a mile's distance, in bright sunlight, the timbers would not be seen; and a good painter's expression of the bridge would be merely the large spot, and the crossed bars, of pure grey; wholly without indication of their cause, as in FIG. 22 *a*; and if we saw it at still greater distances, it would appear as in FIG. 22 *b* and *c*, diminishing at last to a strange, unintelligible, spider-like spot of grey on

FIG. 21

a

b

FIG. 22 *c*

the light hillside. A perfectly great painter, throughout his distances, continually reduces his objects to these shadow abstracts; and the singular, and to many persons unaccountable, effect of the confused touches in Turner's distances, is owing chiefly to this thorough accuracy and intense meaning of the shadow abstracts.

Studies of this kind are easily made, when you are in haste, with an F or HB pencil: it requires some hardness of the point to ensure your drawing delicately enough when the forms of the shadows are very subtle; they are sure to be so somewhere, and are generally so everywhere. The pencil is indeed a very precious instrument after you are master of the pen and brush, for the pencil, cunningly used, is both, and will draw a line with the precision of the one and the gradation of the other; nevertheless, it is so unsatisfactory to see the sharp touches, on which the best of the detail depends, getting gradually deadened by time, or to find the places where force was wanted look shiny, and like a fire-grate, that I should recommend rather the steady use of the pen, or brush, and colour, whenever time admits of it; keeping only a small memorandum-book in the breast-pocket, with its well-cut, sheathed pencil, ready for notes on passing opportunities: but never being without this.

Thus much, then, respecting the manner in which you are at first to draw from Nature. But it may perhaps be serviceable to you, if I also note one or two points respecting your choice of subjects for study, and the best special methods of treating some of them; for one of by no means the least difficulties which you have at first to encounter is a peculiar instinct, common, as far as I have noticed, to all beginners, to fix on exactly the most unmanageable feature in the given scene. There are many things in every landscape which can be drawn, if at all, only by the most accomplished artists; and I have noticed that it is nearly always these which a beginner will dash at; or, if not these, it will be something which, though pleasing to him in itself, is unfit for a picture, and in which, when he has drawn it, he will have little pleasure. As some slight protection against this evil genius of beginners, the following general warnings may be useful:

(1) Do not draw things that you love, on account of their associations; or at least do not draw them because you love them; but merely when you cannot get anything else to draw. If you try to draw places that you love, you are sure to be

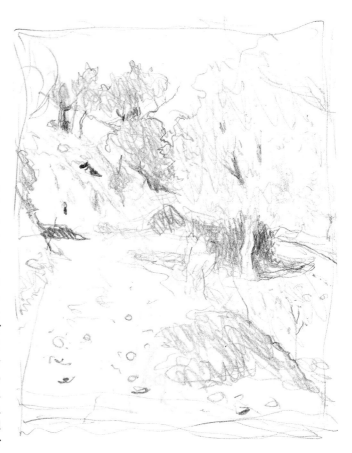

A rapidly drawn note from a sketchbook

Sickert also made a point of advising artists not to draw or paint their friends, or subjects for which they had personal feelings. In a letter to Ethel Sands he argued for a complete detachment: something which, fortunately, he did not put into practice in his own work:

'There is a constant snare in paint-ing what is part of your life. You cannot avoid with yourself or another artist or a member of your own house or family a spoken or silent dialogue which is irrelevant to light and shade, irrelevant to colour . . . The nullity and irrelevance to yourself of the personality of a model is tonic, has incredible virtues.'

always entangled amongst neat brick walls, iron railings, gravel walks, greenhouses, and quickset hedges; besides that you will be continually led into some endeavour to make your drawing pretty, or complete, which will be fatal to your progress. You need never hope to get on, if you are the least anxious that the drawing you are actually at work upon should look nice when it is done. All you have to care about is to make it *right*, and to learn as much in doing it as possible. So then, though when you are sitting in your friend's parlour, or in your own, and have nothing else to do, you may draw anything that is there, for practice; even the fire-irons or the pattern on the carpet: be sure that it *is* for practice, and not because it is a beloved carpet, or a friendly poker and tongs, nor because you wish to please your friend by drawing her room.

Also, never make presents of your drawings. Of course I am addressing you as a beginner – a time may come when your work will be precious to everybody; but be resolute not to give it away till you know that it is worth something (as soon as it is worth anything you will know that it is so). If any one asks you for a present of a drawing, send them a couple of cakes of colour and a piece of Bristol board: those materials are, for the present, of more value in that form than if you had spread the one over the other.

The main reason for this rule is, however, that its observance will much protect you from the great danger of trying to make your drawings pretty.

Renoir also disliked anything shiny. In *Renoir, My Father,* Jean Renoir recalls how he would not allow furniture or floors to be highly polished.

(2) Never, by choice, draw anything polished; especially if complicated in form. Avoid all brass rods and curtain ornaments, chandeliers, plate, glass, and fine steel. A shining knob of a piece of furniture does not matter if it comes in your way; but do not fret yourself if it will not look right, and choose only things that do not shine.

(3) Avoid all very neat things. They are exceedingly difficult to draw, and very ugly when drawn. Choose rough, worn, and clumsy-looking things as much as possible; for instance, you cannot have a more difficult or profitless study than a newly painted Thames wherry, nor a better study than an old empty coal-barge, lying ashore at low tide: in general, everything that you think very ugly will be good for you to draw.

(4) Avoid, as much as possible, studies in which one thing is seen through another. You will constantly find a thin tree

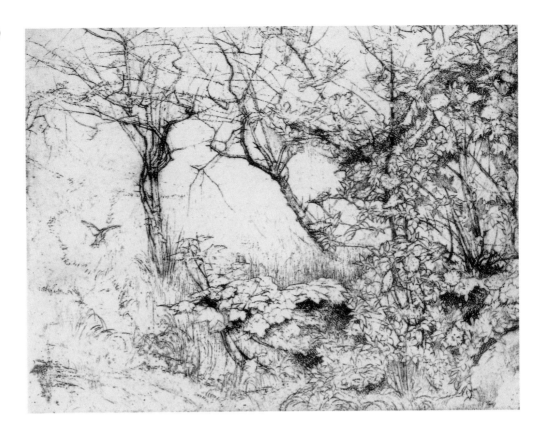

Etching by R. T. Cowern RA (1913–86)

standing before your chosen cottage, or between you and the turn of the river; its near branches all entangled with the distance. It is intensely difficult to represent this; and though, when the tree *is* there, you must not imaginarily cut it down, but do it as well as you can, yet always look for subjects that fall into definite masses, not into network; that is, rather for a cottage with a dark tree beside it, than for one with a thin tree in front of it, rather for a mass of wood, soft, blue, and rounded, than for a ragged copse, or confusion of intricate stems.

(5) Avoid, as far as possible, country divided by hedges. Perhaps nothing in the whole compass of landscape is so utterly unpicturesque and unmanageable as the ordinary English patchwork of field and hedge, with trees dotted over it in independent spots, gnawed straight at the cattle line.

Still, do not be discouraged if you find you have chosen ill, and that the subject overmasters you. It is much better that it should, than that you should think you had entirely mastered *it*. But at first, and even for some time, you must be prepared for very discomfortable failure; which, nevertheless, will not be without some wholesome result.

As, however, I have told you what most definitely to avoid, I may, perhaps, help you a little by saying what to seek. In general, all banks are beautiful things, and will reward work better than large landscapes. If you live in a lowland country, you must look for places where the ground is broken to the river's edges, with decayed posts, or roots of trees; or, if by great good luck there should be such things within your reach, for remnants of stone quays or steps, mossy mill-dams, etc. Nearly every other mile of road in chalk country will present beautiful bits of broken bank at its sides; better in form and colour than high chalk cliffs. In woods, one or two trunks, with the flowery ground below, are at once the richest and easiest kind of study: a not very thick trunk, say nine inches or a foot in diameter, with ivy running up it sparingly, is an easy, and always a rewarding subject.

Large nests of buildings in the middle distance are always beautiful, when drawn carefully, provided they are not modern rows of pattern cottages, or villas with Ionic and Doric porticoes. Any old English village, or cluster of farm-houses, drawn with all its ins and outs, and haystacks, and palings, is sure to be lovely; much more a French one. French landscape is generally as much superior to English as Swiss

81

The whole of this passage is interesting for the way it shows the shift of taste in what is considered to be a 'good' or 'bad' subject for the draughtsman.

Ruskin's remarks on English cathedrals and churches may surprise the reader. He was always particularly hard on English 'neatness' and often made comparison between the orderly English landscape and the spaciousness of the French one.

It is hard to imagine a student today drawing all the flowers and rows of cabbage in a rustic garden; possibly one of the most difficult subjects he could choose, quite apart from the fact that modern art teachers would much rather he drew the dustbin or the local scrapyard. But note that Ruskin, on page 80, says 'in general, everything that you think very ugly will be very good for you to draw'!

*Turner's engraving, 'View on the Seine, with avenue' from *Rivers of France*.

landscape is to French; in some respects, the French is incomparable. Such scenes as that avenue on the Seine* which I have recommended ... admit no rivalship in their expression of graceful rusticity and cheerful peace, and in the beauty of component lines.

In drawing villages, take great pains with the gardens; a rustic garden is in every way beautiful. If you have time, draw all the rows of cabbages, and hollyhocks, and broken fences, and wandering eglantines, and bossy roses; you cannot have better practice, nor be kept by anything in purer thoughts.

Make intimate friends with all the brooks in your neighbourhood, and study them ripple by ripple.

Village churches in England are not often good subjects; there is a peculiar meanness about most of them and awkwardness of line. Old manor-houses are often pretty. Ruins are usually, with us, too prim, and cathedrals too orderly. I do not think there is a single cathedral in England from which it is possible to obtain *one* subject for an impressive drawing. There is always some discordant civility, or jarring vergerism about them.

If you live in a mountain or hill country, your only danger is redundance of subject. Be resolved, in the first place, to draw a piece of rounded rock, with its variegated lichens, quite rightly, getting its complete roundings, and all the patterns of the lichen in true local colour. Till you can do this, it is of no use your thinking of sketching among hills; but when once you have done this, the forms of distant hills will be comparatively easy.

When you have practised for a little time from such of these subjects as may be accessible to you, you will certainly find difficulties arising which will make you wish more than ever for a master's help: these difficulties will vary according to the character of your own mind (one question occurring to one person, and one to another), so that it is impossible to anticipate them all; and it would make this too large a book if I answered all that I *can* anticipate; you must be content to work on, in good hope that Nature will, in her own time, interpret to you much for herself; that farther experience on your own part will make some difficulties disappear; and that others will be removed by the occasional observation of such artists' work as may come in your way. Nevertheless, I will not close this letter without a few general remarks, such as may be useful to you after you are somewhat advanced in

power; and these remarks may, I think, be conveniently arranged under three heads, having reference to the drawing of vegetation, water, and skies.

I. And, first, of vegetation. You may think, perhaps, we have said enough about trees already; yet if you have done as you were bid, and tried to draw them frequently enough, and carefully enough, you will be ready by this time to hear a little more of them. You will also recollect that we left our question, respecting the mode of expressing intricacy of leafage, partly unsettled in the first letter. I left it so because I wanted you to learn the real structure of leaves, by drawing them for yourself, before I troubled you with the most subtle considerations as to method in drawing them. And by this time, I imagine, you must have found out two principal things, universal facts, about leaves; namely, that they always, in the main tendencies of their lines, indicate a beautiful divergence of growth, according to the law of radiation, already referred to; and the second, that this divergence is never formal, but carried out with endless variety of individual line. I must now press both these facts on your attention a little farther.

You may, perhaps, have been surprised that I have not yet spoken of the works of J. D. Harding, especially if you happen to have met with the passages referring to them in *Modern Painters*, in which they are highly praised. They are deservedly praised, for they are the only works by a modern draughtsman which express in any wise the energy of trees, and the laws of growth, of which we have been speaking . . .

You will find, first, in the title-page of the Lessons on Trees, a pretty woodcut, in which the tree stems are drawn with great truth, and in a very interesting arrangement of lines. Plate 1* is not quite worthy of Mr. Harding, tending too much to make his pupil, at starting, think everything depends on black dots; still, the main lines are good, and very characteristic of tree growth. Then, in Plate 2, we come to the point at issue. The first examples in that plate are given to the pupil that he may practise from them till his hand gets into the habit of arranging lines freely in a similar manner; and they are stated by Mr. Harding to be universal in application; 'all outlines expressive of foliage,' he says, 'are but modifications of them.' They consist of groups of lines, more or less resembling our FIG. 23; and the characters especially insisted upon are, that they 'tend at their inner ends to a common centre'; that 'their ends terminate in [are

As Harding's works are very little known or available nowadays, I have thought it best to cut here a passage about his various publications.

*Plate 1 of *Lessons on Trees*, published by Bogue in 1850, contains 'Lessons' 'to afford practice in drawing the forms of stems and branches, and also to show how the character of the bark may be indicated by the simplest means.'

FIG. 23

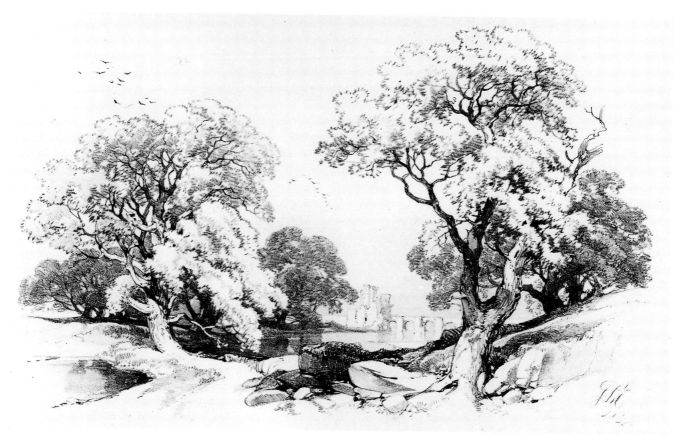

Plate 13 (top half) from *Elementary Art: or, the use of the chalk & lead pencil advocated & explained* by J. D. Harding (1846). Royal Academy of Arts Library, London

enclosed by]* ovoid curves'; and that 'the outer ends are most emphatic.'

Now, as thus expressive of the great laws of radiation and enclosure, the main principle of this method of execution confirms, in a very interesting way, our conclusions respecting foliage composition. The reason of the last rule, that the outer end of the line is to be most emphatic, does not indeed at first appear; for the line at one end of a natural leaf is not more emphatic than the line at the other; but ultimately, in Harding's method, this darker part of the touch stands more or less for the shade at the outer extremity of the leaf mass; and, as Harding uses these touches, they express as much of tree character as any mere habit of touch *can* express. But, unfortunately, there is another law of tree growth, quite as fixed as the law of radiation, which this and all other conventional modes of execution wholly lose sight of. This second law is, that the radiating tendency shall be carried

*An addition to Harding's text made by Ruskin in the notes on Plate 2.

out only as a ruling spirit in reconcilement with perpetual individual caprice on the part of the separate leaves. So that the moment a touch is monotonous, it must be also false, the liberty of the leaf individually being just as essential a truth, as its unity of growth with its companions in the radiating group.

It does not matter how small or apparently symmetrical the cluster may be, nor how large or vague. You can hardly have a more formal one than *b* in FIG. 9, p. 59, nor a less formal one than this shoot of Spanish chestnut, shedding its leaves, FIG. 24; but in either of them, even the general reader, unpractised in any of the previously recommended exercises, must see that there are wandering lines mixed with the radiating ones, and radiating lines with the wild ones: and if he takes the pen, and tries to copy either of these examples, he will find that neither play of hand to left nor to right, neither a free touch nor a firm touch, nor any learnable or describable touch whatsoever, will enable him to produce, currently, a resemblance of it; but that he must either draw it slowly or give it up. And (which makes the matter worse still) though gathering the bough, and putting it close to you, or seeing a piece of near foliage against the sky, you may draw the entire outline of the leaves, yet if the spray has light upon it, and is ever so little a way off, you will miss, as we have seen, a point of a leaf here, and an edge there; some of the surfaces will be confused by glitter, and some spotted with shade; and if you look carefully through this confusion for the edges or dark stems which you really *can* see and put only those down, the result will be neither like FIG. 9 nor FIG. 24, but such an interrupted and puzzling piece of work as FIG. 25. [I draw this figure (a young shoot of oak) in outline only, it being impossible to express the refinements of shade in distant foliage in a woodcut.]

FIG. 24

FIG. 25

Now, it is in the perfect acknowledgment and expression of these *three* laws that all good drawing of landscape consists. There is, first, the organic unity; the law, whether of radiation, or parallelism, or concurrent action, which rules the masses of herbs and trees, of rocks, and clouds, and waves; secondly, the individual liberty of the members subjected to these laws of unity; and, lastly, the mystery under which the separate character of each is more or less concealed.

I say, first, there must be observance of the ruling organic law. This is the first distinction between good artists and bad artists. Your common sketcher or bad painter puts his leaves

John Ruskin *Study of a Gneiss Rock, Glenfinlas*. Ashmolean Museum, Oxford

In another passage, Ruskin describes how the 'men of inferior genius' (such as Salvator Rosa) '. . . looked at clouds, as at everything else which did not particularly help them in their great end of deception, with utter carelessness and bluntness of feeling: saw that there were a great many rounded passages in them: found it much easier to sweep circles than to design beauties, and sat down in their studies, contented with perpetual repetitions of the same spherical conceptions, having about the same relation to the clouds of nature, that a child's carving of a turnip has to the head of the Apollo.'

on the trees as if they were moss tied to sticks; he cannot see the lines of action or growth; he scatters the shapeless clouds over his sky, not perceiving the sweeps of associated curves which the real clouds are following as they fly; and he breaks his mountain side into rugged fragments, wholly unconscious of the lines of force with which the real rocks have risen, or of the lines of couch in which they repose. On the contrary it is the main delight of the great draughtsman, to trace these laws of government; and his tendency to error is always in the exaggeration of their authority rather than in its denial.

Secondly, I say, we have to show the individual character and liberty of the separate leaves, clouds, or rocks. And herein the great masters separate themselves finally from the inferior ones; for if the men of inferior genius ever express law at all, it is by the sacrifice of individuality. Thus, Salvator Rosa has great perception of the sweep of foliage and rolling of clouds, but never draws a single leaflet or mist wreath accurately. Similarly, Gainsborough, in his landscape, has great feeling for masses of form and harmony of colour; but in the detail gives nothing but meaningless touches; not even so much as the species of tree, much less the variety of its

He admires Gainsborough far more, but has reservations: he is 'pure in his English feeling, profound in his seriousness, graceful in his gaiety', yet his 'execution is in some degree mannered, and always hasty'.

Thomas Gainsborough *Landscape with Cows*. Charcoal heightened with white. Private Collection

I have felt justified in leaving out two pages of digression here.

leafage, being ever discernible. Now, although both these expressions of government and individuality are essential to masterly work, the individuality is the *more* essential, and the more difficult of attainment; and, therefore, that attainment separates the great masters *finally* from the inferior ones.

. . .

Now you will be able to understand, among other matters, wherein consists the excellence, and wherein the shortcoming, of the tree-drawing of Harding. It is excellent in so far as it fondly observes, with more truth than any other work of the kind, the great laws of growth and action in trees: it fails – and observe, not in a minor, but in the principal point – because it cannot rightly render any one individual detail or incident of foliage. And in this it fails, not from mere carelessness or incompletion, but of necessity; the true drawing of detail being for evermore impossible to a hand which has contracted a *habit* of execution. The noble draughtsman draws a leaf, and stops, and says calmly – That leaf is of such and such a character; I will give him a friend who will entirely suit him: then he considers what his friend ought to be, and having determined, he draws his friend. This process may be as quick as lightning when the master is great – one of the sons of the giants; or it may be slow and timid: but the process is always gone through; no touch or form is ever added to another by a good painter without a mental determination and affirmation. But when the hand has got into a habit, leaf NO. 1 necessitates leaf NO. 2; you cannot stop, your hand is as a horse with the bit in its teeth; or rather is, for the time, a machine, throwing out leaves to order and pattern, all alike. You must stop that hand of yours, however painfully; make it understand that it is not to have its own way any more, that it shall never more slip from one touch to another without orders; otherwise it is not you who are the master, but your fingers.* You may therefore study Harding's drawing, and take pleasure in it; and you may properly admire the dexterity which applies the habit of the hand so well, and produces results on the whole so satisfactory: but you must never copy it; otherwise your progress will be at once arrested. The utmost you can ever hope to do would be a sketch in Harding's manner, but of far inferior dexterity; for he has given his life's toil to gain his dexterity, and you, I suppose, have other things to work at besides drawing. You

*The way in which drawing can become a lazy and semi-automatic process, no longer dependent on observation, has never been better described.

would also incapacitate yourself from ever understanding what truly great work was, or what Nature was; but, by the earnest and complete study of facts, you will gradually come to understand the one and love the other more and more, whether you can draw well yourself or not.

I have yet to say a few words respecting the third law above stated, that of mystery; the law, namely, that nothing is ever seen perfectly, but only by fragments, and under various conditions of obscurity. This last fact renders the visible objects of Nature complete as a type of the human nature. We have, observe, first, Subordination; secondly, Individuality; lastly, and this not the least essential character, Incomprehensibility; a perpetual lesson, in every serrated point and shining vein which escapes or deceives our sight among the forest leaves, how little we may hope to discern clearly, or judge justly, the rents and veins of the human heart; how much of all that is round us, in men's actions or spirits, which we at first think we understand, a closer and more loving watchfulness would show to be full of mystery, never to be either fathomed or withdrawn.

The expression of this final character in landscape has never been completely reached by any except Turner; nor can you hope to reach it at all until you have given much time to the practice of art. Only try always when you are sketching any object with a view to completion in light and shade, to draw only those parts of it which you really see definitely; preparing for the after development of the forms by chiaroscuro. It is this preparation by isolated touches for a future arrangement of superimposed light and shade which renders the etchings of the Liber Studiorum so inestimable as examples, and so peculiar. The character exists more or less in them exactly in proportion to the pains that Turner has taken. Thus the Æsacus and Hesperie was wrought out with the greatest possible care; and the principal branch on the near tree is etched as in FIG. 26. The work looks at first like a scholar's instead of a master's; but when the light and shade are added, every touch falls into its place, and a perfect expression of grace and complexity results. Nay, even before the light and shade are added, you ought to be able to see that these irregular and broken lines, especially where the expression is given of the way the stem loses itself in the leaves, are more true than the monotonous though graceful leaf-drawing which, before Turner's time, had been employed, even by the best masters, in their distant masses. FIG.

FIG. 26

FIG. 27

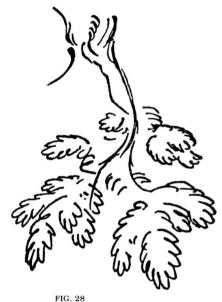

FIG. 28

27 is sufficiently characteristic of the manner of the old woodcuts after Titian; in which, you see, the leaves are too much of one shape, like bunches of fruit; and the boughs too completely seen, besides being somewhat soft and leathery in aspect, owing to the want of angles in their outline. By great men like Titian, this somewhat conventional structure was only given in haste to distant masses; and their exquisite delineation of the foreground, kept their conventionalism from degeneracy: but in the drawings of the Carracci* and other derivative masters, the conventionalism prevails everywhere, and sinks gradually into scrawled work, like FIG. 28, about the worst which it is possible to get into the habit of using, though an ignorant person might perhaps suppose it more 'free,' and therefore better than FIG. 26. Note also, that in noble outline drawing, it does not follow that a bough is wrongly drawn, because it looks contracted unnaturally somewhere, as in FIG. 26, just above the foliage. Very often the muscular action which is to be expressed by the line runs into the middle of the branch, and the actual outline of the branch at that place may be dimly seen, or not at all; and it is then only by the future shade that its actual shape, or the cause of its disappearance, will be indicated.

One point more remains to be noted about trees, and I have done. In the minds of our ordinary water-colour artists a distant tree seems only to be conceived as a flat green blot, grouping pleasantly with other masses, and giving cool colour to the landscape, but differing no wise, in texture, from the blots of other shapes which these painters use to express stones, or water, or figures. But as soon as you have drawn trees carefully a little while, you will be impressed, and impressed more strongly the better you draw them, with the idea of their *softness* of surface. A distant tree is not a flat and even piece of colour, but a more or less globular mass of a downy or bloomy texture, partly passing into a misty vagueness. I find, practically, this lovely softness of far-away trees the most difficult of all characters to reach, because it cannot be got by mere scratching or roughening the surface, but is always associated with such delicate expressions of form and growth as are only imitable by very careful drawing. The penknife passed lightly *over* this careful drawing will do a good deal; but you must accustom yourself, from the beginning, to aim much at this softness in the lines of the drawing itself, by crossing them delicately, and more or less effacing and confusing the edges. You must invent, according to the

*The Carracci family (two brothers and a cousin), Bolognese painters prominent at the end of the sixteenth century. Ruskin remarks, in *Modern Painters* V, that 'their landscape, which may in few words be accurately defined as "Scum of Titian", possesses no single merit, nor any ground for the forgiveness of demerit . . .'

character of tree, various modes of execution adapted to express its texture; but always keep this character of softness in your mind, and in your scope of aim; for in most landscapes it is the intention of Nature that the tenderness and transparent infinitude of her foliage should be felt, even at the far distance, in the most distinct opposition to the solid masses and flat surfaces of rocks or buildings.

II. We were, in the second place, to consider a little the modes of representing water, of which important feature of landscape I have hardly said anything yet.

Water is expressed, in common drawings, by conventional lines, whose horizontality is supposed to convey the idea of its surface. In paintings, white dashes or bars of light are used for the same purpose.

But these and all other such expedients are vain and absurd. A piece of calm water always contains a picture in itself, an exquisite reflection of the objects above it. If you give the time necessary to draw these reflections, disturbing them here and there as you see the breeze or current disturb them, you will get the effect of the water; but if you have not patience to draw the reflections, no expedient will give you a true effect. The picture in the pool needs nearly as much delicate drawing as the picture above the pool; except only that if there be the least motion on the water, the horizontal lines of the images will be diffused and broken, while the vertical ones will remain decisive, and the oblique ones decisive in proportion to their steepness.

A few close studies will soon teach you this: the only thing you need to be told is to watch carefully the lines of disturbance on the surface, as when a bird swims across it, or a fish rises, or the current plays round a stone, reed, or other obstacle. Take the greatest pains to get the *curves* of these lines true; the whole value of your careful drawing of the reflections may be lost by your admitting a single false curve of ripple from a wild duck's breast. And (as in other subjects) if you are dissatisfied with your result, always try for more unity and delicacy: if your reflections are only soft and gradated enough, they are nearly sure to give you a pleasant effect. When you are taking pains, work the softer reflections, where they are drawn out by motion in the water, with touches as nearly horizontal as may be; but when you are in a hurry, indicate the place and play of the images with vertical lines. The actual construction of a calm elongated reflection

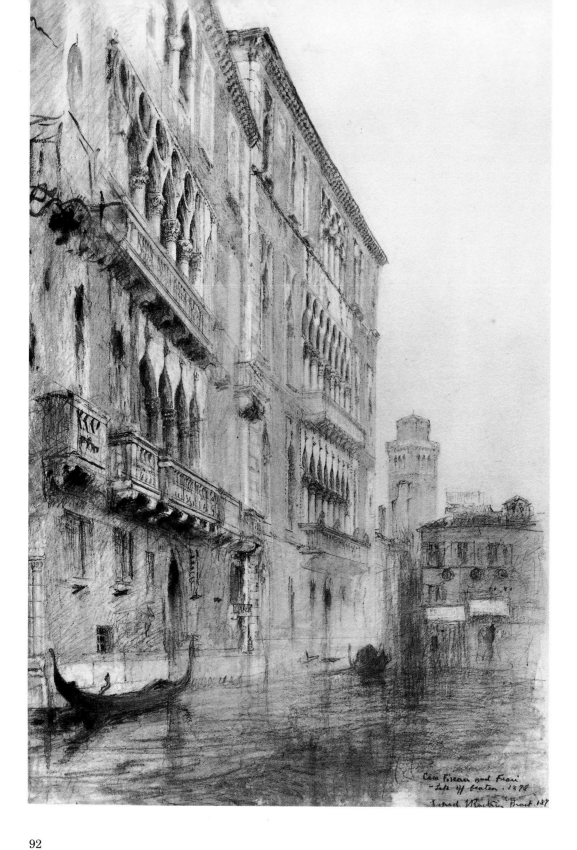

John Ruskin *Casa Foscari*.
Pencil and grey wash heightened
with white. Private Collection

is with horizontal lines: but it is often impossible to draw the descending shades delicately enough with a horizontal touch; and it is best always when you are in a hurry, and sometimes when you are not, to use the vertical touch. When the ripples are large, the reflections become shaken, and must be drawn with bold undulatory descending lines.

I need not, I should think, tell you that it is of the greatest possible importance to draw the curves of the shore rightly. Their perspective is, if not more subtle, at least more stringent than that of any other lines in Nature. It will not be detected by the general observer, if you miss the curve of a branch, or the sweep of a cloud, or the perspective of a building; but every intelligent spectator will feel the difference between a rightly-drawn bend of shore or shingle, and a false one. *Absolutely* right, in difficult river perspectives seen from heights, I believe no one but Turner ever has been yet; and observe, there is NO rule for them. To develop the curve mathematically would require a knowledge of the exact quantity of water in the river, the shape of its bed, and the hardness of the rock or shore; and even with these data, the problem would be one which no mathematician could solve but approximatively. The instinct of the eye can do it; nothing else.

If, after a little study from Nature, you get puzzled by the great differences between the aspect of the reflected image and that of the object casting it; and if you wish to know the law of reflection, it is simply this: Suppose all the objects above the water *actually* reversed (not in appearance, but in fact) beneath the water, and precisely the same in form and in relative position, only all topsy-turvy. Then, whatever you could see, from the place in which you stand, of the solid objects so reversed under the water, you will see in the reflection, always in the true perspective of the solid objects so reversed.

If you cannot quite understand this in looking at water, take a mirror, lay it horizontally on the table, put some books and papers upon it, and draw them and their reflections; moving them about, and watching how their reflections alter, and chiefly how their reflected colours and shades differ from their own colours and shades, by being brought into other oppositions. This difference in chiaroscuro is a more important character in water-painting than mere difference in form.

When you are drawing shallow or muddy water, you will

see shadows on the bottom, or on the surface, continually modifying the reflections; and in a clear mountain stream, the most wonderful complications of effect resulting from the shadows and reflections of the stones in it, mingling with the aspect of the stones themselves seen through the water. Do not be frightened at the complexity; but, on the other hand, do not hope to render it hastily. Look at it well, making out everything that you see, and distinguishing each component part of the effect. There will be, first, the stones seen through the water, distorted always by refraction, so that, if the general structure of the stone shows straight parallel lines about the water, you may be sure they will be bent where they enter it; then the reflection of the part of the stone above the water crosses and interferes with the part that is seen through it, so that you can hardly tell which is which; and wherever the reflection is darkest, you will see through the water best, and *vice versa*. Then the real shadow of the stone crosses both these images, and where that shadow falls, it makes the water more reflective, and where the sunshine falls, you will see more of the surface of the water, and of any dust or motes that may be floating on it: but whether you are to see, at the same spot, most of the bottom of the water, or of the reflection of the objects above, depends on the position of the eye. The more you look down into the water, the better you see objects through it; the more you look along it, the eye being low, the more you see the reflection of objects above it. Hence the colour of a given space of surface in a stream will entirely change while you stand still in the same spot, merely as you stoop or raise your head; and thus the colours with which water is painted are an indication of the position of the spectator, and connected inseparably with the perspective of the shores. The most beautiful of all results that I know in mountain streams is when the water is shallow, and the stones at the bottom are rich reddish-orange and black, and the water is seen at an angle which exactly divides the visible colours between those of the stones and that of the sky, and the sky is of clear, full blue. The resulting purple, obtained by the blending of the blue and the orange-red, broken by the play of innumerable gradations in the stones, is indescribably lovely.

All this seems complicated enough already; but if there be a strong colour in the clear water itself, as of green or blue in the Swiss lakes, all these phenomena are doubly involved; for the darker reflections now become of the colour of the water.

The reflection of a black gondola, for instance, at Venice, is never black, but pure dark green. And, farther, the colour of the water itself is of three kinds: one, seen on the surface, is a kind of milky bloom; the next is seen where the waves let light through them, at their edges; and the third, shown as a change of colour on the objects seen through the water. Thus, the same wave that makes a white object look of a clear blue, when seen through it, will take a red or violet-coloured bloom on its surface, and will be made pure emerald green by transmitted sunshine through its edges. With all this, however, you are not much concerned at present, but I tell it you partly as a preparation for what we have afterwards to say about colour, and partly that you may approach lakes and streams with reverence, and study them as carefully as other things, not hoping to express them by a few horizontal dashes of white, or a few tremulous blots. Not but that much may be done by tremulous blots, when you know precisely what you mean by them, as you will see by many of the Turner sketches, which are now framed at the National Gallery; but you must have painted water many and many a day – yes, and all day long – before you can hope to do anything like those. [It is a useful piece of study to dissolve some Prussian blue in water, so as to make the liquid definitely blue: fill a large white basin with the solution, and put anything you like to float on it, or lie in it; walnut shells, bits of wood, leaves of flowers, etc. Then study the effects of the reflections, and of the stems of the flowers or submerged portions of the floating objects, as they appear through the blue liquid; noting especially how, as you lower your head and look along the surface, you see the reflections clearly; and how, as you raise your head, you lose the reflections, and see the submerged stems clearly.]

III. Lastly. You may perhaps wonder why, before passing to the clouds, I say nothing special about *ground*. But there is too much to be said about that to admit of my saying it here. You will find the principal laws of its structure examined at length in the fourth volume of *Modern Painters*; and if you can get that volume, and copy carefully Plate 21, which I have etched after Turner with great pains, it will give you as much help as you need in the linear expression of ground-surface. Strive to get the retirement and succession of masses in irregular ground: much may be done in this way by careful watching of the perspective diminutions of its herbage, as

Ruskin adds a further comment in his Appendix:

'. . . it is physically impossible to draw a running torrent quite rightly, the lustre of its currents and whiteness of its foam being dependent on intensities of light which art has not at its command . . . Most young painters make their defeat certain by attempting to draw running water, which is a lustrous object in rapid motion, without ever trying their strength on a lustrous object standing still.'

The poet Gerard Manley Hopkins was a talented amateur draughtsman who made very Ruskinian studies of natural forms and accompanied them with notes which are full of quirky observation. Underneath a study of moving water, he wrote: '. . . The curves of the returning wave overlap, the angular space between is smooth but covered with a network of foam. The advancing wave already broken, and now only a mass of foam, upon the point of encountering the reflux of the former. Study from the cliff above, Freshwater Gate. July 23 '63.'

Pass of Faido etched by Ruskin after Turner

well as by contour; and much also by shadows. If you draw the shadows of leaves and tree trunks on any undulating ground with entire carefulness, you will be surprised to find how much they explain of the form and distance of the earth on which they fall.

Passing then to skies, note that there is this great peculiarity about sky subject, as distinguished from earth subject – that the clouds, not being much liable to man's interference, are always beautifully arranged. You cannot be sure of this in any other features of landscape. The rock on which the effect of a mountain scene especially depends is always precisely that which the roadmaker blasts or the landlord quarries; and the spot of green which Nature left with a special purpose by her dark forest sides, and finished with her most delicate grasses, is always that which the farmer ploughs or builds upon. But the clouds, though we can hide them with smoke, and mix them with poison, cannot be quarried nor built over, and they are always therefore gloriously arranged; so gloriously, that unless you have notable powers of memory you need not hope to approach the effect of any sky that interests you. For both its grace and its glow depend upon the

united influence of every cloud within its compass: they all move and burn together in a marvellous harmony; not a cloud of them is out of its appointed place, or fails of its part in the choir: and if you are not able to recollect (which in the case of a complicated sky it is impossible you should) precisely the form and position of all the clouds at a given moment, you cannot draw the sky at all; for the clouds will not fit if you draw one part of them three or four minutes before another.

You must try therefore to help what memory you have, by sketching at the utmost possible speed the whole range of the clouds; marking, by any shorthand or symbolic work you can hit upon, the peculiar character of each, as transparent, or fleecy, or linear, or undulatory; giving afterwards such completion to the parts as your recollection will enable you to do. This, however, only when the sky is interesting from its general aspect; at other times, do not try to draw all the sky, but a single cloud: sometimes a round cumulus will stay five or six minutes quite steady enough to let you mark out his principal masses; and one or two white or crimson lines which cross the sunrise will often stay without serious change for as long. And in order to be the readier in drawing them, practise occasionally drawing lumps of cotton, which will teach you better than any other stable thing the kind of softness there is in clouds. For you will find when you have made a few genuine studies of sky, and then look at any ancient or modern painting, that ordinary artists have always fallen into one of two faults: either, in rounding the clouds, they make them as solid and hard-edged as a heap of stones tied up in a sack, or they represent them not as rounded at all, but as vague wreaths of mist or flat lights in the sky; and think they have done enough in leaving a little white paper between dashes of blue, or in taking an irregular space out with the sponge. Now clouds are not as solid as flour-sacks; but, on the other hand, they are neither spongy nor flat. They are definite and very beautiful forms of sculptured mist; sculptured is a perfectly accurate word; they are not more *drifted* into form than they are *carved* into form, the warm air around them cutting them into shape by absorbing the visible vapour beyond certain limits; hence their angular and fantastic outlines, as different from a swollen, spherical, or globular formation, on the one hand, as from that of flat films or shapeless mists on the other. And the worst of all is, that while these forms are difficult enough to draw on any terms, especially considering that they never

Leslie Worth RWS has this to say about clouds in his book on watercolour:

'Degas said, "When I want to paint a cloud, I crumple my pocket handkerchief and hold it up to the light!" This is not such a bad idea, because success depends to a great extent on close observation of light falling on an accumulation of billowy masses. Other clouds moving across the main mass are seen as dark forms against the light, reflective surface of the cloud behind.

'It is necessary to discover which cloud formation is involved, where the light is coming from and what direction the clouds are moving in. Do not try to copy it, try to understand it. Remember that clouds are basically light masses and that even the darkest areas are light. Working into damp paper will yield soft tones, and if you want a sharp edge, paint on a dry surface.' (*Laying on a Watercolour Wash*, Search Press)

Cloud studies. Pastel. Bernard Dunstan (reproduced in colour on page 101)

Here is a description of a sunset by Gerard Manley Hopkins, from his diaries:

'Mar 12 – A fine sunset: the higher sky dead clear blue bridged by a broad slant causeway rising from left to right of wisped or grass cloud, the wisps lying across; the sundown yellow, moist with light but ending at the top in a foam of delicate white pearling and spotted with big tufts of cloud in colour russet, between brown and purple, but edged with brassy light.'
(Diaries, 1870)

stay quiet, they must be drawn also at greater disadvantage of light and shade than any others, the force of light in clouds being wholly unattainable by art; so that if we put shade enough to express their form as positively as it is expressed in reality, we must make them painfully too dark on the dark sides. Nevertheless, they are so beautiful, if you in the least succeed with them, that you will hardly, I think, lose courage.

Outline them often with the pen, as you can catch them here and there; one of the chief uses of doing this will be, not so much the memorandum so obtained, as the lesson you will get respecting the softness of the cloud-outlines. You will always find yourself at a loss to see where the outline really is; and when drawn it will always look hard and false, and will assuredly be either too round or too square, however often you alter it, merely passing from the one fault to the other and back again, the real cloud striking an inexpressible mean between roundness and squareness in all its coils or battlements. I speak at present, of course, only of the cumulus cloud: the lighter wreaths and flakes of the upper sky cannot be outlined – they can only be sketched, like locks of hair, by many lines of the pen. Firmly developed bars of cloud on the horizon are in general easy enough, and may be drawn with decision. When you have thus accustomed yourself a little to the placing and action of clouds, try to work out their light and shade, just as carefully as you do that of other things, looking exclusively for examples of treatment to the vignettes in Rogers's *Italy* and *Poems*, and to the Liber Studiorum, unless you have access to some examples of Turner's own work. No other artist ever yet drew the sky: even Titian's clouds, and Tintoret's, are conventional. The clouds in the 'Ben Arthur' (opposite), 'Source of Arveron', and 'Calais Pier', are among the best of Turner's storm studies; and of the upper clouds, the vignettes to Rogers's *Poems* furnish as many examples as you need.

And now, as our first lesson was taken from the sky, so, for the present, let our last be. I do not advise you to be in any haste to master the contents of my next letter. If you have any real talent for drawing, you will take delight in the discoveries of natural loveliness, which the studies I have already proposed will lead you into, among the fields and hills; and be assured that the more quietly and single-heartedly you take each step in the art, the quicker, on the whole, will your progress be. I would rather, indeed, have discussed the subjects of the following letter at greater

Samuel Rogers 1763–1855, poet and friend of Wordsworth, Scott and Byron.

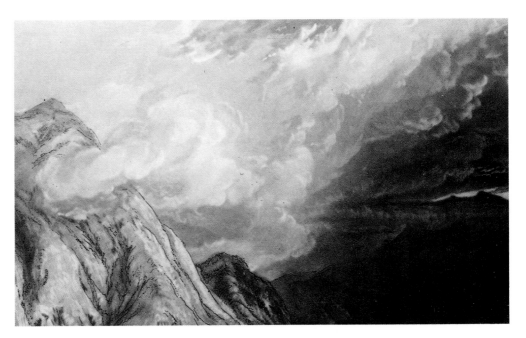

J. M. W. Turner *Ben Arthur* (detail of clouds). Engraving from *Liber Studorium*. Royal Academy of Arts Library, London

length, and in a separate work addressed to more advanced students; but as there are one or two things to be said on composition which may set the young artist's mind somewhat more at rest, or furnish him with defence from the urgency of ill-advisers, I will glance over the main heads of the matter here; trusting that my doing so may not beguile you, my dear reader, from your serious work, or lead you to think me, in occupying part of this book with talk not altogether relevant to it, less entirely or

Faithfully yours,
J. RUSKIN

LETTER III

On Colour and Composition

MY DEAR READER – If you have been obedient, and have hitherto done all that I have told you, I trust it has not been without much subdued remonstrance, and some serious vexation. For I should be sorry if, when you were led by the course of your study to observe closely such things as are beautiful in colour, [feathers, and the like, not to say rocks and clouds,] you had not longed to paint them, and felt considerable difficulty in complying with your restriction to the use of black, or blue, or grey. You *ought* to love colour, and to think nothing quite beautiful or perfect without it; and if you really do love it, for its own sake, and are not merely desirous to colour because you think painting a finer thing than drawing, there is some chance you may colour well. Nevertheless, you need not hope ever to produce anything more than pleasant helps to memory, or useful and sugges-tive sketches in colour, unless you mean to be wholly an artist. You may, in the time which other vocations leave at your disposal, produce finished, beautiful, and masterly drawings in light and shade. But to colour well, requires your life. It cannot be done cheaper. The difficulty of doing right is increased – not twofold nor threefold, but a thousandfold, and more – by the addition of colour to your work. For the chances are more than a thousand to one against your being right both in form and colour with a given touch: it is difficult enough to be right in form, if you attend to that only; but when you have to attend, at the same moment, to a much more subtle thing than the form, the difficulty is strangely increased – and multiplied almost to infinity by this great fact, that, while form is absolute, so that you can say at the moment you draw any line that it is either right or wrong, colour is wholly *relative*.* Every hue throughout your work is altered by every touch that you add in other places; so that what was warm a minute ago, becomes cold when you have put a hotter colour in another place, and what was in harmony when you left it, becomes discordant as you set

Of all the great writers on art, Ruskin had the most imaginative and subtle understanding of colour in nature and in painting. No other writer – and this includes Goethe, even though he did write a thesis on the subject – has described colour so well, or with such a relish for the subtleties, the iridescence and the continuous gradations, of colour in the natural world, of skies and mountains; and no one else has made so clearly the point that much beautiful colour is difficult to analyse, indeed indescribable:

'No colour harmony is of high order unless it involves indescribable tints. It is the best possible sign of a colour when nobody who sees it knows what to call it, or how to give an idea of it to anyone else. Even among simple hues the most valuable are those which cannot be defined; the most precious purples will look brown beside pure purple, and purple beside pure brown; and the most precious green will be called blue if seen beside pure green, and green if seen beside pure blue.'

In the index to the Library Edition there are more than 400 entries under the heading 'Colour'. These include some of the finest set-pieces in *Modern Painters*.

'But as I climbed the long slope of the Alban Mount, the storm swept finally to the north, and the noble outline of the domes of Albano, and graceful darkness of its ilex grove, rose against pure streaks of alternate blue and amber; the upper sky gradually flushing through the last fragments of rain-cloud in deep palpitating azure, half aether and half dew. The noonday sun came slanting down the rocky slopes of La Riccia, and their masses of entangled and tall foliage, whose autumnal tints were mixed with the wet verdure of a thousand evergreens, were penetrated with it as with rain. I cannot call it colour, it was conflagra-tion. Purple, and crimson, and scarlet, like the curtains of God's tabernacle, the rejoicing trees sank into the valley in showers of light, every separate leaf quivering with buoyant and burning light; each, as it turned to reflect or to transmit the sunbeam, first a torch and then an emerald.' (*Modern Painters*)

Ruskin said of himself, 'It is true that I see colour better than most people, and know a thing or two about rocks and clouds. I am very glad I do.' At the beginning of the 'Letter on Colour and Composition', Ruskin warns the reader that to become a colourist requires long and devoted study. As usual, he refuses to make things easy for the student: a very different attitude from modern teaching of the 'anyone can paint' variety.

Cloud studies. Pastel. Bernard Dunstan

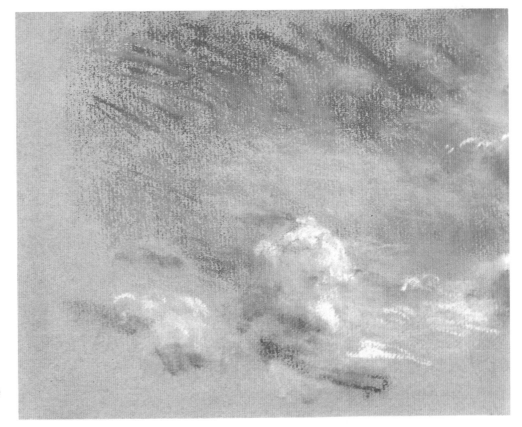

*In *The Laws of Fésole* Ruskin appended the following note: 'No, not "wholly" by any means. This is one of the over-hasty statements which render it impossible for me to republish, without more correction than they are worth, the books I wrote before the year 1860. Colour is no less positive than line, considered as a representation of fact; and you either match a given colour, or do not, as you either draw a given ellipse or square, or do not. Nor, on the other hand, are lines, in their grouping, destitute of relative influence; they exalt or depress their individual powers by association; and the necessity for the correction of the above passage in this respect was pointed out to me by Miss Hill, many and many a year ago, when she was using the *Elements* in teaching design for glass. But the influence of lines on each other is restricted within narrow limits, while the sequences of colour are like those of sound, and susceptible of all the complexity and passion of the most accomplished music.'

other colours beside it; so that every touch must be laid, not with a view to its effect at the time, but with a view to its effect in futurity, the result upon it of all that is afterwards to be done being previously considered. You may easily understand that, this being so, nothing but the devotion of life, and great genius besides, can make a colourist.

But though you cannot produce finished coloured drawings of any value, you may give yourself much pleasure, and be of great use to other people, by occasionally sketching with a view to colour only; and preserving distinct statements of certain colour facts – as that the harvest moon at rising was of such and such a red, and surrounded by clouds of such and such a rosy grey; that the mountains of evening were in truth so deep in purple; and the waves by the boat's side were indeed of that incredible green. This only, observe, if you have an eye for colour; but you may presume that you have this, if you enjoy colour.

And, though of course you should always give as much form to your subject as your attention to its colour will admit of, remember that the whole value of what you are about depends, in a coloured sketch, on the colour merely. If the colour is wrong, everything is wrong: just as, if you are singing, and sing false notes, it does not matter how true the words are. If you sing at all, you must sing sweetly; and if you colour at all, you must colour rightly. Give up all the form, rather than the slightest part of the colour: just as, if you felt yourself in danger of a false note, you would give up the word, and sing a meaningless sound, if you felt that so you could save the note. Never mind though your houses are all tumbling down – though your clouds are mere blots, and your trees mere knobs, and your sun and moon like crooked sixpences – so only that trees, clouds, houses, and sun or moon, are of the right colours. Of course, the discipline you have gone through will enable you to hint something of form, even in the fastest sweep of the brush; but do not let the thought of form hamper you in the least, when you begin to make coloured memoranda. If you want the form of the subject, draw it in black and white. If you want its colour, take its colour, and be sure you *have* it, and not a spurious, treacherous, half-measured piece of mutual concession, with the colours all wrong, and the forms still anything but right. It is best to get into the habit of considering the coloured work merely as supplementary to your other studies; making your careful drawings of the subject first, and then a coloured

The behaviour of colours in relation to one another, particularly the influence of warm and cool, as mentioned here by Ruskin, is one of those matters which is clearly true but is very difficult to prove by means of colour diagrams. Try as one may, these abstract colour exercises so often obstinately refuse to show any influence whatever – a fact familiar to students who have done them when studying 'colour theory'.

memorandum separately, as shapeless as you like, but faithful in hue, and entirely minding its own business. This principle, however, bears chiefly on large and distant subjects: in foregrounds and near studies, the colour cannot be had without a good deal of definition of form. For if you do not map the mosses on the stones accurately, you will not have the right quantity of colour in each bit of moss pattern, and then none of the colours will look right; but it always simplifies the work much if you are clear as to your point of aim, and satisfied, when necessary, to fail of all but that.

Now, of course, if I were to enter into detail respecting colouring, which is the beginning and end of a painter's craft, I should need to make this a work in three volumes instead of three letters, and to illustrate it in the costliest way. I only hope, at present, to set you pleasantly and profitably to work, leaving you, within the tethering of certain leading-strings, to gather what advantages you can from the works of art of which every year brings a greater number within your reach – and from the instruction which, every year, our rising artists will be more ready to give kindly, and better able to give wisely.

And, first, of materials. Use hard cake colours, not moist colours: grind a sufficient quantity of each on your palette every morning, keeping a separate plate, large and deep, for colours to be used in broad washes, and wash both plate and palette every evening, so as to be able always to get good and pure colour when you need it; and force yourself into cleanly and orderly habits about your colours. The two best colourists of modern times, Turner and Rossetti*, afford us, I am sorry to say, no confirmation of this precept by their practice. Turner was, and Rossetti is, as slovenly in all their procedures as men can well be; but the result of this was, with Turner, that the colours have altered in all his pictures, and in many of his drawings; and the result of it with Rossetti is, that though his colours are safe, he has sometimes to throw aside work that was half done, and begin over again. William Hunt, of the Old Water-colour, is very neat in his practice; so, I believe, is Mulready; so is John Lewis; and so are the leading Pre-Raphaelites, Rossetti only excepted. And there can be no doubt about the goodness of the advice, if it were only for this reason, that the more particular you are about your colours the more you will get into a deliberate and methodical habit in using them, and all true speed in colouring comes of this deliberation.

A very rapidly painted colour note in which the main colours of the subject have been put down without any preliminary drawing.

It is no longer necessary, of course, to grind watercolour in the form of hard cakes, as modern colours in pans are made soft enough to work easily with the brush.

*Ruskin adds this footnote, explaining why he classes Rossetti, rather than any other Pre-Raphaelite, as the equal of Turner:

'I give Rossetti this pre-eminence, because, though the leading Pre-Raphaelites have all about equal power over colour in the abstract, Rossetti and Holman Hunt are distinguished above the rest for rendering colour under effects of light; and of these two, Rossetti composes with richer fancy, and with a deeper sense of beauty, Hunt's stern realism leading him continually into harshness. Rossetti's carelessness, to do him justice, is only in water-colour, never in oil.'

On Rossetti's colour-method, Ruskin writes elsewhere: 'Its light is not the light of sunshine itself, but of sunshine diffused through coloured glass . . . whereas Holman Hunt . . . fixed his mind, as a colourist, on the true representation of actual sunshine . . .' (*The Art of England*, Lecture I)

Ruskin's many letters to Rossetti contain much advice and admonishment: 'Please oblige me in two matters or you will make me ill again. Take all the pure green out of the flesh in the 'Nativity' I send, and try to get it a little less like worsted-work by Wednesday, when I will send for it.'

For all his criticisms of Rossetti, Ruskin was much closer to him than to Hunt: 'I believe his name should be placed first on the list of men who have raised and changed the spirit of modern Art.'

Drawings by Rossetti are reproduced on pages 76 and 104.

D. G., Rossetti *Arthur's Tomb: Sir Launcelot parting from Guenevere* 1854. Pen and ink and watercolour with gum arabic. Reproduced by courtesy of the Trustees of the British Museum

Use Chinese white, well ground, to mix with your colours in order to pale them, instead of a quantity of water. You will thus be able to shape your masses more quietly, and play the colours about with more ease; they will not damp your paper so much, and you will be able to go on continually, and lay forms of passing cloud and other fugitive or delicately shaped lights, otherwise unattainable except by time.

This mixing of white with the pigments, so as to render them opaque, constitutes body-colour drawing as opposed to transparent-colour drawing, and you will, perhaps, have it often said to you that this body-colour is 'illegitimate.' It is just as legitimate as oil-painting, being, so far as handling is concerned, the same process, only without its uncleanliness, its unwholesomeness, or its inconvenience; for oil will not dry quickly, nor carry safely, nor give the same effects of

104

atmosphere without tenfold labour. And if you hear it said that the body-colour looks chalky or opaque, and, as is very likely, think so yourself, be yet assured of this, that though certain effects of glow and transparencies of gloom are not to be reached without transparent colour, those glows and glooms are *not* the noblest aim of art. After many years' study of the various results of fresco and oil painting in Italy, and of body-colour and transparent colour in England, I am now entirely convinced that the greatest things that are to be done in art must be done in dead colour. The habit of depending on varnish or on lucid tints for transparency, makes the painter comparatively lose sight of the nobler translucence which is obtained by breaking various colours amidst each other: and even when, as by Correggio, exquisite play of hue is joined with exquisite transparency, the delight in the depth almost always leads the painter into mean and false chiaroscuro; it leads him to like dark backgrounds instead of luminous ones,* and to enjoy, in general, quality of colour more than grandeur of composition, and confined light rather than open sunshine: so that the really greatest thoughts of the greatest men have always, so far as I remember, been reached in dead colour, and the noblest oil pictures of Tintoret and Veronese are those which are likest frescoes.

Besides all this, the fact is, that though sometimes a little chalky and coarse-looking body-colour is, in a sketch, infinitely liker Nature than transparent colour: the bloom and mist of distance are accurately and instantly represented by the film of opaque blue (*quite* accurately, I think, by nothing else); and for ground, rocks, and buildings, the earthy and solid surface is, of course, always truer than the most finished and carefully wrought work in transparent tints can ever be.

Against one thing, however, I must steadily caution you. All kinds of colour are equally illegitimate, if you think they will allow you to alter at your pleasure, or blunder at your ease. There is *no* vehicle or method of colour which admits of alteration or repentance; you must be right at once, or never; and you might as well hope to catch a rifle bullet in your hand, and put it straight, when it was going wrong, as to recover a tint once spoiled. The secret of all good colour in oil, water, or anything else, lies primarily in that sentence spoken to me by Mulready: 'Know what you have to do.'* The process may be a long one, perhaps: you may have to ground

*Ruskin adds this footnote:

'All the degradation of art which was brought about, after the rise of the Dutch school, by asphaltum, yellow varnish, and brown trees would have been prevented, if only painters had been forced to work in dead colour. Any colour will do for some people, if it is browned and shining; but fallacy in dead colour is detected on the instant. I even believe that whenever a painter begins to *wish* that he could touch any portion of his work with gum, he is going wrong.

'It is necessary, however, in this matter, carefully to distinguish between translucency and lustre. Translucency, though, as I have said above, a dangerous temptation, is, in its place, beautiful; but lustre or *shininess* is always, in painting, a defect. Nay, one of my best painter-friends (the "best" being understood to attach to both divisions of that awkward compound word), tried the other day to persuade me that lustre was an ignobleness in anything; and it was only the fear of treason to ladies' eyes, and to mountain streams, and to morning dew, which kept me from yielding the point to him. One is apt always to generalise too quickly in such matters; but there can be no question that lustre is destructive of loveliness in colour, as it is of intelligibility in form. Whatever may be the pride of a young beauty in the knowledge that her eyes shine (though perhaps even her eyes are most beautiful in dimness), she would be sorry if her cheeks did; and which of us would wish to polish a rose?'

As a footnote to Ruskin's footnote, I add this, from *Seven Lamps of Architecture*: '. . . the world has never succeeded, nor ever will, in making itself delight in black clouds more than in blue sky, or love the dark earth better than the rose that grows from it.'

*Ruskin writes about William Mulready in *Seven Lamps of Architecture*, 'Some years ago, in conversation with an artist whose works . . . unite perfection of drawing with resplendence of colour, the writer made some inquiry respecting the general means by which this latter quality was most easily to be attained. The reply was as concise as it was comprehensive – "Know what you have to do, and do it." '

William Mulready *The Sonnet* (drawing). National Gallery of Ireland

with one colour; to touch it with fragments of a second; to crumble a third into the interstices; a fourth into the interstices of the third; to glaze the whole with a fifth; and to reinforce in points with a sixth: but whether you have one, or ten, or twenty processes to go through, you must go *straight* through them knowingly and foreseeingly all the way; and if you get the thing once wrong, there is no hope for you but in washing or scraping boldly down to the white ground, and beginning again.

The drawing in body-colour will tend to teach you all this, more than any other method, and above all it will prevent you from falling into the pestilent habit of sponging to get texture; a trick which has nearly ruined our modern water-colour school of art. There are sometimes places in which a skilful artist will roughen his paper a little to get certain conditions of dusty colour with more ease than he could otherwise; and sometimes a skilfully rased piece of paper will, in the midst of transparent tints, answer nearly the purpose of chalky body-colour in representing the surfaces of rocks or building. But artifices of this kind are always treacherous in a tyro's hands, tempting him to trust in them: and you had better always work on white or grey paper as smooth as silk; [but not shiny or greasy. Bristol board, or hot-pressed imperial, or grey paper that feels slightly adhesive to the hand, is best. Coarse, gritty, and sandy papers are fit only for blotters and blunderers; no good draughtsman would lay a line on them. Turner worked much on a thin tough paper, dead in surface; rolling up his sketches in tight bundles that would go deep into his pockets]; and never disturb the surface of your colour or paper, except finally to scratch out the very highest lights if you are using transparent colours.

I have said above that body-colour drawing will teach you the use of colour better than working with merely transparent tints; but this is not because the process is an easier one, but because it is a more complete one, and also because it involves some working with transparent tints in the best way. You are not to think that because you use body-colour you may make any kind of mess that you like, and yet get out of it. But you are to avail yourself of the characters of your material, which enable you most nearly to imitate the processes of Nature. Thus, suppose you have a red rocky cliff to sketch, with blue clouds floating over it. You paint your cliff first firmly, then take your blue, mixing it to such a tint (and

here is a great part of the skill needed) that when it is laid over the red, in the thickness required for the effect of the mist, the warm rock-colour showing through the blue cloud-colour, may bring it to exactly the hue you want (your upper tint, therefore, must be mixed colder than you want it); then you lay it on, varying it as you strike it, getting the forms of the mist at once, and, if it be rightly done, with exquisite quality of colour, from the warm tint's showing through and between the particles of the other. When it is dry, you may add a little colour to retouch the edges where they want shape, or heighten the lights where they want roundness, or put another tone over the whole: but you can take none away. If you touch or disturb the surface, or by any untoward accident mix the under and upper colours together, all is lost irrecoverably. Begin your drawing from the ground again if you like, or throw it into the fire if you like. But do not waste time in trying to mend it. [I insist upon this unalterability of colour the more because I address you as a beginner, or an amateur: a great artist can sometimes get out of a difficulty with credit, or repent without confession. Yet even Titian's alterations usually show as stains on his work.]

This discussion of the relative merits of transparent and opaque colour has, however, led us a little beyond the point where we should have begun; we must go back to our palette, if you please. Get a cake of each of the hard colours named in the note below and try experiments on their simple combinations, by mixing each colour with every other. If you like to do it in an orderly way, you may prepare a squared piece of pasteboard, and put the pure colours in columns at the top and side; the mixed tints being given at the intersections.

This will give you some general notion of the characters of mixed tints of two colours only, and it is better in practice to confine yourself as much as possible to these, and to get more complicated colours, either by putting the third *over* the first blended tint, or by putting the third into its interstices. Nothing but watchful practice will teach you the effects that colours have on each other when thus put over, or beside, each other.

When you have got a little used to the principal combinations, place yourself at a window which the sun does not shine in at, commanding some simple piece of landscape: outline this landscape roughly; then take a piece of white cardboard, cut out a hole in it about the size of a large pea; and supposing R is the room, *a d* the window, and you are

Ruskin adds this note:
'It is, I think, a piece of affectation to try to work with few colours: it saves time to have enough tints prepared without mixing, and you may at once allow yourself these twenty-four. If you arrange them in your colour-box in the order I have set them down, you will always easily put your finger on the one you want.

Cobalt	Smalt	Antwerp blue	Prussian blue
Black	Gamboge	Emerald green	Hooker's green
Lemon yellow	Cadmium yellow	Yellow ochre	Roman ochre
Raw sienna	Burnt sienna	Light red	Indian red
Mars orange	Extract of vermilion	Carmine	Violet carmine
Brown madder	Burnt umber	Vandyke brown	Sepia

'Antwerp blue and Prussian blue are not very permanent colours, but you need not care much about permanence in your work as yet, and they are both beautiful; while Indigo is marked by Field as more fugitive still, and is very ugly. Hooker's green is a mixed colour, put in the box merely to save you loss of time in mixing gamboge and Prussian blue. No. 1 is the best tint of it. Violet carmine is a noble colour for laying broken shadows with, to be worked into afterwards with other colours.'

Ruskin's list of colours is a surprisingly long one. Some of his colours, such as smalt or Roman ochre, do not appear in makers' lists today.

On purple and grey in nature:

'. . . among mountains . . . large unbroken spaces of pure violet and purple are introduced into their distances; and even near, by films of cloud passing over the darkness of ravines or forests, blues are produced of the most subtle tenderness; these azures and purples passing into rose-colour of otherwise wholly unattainable delicacy among the upper summits, the blue of the sky being at the same time purer and deeper than in the plains.' (*Modern Painters*)

Landscapes by Cézanne can often be found to contain a surprising amount and variety of purple-grey passages.

sitting at *a*, FIG. 29, hold this cardboard a little outside of the window, upright, and in the direction *b d*, parallel to the side of the window, or a little turned, so as to catch more light, as at *a d*, never turned as at *c d*, or the paper will be dark. Then you will see the landscape, bit by bit, through the circular hole. Match the colours of each important bit as nearly as you can, mixing your tints with white, beside the aperture. When matched, put a touch of the same tint at the top of your paper, writing under it: 'dark tree colour,' 'hill colour,' 'field colour,' as the case may be. Then wash the tint away from beside the opening, and the cardboard will be ready to match another piece of the landscape. [A more methodical, though under general circumstances uselessly prolix way, is to cut a square hole, some half an inch wide, in the sheet of cardboard, and a series of small circular holes in a slip of cardboard an inch wide. Pass the slip over the square opening, and match each colour beside one of the circular openings. You will thus have no occasion to wash any of the colours away. But the first rough method is generally all you want, as, after a little practice, you only need to *look* at the hue through the opening in order to be able to transfer it to your drawing at once.] When you have got the colours of the principal masses thus indicated, lay on a piece of each in your sketch in its right place, and then proceed to complete the sketch in harmony with them, by your eye.

In the course of your early experiments, you will be much struck by two things: the first, the inimitable brilliancy of light in sky and in sun-lighted things; and the second, that among the tints which you can imitate, those which you thought the darkest will continually turn out to be in reality the lightest. Darkness of objects is estimated by us, under ordinary circumstances, much more by knowledge than by sight; thus, a cedar or Scotch fir, at 200 yards off, will be thought of darker green than an elm or oak near us; because we know by experience that the peculiar colour they exhibit, at that distance, is the *sign* of darkness of foliage. But when we try them through the cardboard, the near oak will be found, indeed, rather dark green, and the distant cedar, perhaps, pale grey-purple. The quantity of purple and grey in Nature is, by the way, another somewhat surprising subject of discovery.

Well, having ascertained thus your principal tints, you may proceed to fill up your sketch; in doing which observe these following particulars:

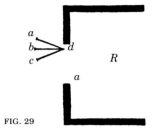

FIG. 29

This seems a very laborious procedure, but it can be useful in demonstrating how inaccurate our judgement of colour and tone can be.

(1) Many portions of your subject appeared through the aperture in the paper brighter than the paper, as sky, sun-lighted grass, etc. Leave these portions, for the present, white; and proceed with the parts of which you can match the tints.

(2) As you tried your subject with the cardboard, you must have observed how many changes of hue took place over small spaces. In filling up your work, try to educate your eye to perceive these differences of hue without the help of the cardboard, and lay them deliberately, like a mosaic-worker, as separate colours, preparing each carefully on your palette, and laying it as if it were a patch of coloured cloth, cut out, to be fitted neatly by its edge to the next patch; so that the *fault* of your work may be, not a slurred or misty look, but a patched bed-cover look, as if it had all been cut out with scissors. For instance, in drawing the trunk of a birch tree, there will be probably white high lights, then a pale rosy grey round them on the light side, then a (probably greenish) deeper grey on the dark side, varied by reflected colours, and, over all, rich black strips of bark and brown spots of moss. Lay first the rosy grey, leaving white for the high lights *and for the spots of moss*, and not touching the dark side. Then lay the grey for the dark side, fitting it well up to the rosy grey of the light, leaving also in the darker grey the white paper in the places for the black and brown moss; then prepare the moss colours separately for each spot, and lay each in the white place left for it. Not one grain of white, except that purposely left for the high lights, must be visible when the work is done, even through a magnifying-glass, so cunningly must you fit the edges to each other. Finally, take your background colours, and put them on each side of the tree trunk, fitting them carefully to its edge.

Fine work you would make of this, wouldn't you, if you had not learned to draw first, and could not now draw a good outline for the stem, much less terminate a colour mass in the outline you wanted?

Your work will look very odd for some time, when you first begin to paint in this way, and before you can modify it, as I shall tell you presently how; but never mind; it is of the greatest possible importance that you should practise this separate laying on of the hues, for all good colouring finally depends on it. It is, indeed, often necessary, and sometimes desirable, to lay one colour and form boldly over another:

thus, in laying leaves on blue sky, it is impossible always in large pictures, or when pressed for time, to fill in the blue through the interstices of the leaves; and the great Venetians constantly lay their blue ground first, and then, having let it dry, strike the golden brown over it in the form of the leaf, leaving the under blue to shine through the gold, and subdue it to the olive-green they want. But in the most precious and perfect work each leaf is inlaid, and the blue worked round it; and, whether you use one or other mode of getting your result, it is equally necessary to be absolute and decisive in your laying the colour. Either your ground must be laid firmly first, and then your upper colour struck upon it in perfect form, for ever, thenceforward, unalterable; or else the two colours must be individually put in their places, and led up to each other till they meet at their appointed border, equally, thenceforward, unchangeable. Either process, you see, involves absolute decision. If you once begin to slur, or change, or sketch, or try this way and that with your colour, it is all over with it and with you. You will continually see bad copyists trying to imitate the Venetians, by daubing their colours about, and retouching, and finishing, and softening: when every touch and every added hue only lead them farther into chaos. There is a dog between two children in a Veronese in the Louvre, which gives the copyists much employment. He has a dark ground behind him,* which Veronese has painted first, and then when it was dry, or nearly so, struck the locks of the dog's white hair over it with some half-dozen curling sweeps of his brush, right at once, and for ever. Had one line or hair of them gone wrong, it would have been wrong for ever; no retouching could have mended it. The poor copyists daub in first some background, and then some dog's hair; then retouch the background, then the hair; work for hours at it, expecting it always to come right tomorrow – 'when it is finished.' They *may* work for centuries at it, and they will never do it. If they can do it with Veronese's allowance of work, half a dozen sweeps of the hand over the dark background, well; if not, they may ask the dog himself whether it will ever come right, and get true answer from him – on Launce's conditions: 'If he say "ay," it will; if he say "no," it will; if he shake his tail and say nothing, it will.' [*Two Gentlemen of Verona*, ii. 5.]

(3) Whenever you lay on a mass of colour, be sure that however large it may be, or however small, it shall be

*Ruskin is here, in fact, describing the difference between oil and tempera techniques, or more explicitly Venetian and Florentine methods.

*A rather puzzling reference, as the dog has a white tablecloth behind his head, not a dark ground. The remark about his 'white hair' does not seem to fit, either. For a time I thought that Ruskin was mistakenly referring to the other dog in this picture; but he is not 'between two children'. For good measure, I have made a note of both dogs.

Drawings after Veronese's *Supper at Emmaus*

gradated. No colour exists in Nature under ordinary circumstances without gradation. If you do not see this, it is the fault of your inexperience: you will see it in due time, if you practise enough. But in general you may see it at once. In the birch trunk, for instance, the rosy grey *must* be gradated by the roundness of the stem till it meets the shaded side; similarly the shaded side is gradated by reflected light. Accordingly, whether by adding water, or white paint, or by unequal force of touch (this you will do at pleasure, according to the texture you wish to produce), you must, in every tint you lay on, make it a little paler at one part than another, and get an even gradation between the two depths. This is very like laying down a formal law or recipe for you; but you will find it is merely the assertion of a natural fact. It is not indeed physically impossible to meet with an ungradated piece of colour, but it is so supremely improbable, that you had better get into the habit of asking yourself invariably, when you are going to copy a tint – not 'Is that gradated?' but 'Which way is that gradated?' and at least in ninety-nine out of a hundred instances, you will be able to answer decisively after a careful glance, though the gradation may have been so subtle that you did not see it at first. And it does not matter how small the touch of colour may be, though not larger than the smallest pin's head, if one part of it is not darker than the rest, it is a bad touch; for it is not merely because the natural fact is so, that your colour should be gradated; the preciousness and pleasantness of the colour itself depends more on this than on any other of its qualities, for gradation is to colours just what curvature is to lines, both being felt to be beautiful by the pure instinct of every human mind, and both, considered as types, expressing the law of gradual change and progress in the human soul itself. What the difference is in mere beauty between a gradated and ungradated colour, may be seen easily by laying an even tint of rose-colour on paper, and putting a rose leaf beside it. The victorious beauty of the rose as compared with other flowers, depends wholly on the delicacy and quantity of its colour gradations, all other flowers being either less rich in gradation, not having so many folds of leaf; or less tender, being patched and veined instead of flushed.

(4) But observe, it is not enough in general that colour should be gradated by being made merely paler or darker at one place than another. Generally colour changes as it

111

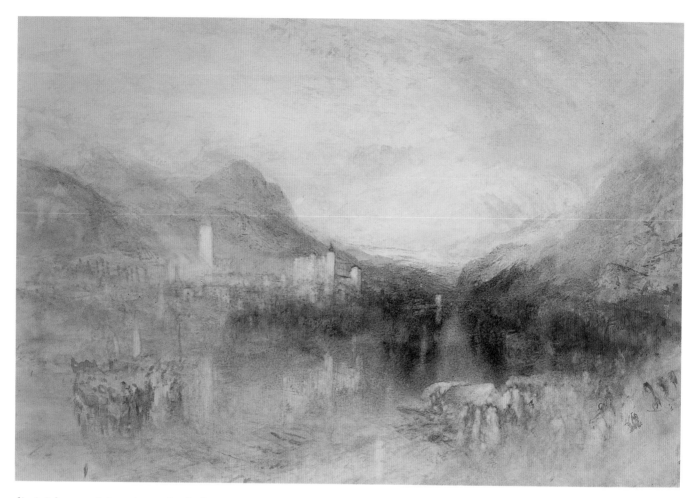

diminishes, and is not merely darker at one spot, but also purer at one spot than anywhere else. It does not in the least follow that the darkest spot should be the purest; still less so that the lightest should be the purest. Very often the two gradations more or less cross each other, one passing in one direction from paleness to darkness, another in another direction from purity to dulness, but there will almost always be both of them, however reconciled; and you must never be satisfied with a piece of colour until you have got both: that is to say, every piece of blue that you lay on must be *quite* blue only at some given spot, nor that a large spot; and must be gradated from that into less pure blue – greyish blue, or greenish blue, or purplish blue – over all the rest of the space it occupies. And this you must do in one of three ways: either,

J. M. W. Turner *Pallanza, Lake Maggiore*. Watercolour. Private Collection

This whole matter of the gradation of colour is very important for Ruskin. It is enlarged upon in many passages from *Modern Painters* and *Stones of Venice*. The following is from *The Two Paths* (Appendix):

'The first necessity of beauty in colour is gradation, as the first necessity of beauty in line is curvature

. . . the second necessity in colour is mystery or subtlety, as the second necessity in line is softness. Colour ungradated is wholly valueless; colour unmysterious is wholly barbarous. Unless it loses itself, and melts away towards other colours, as a true line loses itself and melts away towards other lines, colour has no proper existence, in the noble sense of the word.'

Turner's late watercolours demonstrate this principle of infinitely subtle gradation better than any others.

while the colour is wet, mix with it the colour which is to subdue it, adding gradually a little more and a little more; or else, when the colour is quite dry, strike a gradated touch of another colour over it, leaving only a point of the first tint visible; or else, lay the.subduing tints on in small touches, as in the exercise of tinting the chess-board. Of each of these methods I have something to tell you separately; but that is distinct from the subject of gradation, which I must not quit without once more pressing upon you the pre-eminent necessity of introducing it everywhere. I have profound dislike of anything like habit of hand, and yet, in this one instance, I feel almost tempted to encourage you to get into a habit of never touching paper with colour, without securing a gradation. You will not, in Turner's largest oil pictures, perhaps six or seven feet long by four or five high, find one spot of colour as large as a grain of wheat ungradated: and you will find in practice, that brilliancy of hue, and vigour of light, and even the aspect of transparency in shade, are essentially dependent on this character alone; hardness, coldness, and opacity resulting far more from *equality* of colour than from nature of colour. Give me some mud off a city crossing, some ochre out of a gravel pit, a little whitening, and some coal-dust, and I will paint you a luminous picture, if you give me time to gradate my mud, and subdue my dust: but though you had the red of the ruby, the blue of the gentian, snow for the light, and amber for the gold, you cannot paint a luminous picture, if you keep the masses of those colours unbroken in purity, and unvarying in depth.

(5) Next, note the three processes by which gradation and other characters are to be obtained:

A. Mixing while the colour is wet.
You may be confused by my first telling you to lay on the hues in separate patches, and then telling you to mix hues together as you lay them on: but the separate masses are to be laid, when colours distinctly oppose each other at a given limit; the hues to be mixed, when they palpitate one through the other, or fade one into the other. It is better to err a little on the distinct side. Thus I told you to paint the dark and light sides of the birch trunk separately, though, in reality, the two tints change, as the trunk turns away from the light, gradually one into the other; and, after being laid separately on, will need some farther touching to harmonise them: but they do so in a very narrow space, marked distinctly all the

'Give me some mud . . .'. This typically eloquent passage, which contains an important truth, need not be taken too literally. Ruskin no doubt overstates his case, if one thinks of Persian or Indian miniatures, to say nothing of much modern painting. Bonnard might be quoted, however, as an example of subtle gradation of colour.

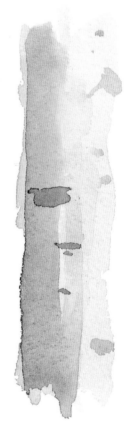

way up the trunk, and it is easier and safer, therefore, to keep them separate at first. Whereas it often happens that the whole beauty of two colours will depend on the one being continued well through the other, and playing in the midst of it: blue and green often do so in water; blue and grey, or purple and scarlet, in sky: in hundreds of such instances the most beautiful and truthful results may be obtained by laying one colour into the other while wet; judging wisely how far it will spread, or blending it with the brush in somewhat thicker consistence of wet body-colour; only observe, never mix in this way two *mixtures*; let the colour you lay into the other be always a simple, not a compound tint.

B. Laying one colour over another.

If you lay on a solid touch of vermilion, and after it is quite dry, strike a little very wet carmine quickly over it, you will obtain a much more brilliant red than by mixing the carmine and vermilion. Similarly, if you lay a dark colour first, and strike a little blue or white body-colour lightly over it, you will get a more beautiful grey than by mixing the colour and the blue or white. In very perfect painting, artifices of this kind are continually used; but I would not have you trust much to them: they are apt to make you think too much of quality of colour. I should like you to depend on little more than the dead colours, simply laid on, only observe always this, that the *less* colour you do the work with, the better it will always be:* so that if you had laid a red colour, and you want a purple one above, do not mix the purple on your palette and lay it on so thick as to overpower the red, but take a little thin blue from your palette, and lay it lightly over the red, so as to let the red be seen through, and thus produce the required purple; and if you want a green hue over a blue one, do not lay a quantity of green on the blue, but a *little* yellow, and so on, always bringing the under colour into service as far as you possibly can. If, however, the colour beneath is wholly opposed to the one you have to lay on, as, suppose, if green is to be laid over scarlet, you must either remove the required parts of the under colour daintily first with your knife, or with water; or else, lay solid white over it massively, and leave that to dry, and then glaze the white with the upper colour. This is better, in general, than laying the upper colour itself so thick as to conquer the ground, which, in fact, if it be a transparent colour, you cannot do. Thus, if you have to

*Ruskin adds a footnote: 'If colours were twenty times as costly as they are, we should have many more good painters. If I were Chancellor of the Exchequer I would lay a tax of twenty shillings a cake on all colours except black, Prussian blue, Vandyke brown, and Chinese white, which I would leave for students. I don't say this jestingly; I believe such a tax would do more to advance real art than a great many schools of design.'

strike warm boughs and leaves of trees over blue sky, and they are too intricate to have their places left for them in laying the blue, it is better to lay them first in solid white, and then glaze with sienna and ochre, than to mix the sienna and white; though, of course, the process is longer and more troublesome. Nevertheless, if the forms of touches required are very delicate, the after glazing is impossible. You must then mix the warm colour thick at once, and so use it: and this is often necessary for delicate grasses, and such other fine threads of light in foreground work.

C. Breaking one colour in small points through or over another.

This is the most important of all processes in good modern oil and water-colour painting, but you need not hope to attain very great skill in it. [I say *modern*, because Titian's quiet way of blending colours, which is the perfectly right one, is not understood now by any artist. The best colour we reach is got by stippling; but this is not quite right.] To do it well is very laborious, and requires such skill and delicacy of hand as can only be acquired by unceasing practice. But you will find advantage in noting the following points:

(a) In distant effects of rich subject, wood, or rippled water, or broken clouds, much may be done by touches or crumbling dashes of rather dry colour, with other colours afterwards put cunningly into the interstices. The more you practise this, when the subject evidently calls for it, the more your eye will enjoy the higher qualities of colour. The process is, in fact, the carrying out of the principle of separate colours to the utmost possible refinement; using atoms of colour in juxtaposition, instead of large spaces. And note, in filling up minute interstices of this kind, that if you want the colour you fill them with to show brightly, it is better to put a rather positive point of it, with a little white left beside or round it in the interstice, than to put a pale tint of the colour over the whole interstice. Yellow or orange will hardly show, if pale, in small spaces; but they show brightly in firm touches, however small, with white beside them.

(b) If a colour is to be darkened by superimposed portions of another, it is, in many cases, better to lay the uppermost colour in rather vigorous small touches, like finely chopped straw, over the under one, than to lay it on as a tint, for two reasons: the first, that the play of the two colours together is pleasant to the eye; the second, that much expression of form

may be got by wise administration of the upper dark touches. In distant mountains they may be made pines of, or broken crags, or villages, or stones, or whatever you choose; in clouds they may indicate the direction of the rain, the roll and outline of the cloud masses; and in water, the minor waves. All noble effects of dark atmosphere are got in good water-colour drawing by these two expedients, interlacing the colours, or retouching the lower one with fine darker drawing in an upper. Sponging and washing for dark atmospheric effect is barbarous, and mere tyro's work, though it is often useful for passages of delicate atmospheric light.

(c) When you have time, practise the production of mixed tints by interlaced touches of the pure colours out of which they are formed, and use the process at the parts of your sketches where you wish to get rich and luscious effects. Study the works of William Hunt, of the Old Water-colour Society, in this respect, continually, and make frequent memoranda of the variegations in flowers; not painting the flower completely, but laying the ground colour of one petal, and painting the spots on it with studious precision: a series of single petals of lilies, geraniums, tulips, etc., numbered with proper reference to their position in the flower, will be interesting to you on many grounds besides those of art. Be careful to get the gradated distribution of the spots well followed in the calceolarias, foxgloves, and the like; and work out the odd, indefinite hues of the spots themselves with minute grains of pure interlaced colour, otherwise you will never get their richness or bloom. You will be surprised to find as you do this, first, the universality of the law of gradation we have so much insisted upon; secondly, that Nature is just as economical of *her* fine colours as I have told you to be of yours. You would think, by the way she paints, that her colours cost her something enormous; she will only give you a single pure touch, just where the petal turns into light; but down in the bell all is subdued, and under the petal all is subdued, even in the showiest flower. What you thought was bright blue is, when you look close, only dusty grey, or green, or purple, or every colour in the world at once, only a single gleam or streak of pure blue in the centre of it. And so with all her colours. Sometimes I have really thought her miserliness intolerable: in a gentian, for instance, the way she economises her ultramarine down in the bell is a little too bad. [I heard it wisely objected to this statement, the other day, by a young lady, that it was not through economy that

116

William Henry Hunt RWS – 'the good old peach and apple painter' – was an artist of whom Ruskin was especially fond, though not always without a certain condescension: 'I . . . esteem Hunt's work all the more exemplary in acknowledging without disguise the restrictions imposed on the use of water-colour as a medium for vigorously realistic effects . . . I am aware of no other pieces of art, in modern days, at once so sincere and so accomplished: only let it be noted that I use the term "sincere" in this case, not as imputing culpable fallacy to pictures of more imaginative power, but only as implying the unbiassed directness of aim at the realisation of very simple facts, which is often impossible to the passions, or inconsistent with the plans, of greater designers.'

This comes from the *Notes on Prout and Hunt*, where Ruskin also speaks of the painter's 'power of giving some kind of interest to the most homely objects, and rendering the transitions of ordinary light and shade impressive, though he had nothing more sacred to illuminate than a lettuce . . .' (See illustration on p.52.)

The phrase to 'dot clumsy foliage with chalky dew' is probably directed at Constable, of whose landscapes Ruskin was often very critical. He compares Constable's drawing of trees with Turner's, very much to the latter's advantage, in *Modern Painters*.

Ruskin's lyrical description of the beauty of whites – 'white roses washed in milk' – makes one think of Whistler, later to be his antagonist, and Vuillard, among more modern painters.

Nature did not colour deep down in the flower bells, but because 'she had not light enough there to see to paint with.' This may be true; but it is certainly not for want of light that, when she is laying the dark spots on a foxglove, she will not use any more purple than she has got already on the bell, but takes out the colour all round the spot, and concentrates it in the middle.]

Next, respecting general tone. I said, just now, that, for the sake of students, my tax should not be laid on black or on white pigments; but if you mean to be a colourist, you must lay a tax on them yourself when you begin to use true colour; that is to say, you must use them little, and make of them much. There is no better test of your colour tones being good, than your having made the white in your picture precious, and the black conspicuous.

I say, first, the white precious. I do not mean merely glittering or brilliant: it is easy to scratch white sea-gulls out of black clouds, and dot clumsy foliage with chalky dew; but when white is well managed, it ought to be strangely delicious – tender as well as bright – like inlaid mother of pearl, or white roses washed in milk. The eye ought to seek it for rest, brilliant though it may be; and to feel it as a space of strange, heavenly paleness in the midst of the flushing of the colours. This effect you can only reach by general depth of middle tint, by absolutely refusing to allow any white to exist except where you need it, and by keeping the white itself subdued by grey, except at a few points of chief lustre.

Secondly, you must make the black conspicuous. However small a point of black may be, it ought to catch the eye, otherwise your work is too heavy in the shadow. All the ordinary shadows should be of some *colour* – never black, nor approaching black, they should be evidently and always of a luminous nature, and the black should look strange among them; never occurring except in a black object, or in small points indicative of intense shade in the very centre of masses of shadow. Shadows of absolutely negative grey, however, may be beautifully used with white, or with gold; but still though the black thus, in subdued strength, becomes spacious, it should always be conspicuous; the spectator should notice this grey neutrality with some wonder, and enjoy, all the more intensely on account of it, the gold colour and the white which it relieves. Of all the great colourists Velasquez is the greatest master of the black chords. His black is more precious than most other people's crimson.

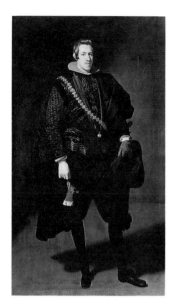

Diego Velasquez *Infante Don Carlos*. Museo del Prado, Madrid. 'Velasquez is the greatest master of the black chords.'

It is not, however, only white and black which you must make valuable; you must give rare worth to every colour you use; but the white and black ought to separate themselves quaintly from the rest, while the other colours should be continually passing one into the other, being all evidently companions in the same gay world; while the white, black, and neutral grey should stand monkishly aloof in the midst of them. You may melt your crimson into purple, your purple into blue, and your blue into green, but you must not melt any of them into black. You should, however, try, as I said, to give preciousness to all your colours; and this especially by never using a grain more than will just do the work, and giving each hue the highest value by opposition. All fine colouring, like fine drawing, is delicate; and so delicate that if, at last, you *see* the colour you are putting on, you are putting on too much. You ought to feel a change wrought in the general tone, by touches of colour which individually are too pale to be seen; and if there is one atom of any colour in the whole picture which is unnecessary to it, that atom hurts it.

Notice also that nearly all good compound colours are *odd* colours. You shall look at a hue in a good painter's work ten minutes before you know what to call it. You thought it was brown, presently you feel that it is red; next that there is, somehow, yellow in it; presently afterwards that there is blue in it. If you try to copy it you will always find your colour too warm or too cold – no colour in the box will seem to have an affinity with it; and yet it will be as pure as if it were laid at a single touch with a single colour.

As to the choice and harmony of colours in general, if you cannot choose and harmonise them by instinct, you will never do it at all. If you need examples of utterly harsh and horrible colour, you may find plenty given in treatises upon colouring, to illustrate the laws of harmony; and if you want to colour beautifully, colour as best pleases yourself at *quiet times*, not so as to catch the eye, nor look as if it were clever or difficult to colour in that way, but so that the colour may be pleasant to you when you are happy or thoughtful. Look much at the morning and evening sky, and much at simple flowers – dog-roses, wood-hyacinths, violets, poppies, thistles, heather, and such like – as Nature arranges them in the woods and fields. If ever any scientific person tells you that two colours are 'discordant,' make a note of the two colours, and put them together whenever you can. I have actually

I have already quoted Ruskin's remarks on what he calls 'indescribable tints'. What he says here cannot, of course, be taken too literally; he is not referring to every hue in a picture; nonetheless, it is an important truth about colour, which, as far as I know, has never been stated by other writers on colour, who tend to concentrate on the relations between 'pure' colours.

Here is another opinion from a Flemish painter about treatises on colour:

'One of my engravers had bought a "Harmony of Colour" and wanted to use its synoptic table and diagrams to find a way out of the labyrinth of the realm of colours. I advised him to put aside the learned book for the moment and rather to spend some time on observing what is to be learned in the way of harmony of colours from the sky at sunrise or sunset. – But then it would be a question of seeing with heart and soul.' (Valerius de Sardeleer)

heard people say that blue and green were discordant; the two colours which Nature seems to intend never to be separated, and never to be felt, either of them, in its full beauty without the other! – a peacock's neck, or a blue sky through green leaves, or a blue wave with green lights through it, being precisely the loveliest things, next to clouds at sunrise, in this coloured world of ours. If you have a good eye for colours, you will soon find out how constantly Nature puts purple and green together, purple and scarlet, green and blue, yellow and neutral grey, and the like; and how she strikes these colour-concords for general tones, and then works into them with innumerable subordinate ones; and you will gradually come to like what she does, and find out new and beautiful chords of colour in her work every day. If you enjoy them, depend upon it you will paint them to a certain point right: or, at least, if you do not enjoy them, you are certain to paint them wrong. If colour does not give you intense pleasure, let it alone; depend upon it, you are only tormenting the eyes and senses of people who feel colour, whenever you touch it; and that is unkind and improper.

You will find, also, your power of colouring depend much on your state of health and right balance of mind; when you are fatigued or ill you will not see colours well, and when you are ill-tempered you will not choose them well: thus, though not infallibly a test of character in individuals, colour power is a great sign of mental health in nations; when they are in a state of intellectual decline, their colouring always gets dull. [The worst general character that colour can possibly have is a prevalent tendency to a dirty yellowish green, like that of a decaying heap of vegetables; this colour is *accurately* indicative of decline or paralysis in missal-painting.] You must also take great care not to be misled by affected talk about colours from people who have not the gift of it: numbers are eager and voluble about it who probably never in all their lives received one genuine colour-sensation. The modern religionists of the school of Overbeck are just like people who eat slate-pencil and chalk, and assure everybody that they are nicer and purer than strawberries and plums.

Take care also never to be misled into any idea that colour can help or display *form*; colour always disguises form, and is meant to do so. [That is to say, local colour inherent in the object. The gradations of colour in the various shadows belonging to various lights exhibit form, and therefore no one but a colourist can ever draw *forms* perfectly; but all notions

Diana Armfield *Aspens, Wyoming*. Oil. Private Collection

'. . . the more faithful and earnest the religion of the painter, the more pure and prevalent is the system of his colour . . . so surely as a painter is irreligious, thoughtless, or obscene in disposition, so surely is his colouring cold, gloomy, and valueless. The opposite poles of art in this respect are Fra Angelico and Salvator Rosa . . .' (*Stones of Venice*)

Johann Friedrich Overbeck, 1789–1869: a German painter associated with the Nazarenes, a group of artists who could be described as German forerunners of the English Pre-Raphaelites. His later work was 'pallid and stereotyped' and much disliked by Ruskin, who wrote: 'It happens very often that a man of weak intellect, sincerely desiring to do what is good and useful, will devote himself to high art subjects because he thinks them the only ones on which time and toil can be usefully spent, or, sometimes, because they are really the only ones he has pleasure in contemplating. But not having intellect enough to enter into the minds of truly great men, or to imagine great events as they really happened, he cannot become a great painter; he degrades the subjects he intended to honour, and his work is more utterly thrown away, and his rank as an artist in reality lower, than if he had devoted himself to the imitation of the simplest objects of natural history. The works of Overbeck are a most notable instance of this form of error.' (*Modern Painters* III)

Which one 'goes back'?

see text on pages 151 and 152

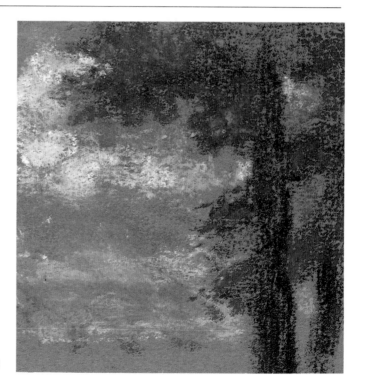

(a) Pure colour
in a light key

(b) darkened with
a glaze of black

(c) made darker in tone,
but remaining pure

'Titianesque' treatment

Of a drawing by Turner in the Turner Bequest, Ruskin says: 'As a composition, the drawing is remarkable for containing the utmost expression of height which it is possible to get at the given distance, and in the given space. Required to show a vertical rock so near, that a castle, on the farthest edge of it, shall show its tiles and windows – you cannot possibly make it look higher than Turner has. The way in which he has done this too is specially interesting, because it contains so point-blank a denial of the common idea that yellow is an approaching colour and blue a retiring one; the foreground being here wholly blue, and the farthest mass the strongest yellow.' (Catalogue of the Turner sketches in the National Gallery)

'If form and colour be brought into complete opposition, so that it should be put to us . . . whether we should have a work of art all form, without colour . . . or all of colour, without form . . ., form is beyond all comparison the more precious of the two . . . yet if colour be introduced at all, it is necessary that, whatever else be wrong, *that* should be right: just as, though the music of a song may not be so essential to its influence as the meaning of the words, yet if the music be given at all, *it* must be right, or its discord will spoil the words . . .' (*Modern Painters*)

of explaining form by superimposed colour, as in architectural mouldings, are absurd. Colour adorns form, but does not interpret it. An apple is prettier because it is striped, but it does not look a bit rounder; and a cheek is prettier because it is flushed, but you would see the form of the cheek bone better if it were not. Colour may, indeed, detach one shape from another, as in grounding a bas-relief, but it always diminishes the appearance of projection, and whether you put blue, purple, red, yellow, or green, for your ground, the bas-relief will be just as clearly or just as imperfectly relieved, as long as the colours are of equal depth. The blue ground will not retire the hundredth part of an inch more than the red one.]

It is a favourite dogma among modern writers on colour that 'warm colours' (reds and yellows) 'approach,' or express nearness, and 'cold colours' (blue and grey) 'retire,' or express distance. So far is this from being the case, that no expression of distance in the world is so great as that of the gold and orange in twilight sky. Colours, as such, are ABSOLUTELY inexpressive respecting distance. It is their quality (as depth, delicacy, etc.) which expresses distance, not their tint. A blue bandbox set on the same shelf with a yellow one will not look an inch farther off, but a red or orange cloud, in the upper sky, will always appear to be beyond a blue cloud close to us, as it is in reality. It is quite true that in certain objects, blue is a *sign* of distance; but that is not because blue is a retiring colour, but because the mist in the air is blue, and therefore any warm colour which has not strength of light enough to pierce the mist is lost or subdued in its blue: but blue is no more, on this account, a 'retiring colour,' than brown is a retiring colour, because, when stones are seen through brown water, the deeper they lie the browner they look; or than yellow is a retiring colour, because, when objects are seen through a London fog, the farther off they are the yellower they look. Neither blue, nor yellow, nor red, can have, as such, the smallest power of expressing either nearness or distance: they express them only under the peculiar circumstances which render them at the moment, or in that place, *signs* of nearness or distance. Thus, vivid orange in an orange is a sign of nearness, for if you put the orange a great way off, its colour will not look so bright; but vivid orange in sky is a sign of distance, because you cannot get the colour of orange in a cloud near you. So purple in a violet or a hyacinth is a sign of nearness, because the closer you look at them the

Here Ruskin contradicts, very effectively, much teaching in modern art schools about colour and space. The dogma that warm colours always come forward, while cool colours recede, has been taken as gospel by many art students. An example comes to mind: a student was painting a still life arranged on a table, the background being only two feet or so behind the objects. When asked why he had painted the background so weak in tone and colour, his reply was, 'I didn't want it to come forward.'

In fact, relations of *shape* – the overlapping of one shape with another – establish nearness or distance most clearly.

121

more purple you see. But purple in a mountain is a sign of distance, because a mountain close to you is not purple, but green or grey. It may, indeed, be generally assumed that a tender or pale colour will more or less express distance, and a powerful or dark colour nearness; but even this is not always so. Heathery hills will usually give a pale and tender purple near, and an intense and dark purple far away; the rose colour of sunset on snow is pale on the snow at your feet, deep and full on the snow in the distance; and the green of a Swiss lake is pale in the clear waves on the beach, but intense as an emerald in the sunstreak six miles from shore. And in any case, when the foreground is in strong light, with much water about it, or white surface, casting intense reflections, all its colours may be perfectly delicate, pale, and faint; while the distance, when it is in shadow, may relieve the whole foreground with intense darks of purple, blue green, or ultramarine blue. So that, on the whole, it is quite hopeless and absurd to expect any help from laws of 'aerial perspective.' Look for the natural effects, and set them down as fully as you can, and as faithfully, and *never* alter a colour because it won't look in its right place. Put the colour strong, if it be strong, though far off; faint, if it be faint, though close to you. Why should you suppose that Nature always means you to know exactly how far one thing is from another? She certainly intends you always to enjoy her colouring, but she does not wish you always to measure her space. You would be hard put to it, every time you painted the sun setting, if you had to express his 95,000,000 miles of distance in 'aerial perspective.'

There is, however, I think, one law about distance, which has some claims to be considered a constant one: namely, that dulness and heaviness of colour are more or less indicative of nearness. All distant colour is *pure* colour: it may not be bright, but it is clear and lovely, not opaque nor soiled; for the air and light coming between us and any earthy or imperfect colour, purify or harmonise it; hence a bad colourist is peculiarly incapable of expressing distance. I do not of course mean that you are to use bad colours in your foreground by way of making it come forward; but only that a failure in colour, there, will not put it out of its place; while a failure in colour in the distance will at once do away with its remoteness; your dull-coloured foreground will still be a foreground, though ill-painted; but your ill-painted distance will not be merely a dull distance – it will be no distance at all.

In *Modern Painters* Ruskin has this to say about the deliberate and intelligent way of working he asks for in a student:

'Good work is always *enjoyed* work. There is not a touch of Vandyck's pencil but he seems to have revelled in – not grossly, but delicately – tasting the colour in every touch as an epicure would wine.'

Ruskin contrasts this with the bad painter who daubs 'like a bricklayer spreading mortar – nay with far less lightness of hand or lightness of spirit than a good bricklayer's – covering his canvas heavily and conceitedly at once, caring only but to catch the public eye with his coarse, presumptuous, ponderous, illiterate work.' (*Modern Painters* V)

FIG. 30

Ruskin's estimate is exact

I have only one thing more to advise you, namely, never to colour petulantly or hurriedly. You will not, indeed, be able, if you attend properly to your colouring, to get anything like the quantity of form you could in a chiaroscuro sketch; nevertheless, if you do not dash or rush at your work, nor do it lazily, you may always get enough form to be satisfactory. An extra quarter of an hour, distributed in quietness over the course of the whole study, may just make the difference between a quite intelligible drawing, and a slovenly and obscure one. If you determine well beforehand what outline each piece of colour is to have, and, when it is on the paper, guide it without nervousness, as far as you can, into the form required; and then, after it is dry, consider thoroughly what touches are needed to complete it, before laying one of them on; you will be surprised to find how masterly the work will soon look, as compared with a hurried or ill-considered sketch. In no process that I know of – least of all in sketching – can time be really gained by precipitation. It is gained only by caution; and gained in all sorts of ways; for not only truth of form, but force of light, is always added by an intelligent and shapely laying of the shadow colours. You may often make a simple flat tint, rightly gradated and edged, express a complicated piece of subject without a single retouch. The two Swiss cottages, for instance, with their balconies, and glittering windows, and general character of shingly eaves, are expressed in FIG. 30 with one tint of grey, and a few dispersed spots and lines of it; all of which you ought to be able to lay on without more than thrice dipping your brush, and without a single touch after the tint is dry.

Here, then, for I cannot without coloured illustrations tell you more, I must leave you to follow out the subject for yourself, with such help as you may receive from the water-colour drawings accessible to you; or from any of the little treatises on their art which have been published lately by our water-colour painters.* But do not trust much to works of this kind. You may get valuable hints from them as to mixture of colours; and here and there you will find a useful artifice or process explained; but nearly all such books are written only to help idle amateurs to a meretricious skill, and they are full of precepts and principles which may, for the most part, be interpreted by their *precise* negatives, and then acted upon with advantage. Most of them praise boldness, when the only safe attendant spirit of a beginner is caution – advise velocity, when the first condition of success is deliberation –

*J. D. Harding's book, *Elementary Art: or, the use of the chalk and lead-pencil advocated and explained* (1846), cannot be dismissed, however, quite as cavalierly as this. He never praises mere boldness; nor does he recommend the acquisition of any particular style or manner. He says, for instance, 'Many who are anxious to avoid the difficulties which diligence is content to struggle with, run off from one "style", as they call it, to another – or, more properly speaking, from one *manner* to another . . .'

But Ruskin is absolutely right in that all these instructional works encourage certain technical tricks. In Fielding's case (*On Painting in Oil and Water Colours* by T. H. Fielding, 1839) the use of particular sorts of line in representing different textures may be instanced: 'In depicting foliage it is best to begin with the shades and with horizontal lines, passing the Pencil from right to left, as the surer way of keeping them horizontal, making them also of equal length and breadth, and of equal strength, so that the entire tone of colour may be *equal*.' – and: 'The lines chosen for representing the Bark must be made dark or light, broad or thin, according to its nature.'

In a word, the difference between these very respectable manuals and Ruskin's is the essential one of ends and means: they are teaching the production of pictures; he aims instead at the development of the student's eye and hand.

The tendency to 'praise boldness, when the only safe attendant spirit of a beginner is caution' is far more marked in our own time.

and plead for generalisation, when all the foundations of power must be laid in knowledge of speciality.

And now, in the last place, I have a few things to tell you respecting that dangerous nobleness of consummate art – COMPOSITION. For though it is quite unnecessary for you yet awhile to attempt it, and it *may* be inexpedient for you to attempt it at all, you ought to know what it means, and to look for and enjoy it in the art of others.

Composition means, literally and simply, putting several things together, so as to make *one* thing out of them; the nature and goodness of which they all have a share in producing. Thus a musician composes an air, by putting notes together in certain relations; a poet composes a poem, by putting thoughts and words in pleasant order; and a painter a picture, by putting thoughts, forms, and colours in pleasant order.

In all these cases, observe, an intended unity must be the result of composition. A paviour cannot be said to compose the heap of stones which he empties from his cart, nor the sower the handful of seed which he scatters from his hand. It is the essence of composition that everything should be in a determined place, perform an intended part, and act, in that part, advantageously for everything that is connected with it.

Composition, understood in this pure sense, is the type, in the arts of mankind, of the Providential government of the world. It is an exhibition, in the order given to notes, or colours, or forms, of the advantage of perfect fellowship, discipline, and contentment. In a well-composed air, no note, however short or low, can be spared, but the least is as necessary as the greatest: no note, however prolonged, is tedious; but the others prepare for, and are benefited by, its duration: no note, however high, is tyrannous; the others prepare for, and are benefited by, its exaltation: no note, however low, is overpowered; the others prepare for, and sympathise with, its humility: and the result is, that each and every note has a value in the position assigned to it, which, by itself, it never possessed, and of which, by separation from the others, it would instantly be deprived.

Similarly, in a good poem, each word and thought enhances the value of those which precede and follow it; and every syllable has a loveliness which depends not so much on its abstract sound as on its position. Look at the same word in a dictionary, and you will hardly recognise it.

Much more in a great picture; every line and colour is so arranged as to advantage the rest. None are inessential, however slight; and none are independent, however forcible. It is not enough that they truly represent natural objects; but they must fit into certain places, and gather into certain harmonious groups: so that, for instance, the red chimney of a cottage is not merely set in its place as a chimney, but that it may affect, in a certain way pleasurable to the eye, the pieces of green or blue in other parts of the picture; and we ought to see that the work is masterly, merely by the positions and quantities of these patches of green, red, and blue, even at a distance which renders it perfectly impossible to determine what the colours represent: or to see whether the red is a chimney, or an old woman's cloak; and whether the blue is smoke, sky, or water.

It seems to be appointed, in order to remind us, in all we do, of the great laws of Divine government and human polity, that composition in the arts should strongly affect every order of mind, however unlearned or thoughtless. Hence the popular delight in rhythm and metre, and in simple musical melodies. But it is also appointed that *power* of composition in the fine arts should be an exclusive attribute of great intellect. All men can more or less copy what they see, and, more or less, remember it: powers of reflection and investigation are also common to us all, so that the decision of inferiority in these rests only on questions of *degree*. A has a better memory than B, and C reflects more profoundly than D. But the gift of composition is not given *at all* to more than one man in a thousand; in its highest range, it does not occur above three or four times in a century.

It follows, from these general truths, that it is impossible to give rules which will enable you to compose. You might much more easily receive rules to enable you to be witty. If it were possible to be witty by rule, wit would cease to be either admirable or amusing: if it were possible to compose melody by rule, Mozart and Cimarosa need not have been born: if it were possible to compose pictures by rule, Titian and Veronese would be ordinary men. The essence of composition lies precisely in the fact of its being unteachable, in its being the operation of an individual mind of range and power exalted above others.

But though no one can *invent* by rule, there are some simple laws of arrangement which it is well for you to know, because, though they will not enable you to produce a good

picture, they will often assist you to set forth what goodness may be in your work in a more telling way than you could have done otherwise; and by tracing them in the work of good composers, you may better understand the grasp of their imagination, and the power it possesses over their materials. I shall briefly state the chief of these laws.

1. THE LAW OF PRINCIPALITY

FIG. 31

a *b* *c*

The great object of composition being always to secure unity; that is, to make out of many things one whole; the first mode in which this can be effected is, by determining that *one* feature shall be more important than all the rest, and that the others shall group with it in subordinate positions.

This is the simplest law of ordinary ornamentation. Thus the group of two leaves, *a*, FIG. 31, is unsatisfactory, because it has no leading leaf; but that at *b* is prettier, because it has a head or master leaf; and *c* more satisfactory still, because the subordination of the other members to this head leaf is made more manifest by their gradual loss of size as they fall back from it. Hence part of the pleasure we have in the Greek honeysuckle ornament, and such others.

Thus, also, good pictures have always one light larger and brighter than the other lights, or one figure more prominent than the other figures, or one mass of colour dominant over all the other masses; and in general you will find it much benefit your sketch if you manage that there shall be one light on the cottage wall, or one blue cloud in the sky, which may attract the eye as leading light, or leading gloom, above all others. But the observance of the rule is often so cunningly concealed by the great composers, that its force is hardly at first traceable; and you will generally find they are vulgar pictures in which the law is strikingly manifest.

This may be simply illustrated by musical melody: for instance, in such phrases as this —

one note (here the upper G) rules the whole passage, and has the full energy of it concentrated in itself. Such passages, corresponding to completely subordinated compositions in

The first phrase is from Bellini's *La Sonnambula*; the second from Mozart's *Don Giovanni*.

126

painting, are apt to be wearisome if often repeated. But, in such a phrase as this –

it is very difficult to say which is the principal note. The A in the last bar is slightly dominant, but there is a very equal current of power running through the whole; and such passages rarely weary. And this principle holds through vast scales of arrangement; so that in the grandest compositions, such as Paul Veronese's Marriage in Cana, or Raphael's Disputa, it is not easy to fix at once on the principal figure; and very commonly the figure which is really chief does not catch the eye at first, but is gradually felt to be more and more conspicuous as we gaze. Thus in Titian's grand composition of the Pesaro Family,* the figure meant to be principal is a youth of fifteen or sixteen, whose portrait it was evidently the painter's object to make as interesting as possible. But a grand Madonna, and a St George with a drifting banner, and many figures more, occupy the centre of the picture, and first catch the eye; little by little we are led away from them to a gleam of pearly light in the lower corner, and find that, from the head which it shines upon, we can turn our eyes no more.

As, in every good picture, nearly all laws of design are more or less exemplified, it will, on the whole, be an easier way of explaining them to analyse one composition thoroughly, than to give instances from various works. I shall therefore take one of Turner's simplest; which will allow us, so to speak, easily to decompose it, and illustrate each law by it as we proceed.

FIG. 32 is a rude sketch of the arrangement of the whole subject; the old bridge over the Moselle at Coblentz, the town of Coblentz on the right, Ehrenbreitstein on the left. The leading or master feature is, of course, the tower on the bridge. It is kept from being *too* principal by an important

*The *Madonna di Ca' Pesaro*, Sta Maria dei Frari, Venice. The three pictures mentioned by Ruskin here are such large and complex compositions that it did not seem to me to be worth while to reproduce them on such a small scale. Comparatively large reproductions can, of course, be found in reference books.

FIG. 32

group on each side of it; the boats, on the right, and Ehrenbreitstein beyond. The boats are large in mass, and more forcible in colour, but they are broken into small divisions, while the tower is simple, and therefore it still leads. Ehrenbreitstein is noble in its mass, but so reduced by aerial perspective of colour that it cannot contend with the tower, which therefore holds the eye, and becomes the key of the picture. We shall see presently how the very objects which seem at first to contend with it for the mastery are made, occultly, to increase its pre-eminence.

2. THE LAW OF REPETITION

Another important means of expressing unity is to mark some kind of sympathy among the different objects, and perhaps the pleasantest, because most surprising, kind of sympathy, is when one group imitates or repeats another; not in the way of balance or symmetry, but subordinately, like a far-away and broken echo of it. Prout has insisted much on this law in all his writings on composition; and I think it is even more authoritatively present in the minds of most great composers than the law of principality. It is quite curious to see the pains that Turner sometimes takes to echo an important passage of colour; in the Pembroke Castle, for instance, there are two fishing-boats, one with a red, and another with a white sail. In a line with them, on the beach, are two fish in precisely the same relative positions; one red and one white. It is observable that he uses the artifice chiefly in pictures where he wishes to obtain an expression of repose: in my notice of the plate of Scarborough, in the series of the *Harbours of England*, I have already had occasion to dwell on this point; and I extract in the note* one or two sentences which explain the principle. In the composition I have chosen for our illustration, this reduplication is employed to a singular extent. The tower, or leading feature, is first repeated by the low echo of it to the left; put your finger over this lower tower, and see how the picture is spoiled. Then the spires of Coblentz are all arranged in couples (how they are arranged in reality does not matter; when we are composing a great picture, we must play the towers about till they come right, as fearlessly as if they were chessmen instead of cathedrals). The dual arrangement of these towers would have been too easily seen, were it not for the little one which pretends to make a triad of the last group on the right,

*Ruskin adds this note:

'In general, throughout Nature, reflection and repetition are peaceful things, associated with the idea of quiet succession in events; that one day should be like another day, or one history the repetition of another history, being more or less results of quietness, while dissimilarity and non-succession are results of interference and disquietude. Thus, though an echo actually increases the quantity of sound heard, its repetition of the note or syllable gives an idea of calmness attainable in no other way; hence also the feeling of calm given to a landscape by the voice of a cuckoo.'

Right: John Ruskin *Bay of Naples with the Palazzo Donn'Anna*. Private Collection. This is an early drawing by Ruskin, showing his very delicate use of line. Compare it with the more tonal handling of a late drawing such as *Casa Foscari* (page 92)

128

but is so faint as hardly to be discernible; it just takes off the attention from the artifice, helped in doing so by the mast at the head of the boat, which, however, has instantly its own duplicate put at the stern. [This is obscure in the rude woodcut, the masts being so delicate that they are confused among the lines of reflection. In the original they have orange light upon them, relieved against purple behind.] Then there is the large boat near, and its echo beyond it. The echo is divided into two again, and each of those two smaller boats has two figures in it; while two figures are also sitting together on the great rudder that lies half in the water, and half aground. Then, finally, the great mass of Ehrenbreitstein, which appears at first to have no answering form, has almost its *facsimile* in the bank on which the girl is sitting; this bank is as absolutely essential to the completion of the picture as any object in the whole series. All this is done to deepen the effect of repose.

Symmetry, or the balance of parts or masses in nearly equal opposition, is one of the conditions of treatment under the law of Repetition. For the opposition, in a symmetrical

object, is of like things reflecting each other: it is not the balance of contrary natures (like that of day and night), but of like natures or like forms; one side of a leaf being set like the reflection of the other in water.

Symmetry in Nature is, however, never formal nor accurate. She takes the greatest care to secure some difference between the corresponding things or parts of things; and an approximation to accurate symmetry is only permitted in animals, because their motions secure perpetual difference between the balancing parts. Stand before a mirror; hold your arms in precisely the same position at each side, your head upright, your body straight; divide your hair exactly in the middle and get it as nearly as you can into exactly the same shape over each ear; and you will see the effect of accurate symmetry: you will see, no less, how all grace and power in the human form result from the interference of motion and life with symmetry, and from the reconciliation of its balance with its changefulness. Your position, as seen in the mirror, is the highest type of symmetry as understood by modern architects.

In many sacred compositions, living symmetry, the balance

Study after Perugino *Madonna and Child with Saints Michael and Raphael*, (in the National Gallery, London)

of harmonious opposites, is one of the profoundest sources of their power: almost any works of the early painters, Angelico, Perugino, Giotto, etc., will furnish you with notable instances of it. The Madonna of Perugino in the National Gallery, with the angel Michael on one side and Raphael on the other, is as beautiful an example as you can have.

In landscape, the principle of balance is more or less carried out, in proportion to the wish of the painter to express disciplined calmness. In bad compositions, as in bad architecture, it is formal, a tree on one side answering a tree on the other; but in good compositions, as in graceful statues, it is always easy and sometimes hardly traceable. In the Coblentz, however, you cannot have much difficulty in seeing how the boats on one side of the tower and the figures on the other are set in nearly equal balance; the tower, as a central mass, uniting both.

FIG. 33

It has been impossible to trace the original drawing by Turner from which Ruskin made this study.

3. THE LAW OF CONTINUITY

Another important and pleasurable way of expressing unity, is by giving some orderly succession to a number of objects more or less similar. And this succession is most interesting when it is connected with some gradual change in the aspect or character of the objects. Thus the succession of the pillars of a cathedral aisle is most interesting when they retire in perspective, becoming more and more obscure in distance: so the succession of mountain promontories one behind another, on the flanks of a valley; so the succession of clouds, fading farther and farther towards the horizon; each promontory and each cloud being of different shape, yet all evidently following in a calm and appointed order. If there be no change at all in the shape or size of the objects, there is no continuity; there is only repetition – monotony. It is the change in shape which suggests the idea of their being individually free, and able to escape, if they liked, from the law that rules them, and yet submitting to it.

I will leave our chosen illustrative composition for a moment to take up another, still more expressive of this law. It is one of Turner's most tender studies, a sketch on Calais Sands at sunset; so delicate in the expression of wave and cloud, that it is of no use for me to try to reach it with any kind of outline in a woodcut; but the rough sketch, FIG. 33, is enough to give an idea of its arrangement. The aim of the painter has been to give the intensest expression of repose,

together with the enchanted, lulling, monotonous motion of cloud and wave. All the clouds are moving in innumerable ranks after the sun, meeting towards that point in the horizon where he has set; and the tidal waves gain in winding currents upon the sand, with that stealthy haste in which they cross each other so quietly, at their edges; just folding one over another as they meet, like a little piece of ruffled silk, and leaping up a little as two children kiss and clap their hands, and then going on again, each in its silent hurry, drawing pointed arches on the sand as their thin edges intersect in parting. But all this would not have been enough expressed without the line of the old pier-timbers, black with weeds, strained and bent by the storm waves, and now seeming to stoop in following one another, like dark ghosts escaping slowly from the cruelty of the pursuing sea.

I need not, I hope, point out to the reader the illustration of this law of continuance in the subject chosen for our general illustration. It was simply that gradual succession of the retiring arches of the bridge which induced Turner to paint the subject at all; and it was this same principle which led him always to seize on subjects including long bridges wherever he could find them; but especially, observe, un-equal bridges, having the highest arch at one side rather than at the centre. There is a reason for this, irrespective of general laws of composition, and connected with the nature

of rivers, which I may as well stop a minute to tell you about, and let you rest from the study of composition.

All rivers, small or large, agree in one character, they like to lean a little on one side: they cannot bear to have their channels deepest in the middle, but will always, if they can, have one bank to sun themselves upon, and another to get cool under; one shingly shore to play over, where they may be shallow, and foolish, and childlike, and another steep shore, under which they can pause, and purify themselves, and get their strength of waves fully together for due occasion. Rivers in this way are just like wise men, who keep one side of their life for play, and another for work; and can be brilliant, and chattering, and transparent, when they are at ease, and yet take deep counsel on the other side when they set themselves to their main purpose. And rivers are just in this divided, also, like wicked and good men: the good rivers have service-able deep places all along their banks, that ships can sail in; but the wicked rivers go scooping irregularly under their banks until they get full of strangling eddies, which no boat can row over without being twisted against the rocks; and pools like wells, which no one can get out of but the water-kelpie that lives at the bottom; but, wicked or good, the rivers all agree in having two kinds of sides. Now the natural way in which a village stone-mason therefore throws a bridge over a strong stream is, of course, to build a great door to let the cat through, and little doors to let the kittens through; a great arch for the great current, to give it room in flood time, and little arches for the little currents along the shallow shore. This, even without any prudential respect for the floods of the great current, he would do in simple economy of work and stone; for the smaller your arches are, the less material you want on their flanks. Two arches over the same span of river, supposing the butments are at the same depth, are cheaper than one, and that by a great deal; so that, where the current is shallow, the village mason makes his arches many and low: as the water gets deeper, and it becomes troublesome to build his piers up from the bottom, he throws his arches wider; at last he comes to the deep stream, and, as he cannot build at the bottom of that, he throws his largest arch over it with a leap, and with another little one or so gains the opposite shore. Of course as arches are wider they must be higher, or they will not stand; so the roadway must rise as the arches widen. And thus we have the general type of bridge, with its highest and widest arch towards one side,

132

and a train of minor arches running over the flat shore on the other: usually a steep bank at the river-side next the large arch; always, of course, a flat shore on the side of the small ones: and the bend of the river assuredly concave towards this flat, cutting round, with a sweep into the steep bank; or, if there is no steep bank, still assuredly cutting into the shore at the steep end of the bridge.

Now this kind of bridge, sympathising, as it does, with the spirit of the river, and marking the nature of the thing it has to deal with and conquer, is the ideal of a bridge; and all endeavours to do the thing in a grand engineer's manner, with a level roadway and equal arches, are barbarous; not only because all monotonous forms are ugly in themselves, but because the mind perceives at once that there has been cost uselessly thrown away for the sake of formality.

Well, to return to our continuity. We see that the Turnerian bridge in FIG. 32 is of the absolutely perfect type, and is still farther interesting by having its main arch crowned by a watch-tower. But as I want you to note especially what perhaps was not the case in the real bridge, but is entirely Turner's doing, you will find that though the arches diminish gradually, not one is *regularly* diminished – they are all of different shapes and sizes: you cannot see this clearly in FIG. 32, but in the larger diagram, FIG. 34, you will with ease. This is indeed also part of the ideal of a bridge, because the lateral currents near the shore are of course irregular in size, and a simple builder would naturally vary his arches accordingly; and also, if the bottom was rocky, build his piers where the rocks came. But it is not as a part of bridge ideal, but as a necessity of all noble composition, that this irregularity is introduced by Turner. It at once raises the object thus treated from the lower or vulgar unity of rigid law to the greater unity of clouds, and waves, and trees, and human souls, each different, each obedient, and each in harmonious service.

4. THE LAW OF CURVATURE

There is, however, another point to be noticed in this bridge of Turner's. Not only does it slope away unequally at its sides, but it slopes in a gradual though very subtle curve. And if you substitute a straight line for this curve (drawing one with a rule from the base of the tower on each side to the ends of the bridge, in FIG. 34, and effacing the curve), you will instantly see that the design has suffered grievously. You may ascer-

Coblentz. Engraving after Turner

FIG. 34

tain, by experiment, that all beautiful objects whatsoever are thus terminated by delicately curved lines, except where the straight line is indispensable to their use or stability; and that when a complete system of straight lines, throughout the form, is necessary to that stability, as in crystals, the beauty, if any exists, is in colour and transparency, not in form. Cut out the shape of any crystal you like, in white wax or wood, and put it beside a white lily, and you will feel the force of the curvature in its purity, irrespective of added colour, or other interfering elements of beauty.

Well, as curves are more beautiful than straight lines, it is necessary to a good composition that its continuities of object, mass, or colour should be, if possible, in curves, rather than straight lines or angular ones. Perhaps one of the simplest and prettiest examples of a graceful continuity of this kind is in the line traced at any moment by the corks of a net as it is being drawn: nearly every person is more or less attracted by the beauty of the dotted line. Now, it is almost always possible, not only to secure such a continuity in the arrangement or boundaries of objects which, like these bridge arches or the corks of the net, are actually connected with each other, but – and this is a still more noble and interesting kind of continuity – among features which appear at first entirely separate. Thus the towers of Ehrenbreitstein, on the left, in FIG. 32, appear at first independent of each other; but when I give their profile, on a larger scale, FIG. 35, the reader may easily perceive that there is a subtle cadence and harmony among them. The reason of this is, that they are all bounded by one grand curve, traced by the dotted line; out of the seven towers, four precisely touch this curve, the others only falling back from it here and there to keep the eye from discovering it too easily.

And it is not only always possible to obtain continuities of this kind: it is, in drawing large forest or mountain forms, essential to truth. The towers of Ehrenbreitstein might or might not in reality fall into such a curve, but assuredly the basalt rock on which they stand did; for all mountain forms not cloven into absolute precipice, nor covered by straight slopes of shales, are more or less governed by these great curves, it being one of the aims of Nature in all her work to produce them. The reader must already know this, if he has been able to sketch at all among mountains; if not, let him merely draw for himself, carefully, the outlines of any low hills accessible to him, where they are tolerably steep, or of

FIG. 35

the woods which grow on them. The steeper shore of the Thames at Maidenhead, or any of the downs at Brighton or Dover, or, even nearer, about Croydon (as Addington Hills), is easily accessible to a Londoner; and he will soon find not only how constant, but how graceful the curvature is. Graceful curvature is distinguished from ungraceful by two characters; first in its moderation, that is to say, its close approach to straightness in some part of its course; and, secondly, by its variation, that is to say, its never remaining equal in degree at different parts of its course.

This variation is itself twofold in all good curves.

A. There is, first, a steady change through the whole line, from less to more curvature, or more to less, so that *no* part of the line is a segment of a circle, or can be drawn by compasses in any way whatever. Thus, in FIG. 36, *a* is a bad curve because it is part of a circle, and is therefore monotonous throughout; but *b* is a good curve, because it continually changes its direction as it proceeds.

The *first* difference between good and bad drawing of tree boughs consists of observance of this fact. Thus, when I put leaves on the line *b*, as in FIG. 37, you can immediately feel the springiness of character dependent on the changefulness of the curve. You may put leaves on the other line for yourself, but you will find you cannot make a right tree spray of it. For *all* tree boughs, large or small, as well as all noble natural lines whatsoever, agree in this character; and it is a point of primal necessity that your eye should always seize and your hand trace it. Here are two more portions of good curves, with leaves put on them at the extremities instead of the flanks, FIG. 38; and two showing the arrangement of masses of foliage seen a little farther off, FIG. 39, which you may in like manner amuse yourself by turning into segments of circles – you will see with what result. I hope however you have beside you, by this time, many good studies of tree boughs carefully made, in which you may study variations of curvature in their most complicated and lovely forms.

B. Not only does every good curve vary in general tendency, but it is modulated, as it proceeds, by myriads of subordinate curves. Thus the outlines of a tree trunk are never as at *a*, FIG. 40, but as at *b*. So also in waves, clouds, and all other nobly formed masses. Thus another essential difference between good and bad drawing, or good and bad sculpture, depends on the quantity and refinement of minor curvatures

FIG. 36

FIG. 37

FIG. 38

FIG. 39

136

FIG. 40

a *b*

carried, by good work, into the great lines. Strictly speaking, however, this is not variation in large curves, but composition of large curves out of small ones; it is an increase in the quantity of the beautiful element, but not a change in its nature.

5. THE LAW OF RADIATION

We have hitherto been concerned only with the binding of our various objects into beautiful lines or processions. The next point we have to consider is, how we may unite these lines or processions themselves, so as to make groups of *them*.

Now, there are two kinds of harmonies of lines. One in which, moving more or less side by side, they variously, but evidently with consent, retire from or approach each other, intersect or oppose each other; currents of melody in music, for different voices, thus approach and cross, fall and rise, in harmony; so the waves of the sea, as they approach the shore, flow into one another or cross, but with a great unity through all; and so various lines of composition often flow harmoniously through and across each other in a picture. But the most simple and perfect connexion of lines is by radiation; that is, by their all springing from one point, or closing towards it; and this harmony is often, in Nature almost always, united with the other; as the boughs of trees, though they intersect and play amongst each other irregularly, indicate by their general tendency their origin from one root. An essential part of the beauty of all vegetable form is in this radiation; it is seen most simply in a single flower or leaf, as in a convolvulus bell, or chestnut leaf; but more beautifully in the complicated arrangements of the large boughs and sprays. For a leaf is only a flat piece of radiation; but the tree throws its branches on all sides, and even in every profile view of it, which presents a radiation more or less correspondent to that of its leaves, it is more beautiful, because varied by the freedom of the separate branches. I believe it has been ascertained that, in all trees, the angle at which, in their leaves, the lateral ribs are set on their central rib is approximately the same at which the branches leave the great stem; and thus each section of the tree would present a kind of magnified view of its own leaf, were it not for the interfering force of gravity on the masses of foliage. This force in proportion to their age, and the lateral leverage upon them, bears them downwards at the extremities, so that, as before

FIG. 41 *R*

FIG. 42 *R*

noticed, the lower the bough grows on the stem, the more it droops (FIG. 17, page 71); besides this, nearly all beautiful trees have a tendency to divide into two or more principal masses, which give a prettier and more complicated symmetry than if one stem ran all the way up the centre. FIG. 41 may thus be considered the simplest type of tree radiation, as opposed to leaf radiation. In this figure, however, all secondary ramification is unrepresented, for the sake of simplicity; but if we take one half of such a tree, and merely give two secondary branches to each main branch (as represented in the general branch structure shown at *b*, FIG. 18, page 71), we shall have the form FIG. 42. This I consider the perfect general type of tree structure; and it is curiously connected with certain forms of Greek, Byzantine, and Gothic ornamentation, into the discussion of which, however, we must not enter here. It will be observed, that both in FIGS. 41 and 42 all the branches so spring from the main stem as very nearly to suggest their united radiation from the root R. This is by no means universally the case; but if the branches do not bend towards a point in the root, they at least converge to some point or other. In the examples in FIG. 43, the mathematical centre of curvature, *a*, is thus, in one case, on the ground, at some distance from the root, and in the other, near the top of the tree. Half, only, of each tree is given, for the sake of clearness: FIG. 44 gives both sides of another example, in which the origins of curvature are below the root. As the positions of such points may be varied without end, and as the arrangement of the lines is also farther complicated by the fact of the boughs springing for the most part in a spiral order round the tree, and at proportionate distances, the systems of curvature which regulate the form of vegetation are quite infinite. Infinite is a word easily said, and easily written, and people do not always mean it when they say it; in this case I *do* mean it: the number of systems is incalculable, and even to furnish anything like a representative number of types, I should have to give several hundreds of figures such as FIG. 44. [The reader, I hope, observes always that every line in these figures is itself one of varying curvature, and cannot be drawn by compasses.]

Thus far, however, we have only been speaking of the great relations of stem and branches. The forms of the branches themselves are regulated by still more subtle laws, for they occupy an intermediate position between the form of the tree and of the leaf. The leaf has a flat ramification; the tree a

a

a

R *R*

FIG. 43

R

FIG. 44

completely rounded one; the bough is neither rounded nor flat, but has a structure exactly balanced between the two, in a half-flattened, half-rounded flake, closely resembling in shape one of the thick leaves of an artichoke or the flake of a fir cone; by combination forming the solid mass of the tree, as the leaves compose the artichoke head. I have before pointed out to you the general resemblance of these branch flakes to an extended hand; but they may be more accurately represented by the ribs of a boat. If you can imagine a very broad-headed and flattened boat applied by its keel to the end of a main branch, as in FIG. 45, the lines which its ribs will take, supposing them outside of its timbers instead of inside, and the general contour of it, as seen in different directions, from above and below, will give you the closest approximation to the perspectives and foreshortenings of a well-grown branch-flake. FIG. 25, page 85, is an unharmed and unrestrained shoot of healthy young oak; and, if you compare it with FIG. 45, you will understand at once the action of the lines of leafage; the boat only failing as a type in that its ribs are too nearly parallel to each other at the sides, while the bough sends all its ramification well forwards, rounding to the head, that it may accomplish its part in the outer form of the whole tree, yet always securing the compliance with the great universal law that the branches nearest the root bend most back; and, of course, throwing *some* always back as well as forwards; the appearance of reversed action being much increased, and rendered more striking and beautiful, by perspective. FIG. 25 shows the perspective of such a bough as it is seen from below; FIG. 46 gives rudely the look it would have from above.

FIG. 45

Ruskin adds this note:

'I hope the reader understands that these woodcuts are merely facsimiles of the sketches I make at the side of my paper to illustrate my meaning as I write – often sadly scrawled if I want to get on to something else. This one is really a little too careless; but it would take more time and trouble to make a proper drawing of so odd a boat than the matter is worth. It will answer the purpose well enough as it is.'

FIG. 46

You may suppose, if you have not already discovered, what subtleties of perspective and light and shade are involved in the drawing of these branch-flakes, as you see them in different directions and actions; now raised, now depressed: touched on the edges by the wind, or lifted up and bent back so as to show all the white under surfaces of the leaves shivering in light, as the bottom of a boat rises white with spray at the surge-crest; or dropping in quietness towards the dew of the grass beneath them in windless mornings, or bowed down under oppressive grace of deep-charged snow. Snow time, by the way, is one of the best for practice in the placing of tree masses; but you will only be able to understand them thoroughly by beginning with a single bough and a few leaves placed tolerably even, as in FIG. 38, page 136.

First one with three leaves, a central and two lateral ones, as at a; then with five, as at b, and so on; directing your whole attention to the expression, both by contour and light and shade, of the boat-like arrangements, which, in your earlier studies, will have been a good deal confused, partly owing to your inexperience, and partly to the depth of shade, or absolute blackness of mass required in those studies.

One thing more remains to be noted, and I will let you out of the wood. You see that in every generally representative figure I have surrounded the radiating branches with a dotted line: such lines do indeed terminate every vegetable form; and you see that they are themselves beautiful curves, which, according to their flow, and the width of narrowness of the spaces they enclose, characterise the species of tree or leaf, and express its free or formal action, its grace of youth or weight of age. So that, throughout all the freedom of her wildest foliage, Nature is resolved on expressing an encompassing limit; and marking a unity in the whole tree, caused not only by the rising of its branches from a common root, but by their joining in one work, and being bound by a common law. And having ascertained this, let us turn back for a moment to a point in leaf structure which, I doubt not, you must already have observed in your earlier studies, but which it is well to state here, as connected with the unity of the branches in the great trees. You must have noticed, I should think, that whenever a leaf is compound – that is to say, divided into other leaflets which in any way repeat or imitate the form of the whole leaf – those leaflets are not symmetrical, as the whole leaf is, but always smaller on the side towards the point of the great leaf, so as to express their subordination to it, and show, even when they are pulled off, that they are not small independent leaves, but members of one large leaf.

FIG. 47

FIG. 47, which is a block-plan of a leaf of columbine, without its minor divisions on the edges, will illustrate the principle clearly. It is composed of a central large mass, A, and two lateral ones, of which the one on the right only is lettered, B. Each of these masses is again composed of three others, a central and two lateral ones; but observe, the minor one, a of A, is balanced equally by its opposite; but the minor $b1$ of B is larger than its opposite $b2$. Again, each of these minor masses is divided into three; but while the central mass, A of A, is symmetrically divided, the B of B is unsymmetrical, its largest side-lobe being lowest. Again, in $b2$, the lobe $c1$ (its

A cranesbill leaf

lowest lobe in relation to B) is larger than $c2$; and so also in $b1$. So that universally one lobe of a lateral leaf is always larger than the other, and the smaller lobe is that which is nearer the central mass; the lower leaf, as it were by courtesy, subduing some of its own dignity or power, in the immediate presence of the greater or captain leaf, and always expressing, therefore, its own subordination and secondary character. This law is carried out even in single leaves. As far as I know, the upper half, towards the point of the spray, is always the smaller; and a slightly different curve, more convex at the springing, is used for the lower side, giving an exquisite variety to the form of the whole leaf; so that one of the chief elements in the beauty of every subordinate leaf throughout the tree is made to depend on its confession of its own lowliness and subjection.

And now, if we bring together in one view the principles we have ascertained in trees, we shall find they may be summed under four great laws; and that all perfect vegetable form is appointed to express these four laws in noble balance of authority.

1. Support from one living root.

2. Radiation, or tendency of force from some one given point, either in the root, or in some stated connection with it.

3. Liberty of each bough to seek it own livelihood and happiness according to its needs, by irregularities of action both in its play and its work, either stretching out to get its required nourishment from light and rain, by finding some sufficient breathing-place among the other branches, or knotting and gathering itself up to get strength for any load which its fruitful blossoms may lay upon it, and for any stress of its storm-tossed luxuriance of leaves; or playing hither and thither as the fitful sunshine may tempt its young shoots, in their undecided states of mind about their future life.

4. Imperative requirement of each bough to stop within certain limits, expressive of its kindly fellowship and fraternity with the boughs in its neighbourhood; and to work with them according to its power, magnitude, and state of health, to bring out the general perfectness of the great curve, and circumferent stateliness of the whole tree.

I think I may leave you, unhelped, to work out the moral analogies of these laws; you may, perhaps, however, be a little puzzled to see the meaning of the second one. It typically expresses that healthy human actions should spring radiantly (like rays) from some single heart motive;

Imperfect vegetable form, Ruskin considers, is that which is by nature dependent, as in runners and climbers; or which is susceptible of continual injury without materially losing the power of giving pleasure by its aspect, as in the case of the smaller grasses.

the most beautiful systems of action taking place when this motive lies at the root of the whole life, and the action is clearly seen to proceed from it; while also many beautiful secondary systems of action taking place from motives not so deep or central, but in some beautiful subordinate connection with the central or life motive.

The other laws, if you think over them, you will find equally significant; and as you draw trees more and more in their various states of health and hardship, you will be every day more struck by the beauty of the types they present of the truths most essential for mankind to know;* and you will see what this vegetation of the earth, which is necessary to our life, first, as purifying the air for us and then as food, and just as necessary to our joy in all places of the earth – what these trees and leaves, I say, are meant to teach us as we contemplate them, and read or hear their lovely language, written or spoken for us, not in frightful black letters nor in dull sentences, but in fair green and shadowy shapes of waving words, and blossomed brightness of odoriferous wit, and sweet whispers of unintrusive wisdom, and playful morality.

Well, I am sorry myself to leave the wood, whatever my reader may be; but leave it we must, or we shall compose no more pictures to-day.

This law of radiation, then, enforcing unison of action in arising from, or proceeding to, some given point, is perhaps, of all principles of composition, the most influential in producing the beauty of groups of form. Other laws make them forcible or interesting, but this generally is chief in rendering them beautiful. In the arrangement of masses in pictures, it is constantly obeyed by the great composers; but, like the law of principality, with careful concealment of its imperativeness, the point to which the lines of main curvature are directed being very often far away out of the picture. Sometimes, however, a system of curves will be employed definitely to exalt, by their concurrence, the value of some leading object, and then the law becomes traceable enough.

In the instance before us, the principal object being, as we have seen, the tower on the bridge, Turner has determined that his system of curvature should have its origin in the top of this tower. The diagram FIG. 34, compared with FIG. 32, will show how this is done. One curve joins the two towers, and is continued by the back of the figure sitting on the bank into the piece of bent timber. This is a limiting curve of great importance, and Turner has drawn a considerable part of it

*A footnote is added here:

'There is a very tender lesson of this kind in the shadows of leaves upon the ground; shadows which are the most like of all to attract attention, by their pretty play and change. If you examine them, you will find that the shadows do not take the forms of the leaves, but that, through each interstice, the light falls, at a little distance, in the form of a round or oval spot; that is to say, it produces the image of the sun itself, cast either vertically or obliquely, in circle or ellipse according to the slope of the ground . . .'

with the edge of the timber very carefully, and then led the eye up to the sitting girl by some white spots and indications of a ledge in the bank; then the passage to the tops of the towers cannot be missed.

The next curve is begun and drawn carefully for half an inch of its course by the rudder; it is then taken up by the basket and the heads of the figures, and leads accurately to the tower angle. The gunwales of both the boats begin the next two curves, which meet in the same point; and all are centralised by the long reflection which continues the vertical lines.

Subordinated to this first system of curves there is another, begun by the small crossing bar of wood inserted in the angle behind the rudder; continued by the bottom of the bank on which the figure sits, interrupted forcibly beyond it, but taken up again by the water-line leading to the bridge foot, and passing on in delicate shadows under the arches, not easily shown in so rude a diagram, towards the other extremity of the bridge. This is a most important curve, indicating that the force and sweep of the river have indeed been in old times under the large arches; while the antiquity of the bridge is told us by a long tongue of land, either of carted rubbish, or washed down by some minor stream, which has interrupted this curve, and is now used as a landing-place for the boats, and for embarkation of merchandise, of which some bales and bundles are laid in a heap, immediately beneath the great tower. A common composer would have put these bales to one side or the other, but Turner knows better; he uses them as a foundation for his tower, adding to its importance precisely as the sculptured base adorns a pillar; and he farther increases the aspect of its height by throwing the reflection of it far down in the nearer water. All the great composers have this same feeling about sustaining their vertical masses: you will constantly find Prout using the artifice most dexterously ... and Veronese, Titian, and Tintoret continually put their principal figures at bases of pillars. Turner found out their secret very early ... I chose FIG. 20, already given to illustrate foliage drawing, chiefly because, being another instance of precisely the same arrangement, it will serve to convince you of its being intentional. There, the vertical, formed by the larger tree, is continued by the figure of the farmer, and that of one of the smaller trees by his stick. The lines of the interior mass of the bushes radiate, under the law of radiation, from a point

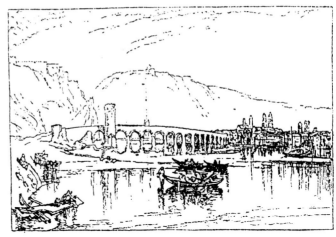

FIG. 32

FIG. 34

143

FIG. 20

6. THE LAW OF CONTRAST

Of course the character of everything is best manifested by Contrast. Rest can only be enjoyed after labour; sound to be heard clearly, must rise out of silence; light is exhibited by darkness, darkness by light; and so on in all things. Now in art every colour has an opponent colour, which, if brought near it, will relieve it more completely than any other; so, also, every form and line may be made more striking to the eye by an opponent form or line near them; a curved line is set off by a straight one, a massy form by a slight one, and so on; and in all good work nearly double the value, which any given colour or form would have uncombined, is given to each by contrast.

In this case again, however, a too manifest use of the artifice vulgarises a picture. Great painters do not commonly, or very visibly, admit violent contrast. They introduce it by stealth, and with intermediate links of tender change; allowing, indeed, the opposition to tell upon the mind as a surprise, but not as a shock. [Turner hardly ever, as far as I remember, allows a strong light to oppose a full dark, without some intervening tint. His suns never set behind dark mountains without a film or cloud above the mountain's edge.]

Thus in the rock of Ehrenbreitstein, FIG. 35, the main current of the lines being downwards, in a convex swell, they are suddenly stopped at the lowest tower by a counter series of beds, directed nearly straight across them. This adverse force sets off and relieves the great curvature, but it is reconciled to it by a series of radiating lines below, which at first sympathise with the oblique bar, then gradually get steeper, till they meet and join in the fall of the great curve. No passage, however intentionally monotonous, is ever introduced by a good artist without *some* slight counter current of this kind; so much, indeed, do the great composers feel the necessity of it, that they will even do things purposely ill or unsatisfactorily, in order to give greater value to their well-doing in other places. In a skilful poet's versification the so-called bad or inferior lines are not inferior because he could not do them better, but because he feels that if all were equally weighty, there would be no real sense of weight anywhere; if all were equally melodious, the melody itself would be fatiguing; and he purposely introduces the labouring or discordant verse, that the full ring may be felt in his

behind the farmer's head; but their outline curves are carried on and repeated, under the law of continuity, by the curves of the dog and boy – by the way, note the remarkable instance in these of the use of darkest lines towards the light – all more or less guiding the eye up to the right, in order to bring it finally to the Keep of Windsor, which is the central object of the picture, as the bridge tower is in the Coblentz. The wall on which the boy climbs answers the purpose of contrasting, both in direction and character, with these greater curves; thus corresponding as nearly as possible to the minor tongue of land in the Coblentz. This, however, introduces us to another law, which we must consider separately.

FIG. 35

Drawing after Correggio *Antiope* (in the Louvre)

main sentence, and the finished sweetness in his chosen rhythm. And continually in painting, inferior artists destroy their work by giving too much of all that they think is good, while the great painter gives just enough to be enjoyed, and passes to an opposite kind of enjoyment, or to an inferior state of enjoyment: he gives a passage of rich, involved, exquisitely wrought colour, then passes away into slight, and pale, and simple colour; he paints for a minute or two with intense decision, then suddenly becomes, as the spectator thinks, slovenly; but he is not slovenly: you could not have *taken* any more decision from him just then; you have had as much as is good for you: he paints over a great space of his picture forms of the most rounded and melting tenderness, and suddenly, as you think by a freak, gives you a bit as jagged and sharp as a leafless blackthorn. Perhaps the most exquisite piece of subtle contrast in the world of painting is the arrow point, laid sharp against the white side and among the flowing hair of Correggio's Antiope. It is quite singular how very little contrast will sometimes serve to make an entire group of forms interesting which would otherwise have been valueless. There is a good deal of picturesque material, for instance, in this top of an old tower, FIG. 48, tiles and stones and sloping roof not disagreeably mingled; but all would have been unsatisfactory if there had not happened to be that iron ring on the inner wall, which by its vigorous black *circular* line precisely opposes all the square and angular characters of the battlements and roof. Draw the tower without the ring, and see what a difference it will make.

FIG. 48

145

One of the most important applications of the law of contrast is in association with the law of continuity, causing an unexpected but gentle break in a continuous series. This artifice is perpetual in music, and perpetual also in good illumination; the way in which little surprises of change are prepared in any current borders, or chains of ornamental design, being one of the most subtle characteristics of the work of the good periods. We take, for instance, a bar of ornament between two written columns of an early four-teenth century MS, and at the first glance we suppose it to be quite monotonous all the way up, composed of a winding tendril, with alternately a blue leaf and a scarlet bud. Presently, however, we see that, in order to observe the law of principality, there is one large scarlet leaf instead of a bud, nearly half-way up, which forms a centre to the whole rod; and when we begin to examine the order of the leaves, we find it varied carefully ... Very often, however, the designer is satisfied with *one* surprise, but I never saw a good illuminated border without one at least; and no series of any kind was ever introduced by a great composer in a painting without a snap somewhere. There is a pretty one in Turner's drawing of Rome with the large balustrade for a foreground in the Hakewill's Italy series: the single baluster struck out of the line, and showing the street below through the gap, simply makes the whole composition right, when otherwise it would have been stiff and absurd.

Here Ruskin analyses at some length the order of leaves and buds in this MS, but without illustrating it. I have omitted this paragraph.

If you look back to FIG. 48 you will see, in the arrangement of the battlements, a simple instance of the use of such variation. The whole top of the tower, though actually three sides of a square, strikes the eye as a continuous series of five masses. The first two, on the left, somewhat square and blank, then the next two higher and richer, the tiles being seen on their slopes. Both these groups being couples, there is enough monotony in the series to make a change pleasant; and the last battlement, therefore, is a little higher than the first two – a little lower than the second two – and different in shape from either. Hide it with your finger, and see how ugly and formal the other four battlements look.

There are in this figure several other simple illustrations of the laws we have been tracing. Thus the whole shape of the walls' mass being square, it is well, still for the sake of contrast, to oppose it not only by the element of curvature, in the ring, and lines of the roof below, but by that of sharpness;

hence the pleasure which the eye takes in the projecting point of the roof. Also, because the walls are thick and sturdy, it is well to contrast their strength with weakness; therefore we enjoy the evident decrepitude of this roof as it sinks between them. The whole mass being nearly white, we want a contrasting shadow somewhere; and get it, under our piece of decrepitude. This shade, with the tiles of the wall below, forms another pointed mass, necessary to the first by the law of repetition. Hide this inferior angle with your finger, and see how ugly the other looks. A sense of the law of symmetry, though you might hardly suppose it, has some share in the feeling with which you look at the battlements; there is a certain pleasure in the opposed slopes of their top, on one side down to the left, on the other to the right. Still less would you think the law of radiation had anything to do with the matter: but if you take the extreme point of the black shadow on the left for a centre, and follow first the low curve of the eaves of the wall, it will lead you, if you continue it, to the point of the tower cornice; follow the second curve, the top of the tiles of the wall, and it will strike the top of the right-hand battlement; then draw a curve from the highest point of the angled battlement on the left, through the points of the roof and its dark echo; and you will see how the whole top of the tower radiates from this lowest dark point. There are other curvatures crossing these main ones, to keep them from being too conspicuous. Follow the curve of the upper roof, it will take you to the top of the highest battlement; and the stones indicated at the right-hand side of the tower are more extended at the bottom, in order to get some less direct expression of sympathy, such as irregular stones may be capable of, with the general flow of the curves from left to right.

You may not readily believe, at first, that all these laws are indeed involved in so trifling a piece of composition. But, as you study longer, you will discover that these laws, and many more, are obeyed by the powerful composers in every *touch*: that literally, there is never a dash of their pencil which is not carrying out appointed purposes of this kind in twenty various ways at once; and that there is as much difference, in way of intention and authority, between one of the great composers ruling his colours, and a common painter confused by them, as there is between a general directing the march of an army, and an old lady carried off her feet by a mob.

7. THE LAW OF INTERCHANGE

Closely connected with the law of contrast is a law which enforces the unity of opposite things, by giving to each a portion of the character of the other. If, for instance, you divide a shield into two masses of colour, all the way down – suppose blue and white, and put a bar, or figure of an animal, partly on one division, partly on the other, you will find it pleasant to the eye if you make the part of the animal blue which comes upon the white half, and white which comes upon the blue half. This is done in heraldry, partly for the sake of perfect intelligibility, but yet more for the sake of delight in interchange of colour, since, in all ornamentation whatever, the practice is continual, in the ages of good design.

Sometimes this alternation is merely a reversal of contrasts; as that, after red has been for some time on one side, and blue on the other, red shall pass to blue's side and blue to red's. This kind of alternation takes place simply in four-quartered shields; in more subtle pieces of treatment, a little bit only of each colour is carried into the other, and they are as it were dovetailed together. One of the most curious facts which will impress itself upon you, when you have drawn some time carefully from Nature in light and shade, is the appearance of intentional artifice with which contrasts of this alternate kind are produced by her; the artistry with which she will darken a tree trunk as long as it comes against light sky, and throw sunlight on it precisely at the spot where it comes against a dark hill, and similarly treat all her masses of shade and colour, is so great, that if you only follow her closely, every one who looks at your drawing with attention will think that you have been inventing the most artificially and unnaturally delightful interchanges of shadow that could possibly be devised by human wit.

You will find this law of interchange insisted upon at length by Prout in his Lessons on Light and Shade:* it seems of all his principles of composition to be the one he is most conscious of; many others he obeys by instinct, but this he formally accepts and forcibly declares.

The typical purpose of the law of interchange is, of course, to teach us how opposite natures may be helped and strengthened by receiving each, as far as they can, some impress or reflection, or imparted power, from the other.

What Ruskin calls 'interchange' is usually known as 'counterchange' nowadays.

A detail from a lithograph by Samuel Prout. Royal Academy of Arts Library, London

*Hints on Light and Shadow, Composition, etc. by Samuel Prout.

This detail from an etching by R. T. Cowern may serve to illustrate several of the points made by Ruskin in the preceding pages: opposed masses; the connections between them; counterchange – dark against light, light against dark; breadth of tonal massing.

8. THE LAW OF CONSISTENCY

It is to be remembered, in the next place, that while contrast exhibits the *characters* of things, it very often neutralises or paralyses their *power*. A number of white things may be shown to be clearly white by opposition of a black thing, but if we want the full power of their gathered light, the black thing may be seriously in our way. Thus, while contrast displays things, it is unity and sympathy which employ them, concentrating the power of several into a mass. And, not in art merely, but in all the affairs of life, the wisdom of man is continually called upon to reconcile these opposite methods of exhibiting, or using, the materials in his power. By change he gives them pleasantness, and by consistency value; by change he is refreshed, and by perseverance strengthened.

Hence many compositions address themselves to the spectator by aggregate force of colour or line, more than by contrasts of either; many noble pictures are painted almost exclusively in various tones of red, or grey, or gold, so as to be instantly striking by their breadth of flush, or glow, or tender coldness, these qualities being exhibited only by slight and subtle use of contrast. Similarly as to form; some compositions associate massive and rugged forms, others slight and graceful ones, each with few interruptions by lines of contrary character. And, in general, such compositions possess higher sublimity than those which are more mingled in their elements. They tell a special tale, and summon a definite state of feeling, while the grand compositions merely please the eye.

This unity or breadth of character generally attaches most

to the works of the greatest men; their separate pictures have all separate aims. We have not, in each, grey colour set against sombre, and sharp forms against soft, and loud passages against low: but we have the bright picture, with its delicate sadness; the sombre picture, with its single ray of relief; the stern picture, with only one tender group of lines; the soft and calm picture, with only one rock angle at its flank; and so on. Hence the variety of their work, as well as its impressiveness. The principal bearing of this law, however, is on the separate masses or divisions of a picture: the character of the whole composition may be broken or various, if we please, but there must certainly be a tendency to consistent assemblage in its divisions. As an army may act on several points at once, but can only act effectually by having somewhere formed and regular masses, and not wholly by skirmishers; so a picture may be various in its tendencies, but must be somewhere united and coherent in its masses. Good composers are always associating their colours in great groups; binding their forms together by encompassing lines, and securing, by various dexterities of expedient, what they themselves call 'breadth': that is to say, a large gathering of each kind of thing into one place; light being gathered to light, darkness to darkness, and colour to colour. If, however, this be done by introducing false lights or false colours, it is absurd and monstrous; the skill of a painter consists in obtaining breadth by rational arrangement of his objects, not by forced or wanton treatment of them. It is an easy matter to paint one thing all white, and another all black or brown; but not an easy matter to assemble all the circumstances which will naturally produce white in one place, and brown in another. Generally speaking, however, breadth will result in sufficient degree from fidelity of study: Nature is always broad; and if you paint her colours in true relations, you will paint them in majestic masses. If you find your work look broken and scattered, it is, in all probability, not only ill composed, but untrue.

The opposite quality to breadth, that of division or scattering of light and colour, has a certain contrasting charm, and is occasionally introduced with exquisite effect by good composers. Still it is never the mere scattering, but the order discernible through this scattering, which is the real source of pleasure; not the mere multitude, but the constellation of multitude. The broken lights in the work of a good painter wander like flocks upon the hills, not unshepherded, speak-ing of life and peace: the broken lights of a bad painter fall like hailstones, and are capable only of mischief, leaving it to be wished they were also of dissolution.

9. THE LAW OF HARMONY

This last law is not, strictly speaking, so much one of composition as of truth, but it must guide composition, and is properly, therefore, to be stated in this place.

Good drawing is, as we have seen, an *abstract* of natural facts; you cannot represent all that you would, but must continually be falling short, whether you will or no, of the force, or quantity, of Nature. Now, suppose that your means and time do not admit of your giving the depth of colour in the scene, and that you are obliged to paint it paler. If you paint all the colours proportionately paler, as if an equal quantity of tint had been washed away from each of them, you still obtain a harmonious, though not an equally forcible, statement of natural fact. But if you take away the colours unequally, and leave some tints nearly as deep as they are in Nature, while others are much subdued, you have no longer a true statement. You cannot say to the observer, 'Fancy all those colours a little deeper, and you will have the actual fact.' However he adds in imagination, or takes away, some-thing is sure to be still wrong. The picture is out of harmony.

It will happen, however, much more frequently, that you have to darken the whole system of colours, than to make them paler. You remember, in your first studies of colour from Nature, you were to leave the passages of light which were too bright to be imitated, as white paper. But, in completing the picture, it becomes necessary to put colour into them; and then the other colours must be made darker, in some fixed relation to them. If you deepen all proportionately, though the whole scene is darker than reality, it is only as if you were looking at the reality in a lower light: but if, while you darken some of the tints, you leave others undarkened, the picture is out of harmony, and will not give the impression of truth.

It is not, indeed, possible to deepen *all* the colours so much as to relieve the lights in their natural degree, you would merely sink most of your colours, if you tried to do so, into a broad mass of blackness: but it is quite possible to lower them harmoniously, and yet more in some parts of the picture than in others, so as to allow you to show the light you want in a

The 'black convex mirror', or Claude Glass, referred to here, was a popular device used by landscape painters of the eighteenth and early nineteenth century. Viewed through it, a landscape could be simplified into a miniature, low-toned, and therefore almost colourless, composition, which was supposed to be nearer to an 'old-masterish' effect.

Ruskin notes: 'I fully believe that the strange grey gloom, accompanied by considerable power of effect, which prevails in modern French art, must be owing to the use of this mischievous instrument; the French landscape always gives me the idea of Nature seen carelessly in the dark mirror, and painted coarsely, but scientifically, through the veil of its perversion.'

It is perhaps odd to a modern reader to hear of the 'grey gloom' of modern French art – particularly of French landscape, when Corot, Millet and the Barbizon school were working at the time Ruskin wrote. Even the more academic landscape painters, Troyon, Vernet and Dupré, could hardly be said to display grey gloom in their landscapes. Was Ruskin thinking more generally of painters such as Géricault and Gros?

visible relief. In well-harmonised pictures this is done by gradually deepening the tone of the picture towards the lighter parts of it, without materially lowering it in the very dark parts; the tendency in such pictures being, of course, to include large masses of middle tints. But the principal point to be observed in doing this, is to deepen the individual tints without dirtying or obscuring them. It is easy to lower the tone of the picture by washing it over with grey or brown; and easy to see the effect of the landscape, when its colours are thus universally polluted with black, by using the black convex mirror, one of the most pestilent inventions for falsifying Nature and degrading art which ever was put into an artist's hand. For the thing required is not to darken pale yellow by mixing grey with it, but to deepen the pure yellow; not to darken crimson by mixing black with it, but by making it deeper and richer crimson: and thus the required effect could only be seen in Nature, if you had pieces of glass of the colour of every object in your landscape, and of every minor hue that made up those colours, and then could see the real landscape through this deep gorgeousness of the varied glass. You cannot do this with glass, but you can do it for yourself as you work; that is to say, you can put deep blue for pale blue, deep gold for pale gold, and so on, in the proportion you need; and then you may paint as forcibly as you choose, but your work will still be in the manner of Titian, not of Caravaggio or Spagnoletto, or any other of the black slaves of painting.

Supposing those scales of colour, which I told you to prepare in order to show you the relations of colour to grey, were quite accurately made, and numerous enough, you would have nothing more to do, in order to obtain a deeper tone in any given mass of colour, than to substitute for each of its hues the hue as many degrees deeper in the scale as you wanted, that is to say, if you wanted to deepen the whole two degrees, substituting for the yellow NO. 5 the yellow NO. 7, and for the red NO. 9 the red NO. 11, and so on: but the hues of any object in Nature are far too numerous, and their degrees too subtle, to admit of so mechanical a process. Still, you may see the principle of the whole matter clearly by taking a group of colours out of your scale, arranging them prettily, and then washing them all over with grey: that represents the treatment of Nature by the black mirror. Then arrange the same group of colours, with the tints five or six degrees deeper in the scale; and that will represent the treatment of Nature by Titian.

see page 120

You can only, however, feel your way fully to the right of the thing by working from Nature.

The best subject on which to begin a piece of study of this kind is a good thick tree trunk, seen against blue sky with some white clouds in it. Paint the clouds in true and tenderly gradated white; then give the sky a bold full blue, bringing them well out; then paint the trunk and leaves grandly dark against all, but in such glowing dark green and brown as you see they will bear. Afterwards proceed to more complicated studies, matching the colours carefully first by your old method; then deepening each colour with its own tint, and being careful, above all things, to keep truth of equal change when the colours are connected with each other, as in dark and light sides of the same object. Much more aspect and sense of harmony are gained by the precision with which you observe the relation of colours in dark sides and light sides, and the influence of modifying reflections, than by mere accuracy of added depth in independent colours.

This harmony of tone, as it is generally called, is the most important of those which the artist has to regard. But there are all kinds of harmonies in a picture, according to its mode of production. There is even a harmony of touch. If you paint one part of it very rapidly and forcibly, and another part slowly and delicately, each division of the picture may be right separately, but they will not agree together: the whole will be effectless and valueless, out of harmony. Similarly, if you paint one part of it by a yellow light in a warm day, and another by a grey light in a cold day, though both may have been sunlight, and both may be well toned, and have their relative shadows truly cast, neither will look like light; they will destroy each other's power, by being out of harmony. These are only broad and definable instances of discordance; but there is an extent of harmony in all good work much too subtle for definition; depending on the draughtsman's carrying everything he draws up to just the balancing and harmonious point, in finish, and colour, and depth of tone, and intensity of moral feeling, and style of touch, all considered at once; and never allowing himself to lean too emphatically on detached parts, or exalt one thing at the expense of another, or feel acutely in one place and coldly in another . . .*
All German work is apt to be out of harmony, in consequence of its too frequent conditions of affectation, and its wilful refusals of fact; as well as by reason of a feverish kind of excitement, which dwells violently on particular points, and

*Here Ruskin compares the work of various English and German engravers.

makes all the lines of thought in the picture to stand on end, as it were, like a cat's fur electrified; while good work is always as quiet as a couchant leopard, and as strong.

I have now stated to you all the laws of composition which occur to me as capable of being illustrated or defined; but there are multitudes of others which, in the present state of my knowledge, I cannot define, and others which I never hope to define; and these the most important, and connected with the deepest powers of the art. I hope, when I have thought of them more, to be able to explain some of the laws which relate to nobleness and ignobleness; that ignobleness especially which we commonly call 'vulgarity,' and which, in its essence, is one of the most curious subjects of inquiry connected with human feeling. Others I never hope to explain, laws of expression, bearing simply on simple matters; but, for that very reason, more influential than any others. These are, from the first, as inexplicable as our bodily sensations are; it being just as impossible, I think, to show, finally, why one succession of musical notes shall be lofty and pathetic, and such as might have been sung by Casella to Dante, and why another succession is base and ridiculous, and would be fit only for the reasonably good ear of Bottom, as to explain why we like sweetness, and dislike bitterness. [In all the best arrangements of colour, the delight occasioned by their mode of succession is entirely inexplicable, nor can it be reasoned about; we like it just as we like an air in music, but cannot reason any refractory person into liking it, if they do not: and yet there is distinctly a right and a wrong in it, and a good taste and bad taste respecting it, as also in music.] The best part of every great work is always inexplicable: it is good because it is good; and innocently gracious, opening as the green of the earth, or falling as the dew of heaven.

But though you cannot explain them, you may always render yourself more and more sensitive to these higher qualities by the discipline which you generally give to your character, and this especially with regard to the choice of incidents; a kind of composition in some sort easier than the artistical arrangements of lines and colours, but in every sort nobler, because addressed to deeper feelings.

For instance, in the 'Datur Hora Quieti,' the last vignette to Rogers's *Poems*, the plough in the foreground has three purposes. The first purpose is to meet the stream of sunlight

Ruskin later (in *Academy Notes*, 1859) defines vulgarity as 'the habit of mind and act resulting from the prolonged combination of insensibility with insincerity'. He continues: 'I think the special manifestation of it in artists has resulted, in the first place, from the withdrawal of all right, and therefore of all softening, or animating motive for their work; and, in the second place, from the habit of assuming, or striving by rule to express, feelings which did not, and could not, arise out of their work under such conditions.'

153

on the river, and make it brighter by opposition; but any dark object whatever would have done this. Its second purpose is, by its two arms, to repeat the cadence of the group of the two ships, and thus give a greater expression of repose; but two sitting figures would have done this. Its third and chief, or pathetic, purpose is, as it lies abandoned in the furrow (the vessels also being moored, and having their sails down), to be a type of human labour closed with the close of day. The parts of it on which the hand leans are brought most clearly into sight; and they are the chief dark of the picture, because the tillage of the ground is required of man as a punishment: but they make the soft light of the setting sun brighter, because rest is sweetest after toil. These thoughts may never occur to us as we glance carelessly at the design; and yet their undercurrent assuredly affects the feelings, and increases, as the painter meant it should, the impression of melancholy, and of peace.

Again, in the 'Lancaster Sands,' which is one of the plates I have marked as most desirable for your [study], the stream of light which falls from the setting sun on the advancing tide stands similarly in need of some force of near object to relieve

its brightness. But the incident which Turner has here adopted is the swoop of an angry sea-gull at a dog, who yelps at it, drawing back as the wave rises over his feet, and the bird shrieks within a foot of his face. Its unexpected boldness is a type of the anger of its ocean element, and warns us of the sea's advance just as surely as the abandoned plough told us of the ceased labour of the day.

It is not, however, so much in the selection of single incidents of this kind, as in the feeling which regulates the arrangement of the whole subject, that the mind of a great composer is known. A single incident may be suggested by a felicitous chance, as a pretty motto might be for the heading of a chapter. But the great composers so arrange *all* their designs that one incident illustrates another, just as one colour relieves another. Perhaps the 'Heysham,' of the Yorkshire series which, as to its locality, may be considered a companion to the last drawing we have spoken of, the 'Lancaster Sands,' presents as interesting an example as we could find of Turner's feeling in this respect. The subject is a simple north-country village, on the shore of Morecambe Bay; not in the common sense a picturesque village; there are no

Lancaster Sands. Engraving after Turner

Heysham. Engraving after Turner

155

pretty bow-windows, or red roofs, or rocky steps of entrance to the rustic doors, or quaint gables; nothing but a single street of thatched and chiefly clay-built cottages, ranged in a somewhat monotonous line, the roofs so green with moss that at first we hardly discern the houses from the fields and trees. The village street is closed at the end by a wooden gate, indicating the little traffic there is on the road through it, and giving it something the look of a large farmstead, in which a right of way lies through the yard. The road which leads to this gate is full of ruts, and winds down a bad bit of hill between two broken banks of moor ground, succeeding immediately to the few enclosures which surround the village; they can hardly be called gardens: but a decayed fragment or two of fencing fill the gaps in the bank; a clothes-line, with some clothes on it, striped blue and red, and a smock-frock, is stretched between the trunks of some stunted willows; a *very* small haystack and pig-stye being seen at the back of the cottage beyond. An empty, two-wheeled, lumbering cart, drawn by a pair of horses with huge wooden collars, the driver sitting lazily in the sun, sideways on the leader, is going slowly home along the rough road, it being about country dinner-time. At the end of the village there is a better house, with three chimneys and a dormer window in its roof, and the roof is of stone shingle instead of thatch, but very rough. This house is no doubt the clergyman's: there is some smoke from one of its chimneys, none from any other in the village; this smoke is from the lowest chimney at the back, evidently that of the kitchen, and it is rather thick, the fire not having been long lighted. A few hundred yards from the clergyman's house, nearer the shore, is the church, discernible from the cottages only by its low two-arched belfry, a little neater than one would expect in such a village; perhaps lately built by the Puseyite incumbent: and beyond the church, close to the sea, are two fragments of a border war-tower, standing on their circular mound, worn on its brow deep into edges and furrows by the feet of the village children. On the bank of moor, which forms the foreground, are a few cows, the carter's dog barking at a vixenish one: the milkmaid is feeding another, a gentle white one, which turns its head to her, expectant of a handful of fresh hay, which she has brought for it in her blue apron, fastened up round her waist; she stands with her pail on her head, evidently the village coquette, for she has a neat bodice, and pretty striped petticoat under the blue apron, and red stockings. Nearer us,

the cowherd, barefooted, stands on a piece of the limestone rock (for the ground is thistly and not pleasurable to bare feet) – whether boy or girl we are not sure: it may be a boy, with a girl's worn-out bonnet on, or a girl with a pair of ragged trousers on; probably the first, as the old bonnet is evidently useful to keep the sun out of our eyes when we are looking for strayed cows among the moorland hollows, and helps us at present to watch (holding the bonnet's edge down) the quarrel of the vixenish cow with the dog, which, leaning on our long stick, we allow to proceed without any interference. A little to the right the hay is being got in, of which the milkmaid has just taken her apronful to the white cow; but the hay is very thin, and cannot well be raked up because of the rocks; we must glean it like corn, hence the smallness of our stack behind the willows; and a woman is pressing a bundle of it hard together, kneeling against the rock's edge, to carry it safely to the hay-cart without dropping any. Beyond the village is a rocky hill, deep set with brushwood, a square crag or two of limestone emerging here and there, with pleasant turf on their brows, heaved in russet and mossy mounds against the sky, which, clear and calm, and as golden as the moss, stretches down behind it towards the sea. A single cottage just shows its roof over the edge of the hill, looking seawards: perhaps one of the village shepherds is a sea captain now, and may have built it there, that his mother may first see the sails of his ship whenever it runs into the bay. Then under the hill, and beyond the border tower, is the blue sea itself, the waves flowing in over the sand in long curved lines slowly; shadows of cloud, and gleams of shallow water on white sand alternating – miles away; but no sail is visible, not one fisher-boat on the beach, not one dark speck on the quiet horizon. Beyond all are the Cumberland mountains, clear in the sun, with rosy light on all their crags.

I should think the reader cannot but feel the kind of harmony there is in this composition; the entire purpose of the painter to give us the impression of wild, yet gentle, country life, monotonous as the succession of the noiseless waves, patient and enduring as the rocks; but peaceful, and full of health and quiet hope, and sanctified by the pure mountain air and baptismal dew of heaven, falling softly between days of toil and nights of innocence.

All noble composition of this kind can be reached only by instinct; you cannot set yourself to arrange such a subject; you may see it, and seize it, at all times, but never laboriously

invent it. And your power of discerning what is best in expression, among natural subjects, depends wholly on the temper in which you keep your own mind; above all, on your living so much alone as to allow it to become acutely sensitive in its own stillness. The noisy life of modern days is wholly incompatible with any true perception of natural beauty. If you go down into Cumberland by the railroad, live in some frequented hotel, and explore the hills with merry companions, however much you may enjoy your tour or their conversation, depend upon it you will never choose so much as one pictorial subject rightly; you will not see into the depth of any. But take knapsack and stick, walk towards the hills by short day's journeys – ten or twelve miles a day – taking a week from some starting-place sixty or seventy miles away: sleep at the pretty little wayside inns, or the rough village ones; then take the hills as they tempt you, following glen or shore as your eye glances or your heart guides, wholly scornful of local fame or fashion, and of everything which it is the ordinary traveller's duty to see, or pride to do. Never force yourself to admire anything when you are not in the humour; but never force yourself away from what you feel to be lovely, in search of anything better; and gradually the deeper scenes of the natural world will unfold themselves to you in still increasing fulness of passionate power; and your difficulty will be no more to seek or to compose subjects, but only to choose one from among the multitude of melodious thoughts with which you will be haunted, thoughts which will of course be noble or original in proportion to your own depth of character and general power of mind; for it is not so much by the consideration you give to any single drawing, as by the previous discipline of your powers of thought, that the character of your composition will be determined. Simplicity of life will make you sensitive to the refinement and modesty of scenery, just as inordinate excitement and pomp of daily life will make you enjoy coarse colours and affected forms. Habits of patient comparison and accurate judgment will make your art precious, as they will make your actions wise; and every increase of noble enthusiasm in your living spirit will be measured by the reflection of its light upon the works of your hands.

Faithfully yours,
J. RUSKIN

Ruskin's advice here, which in its recommendation of quiet and solitary contemplation is as apposite as ever today, may be compared with his description of the young Turner among the Yorkshire hills, from vol. V of *Modern Painters*:

'And at last fortune wills that the lad's true life shall begin; and one summer's evening, after various wonderful stage coach experiences on the north road, which gave him a love of stage coaches ever after, he finds himself sitting alone among the Yorkshire hills. For the first time, the silence of Nature round him, her freedom sealed to him, her glory opened to him. Peace at last; no roll of cartwheel, nor mutter of sullen voices in the back shop; but curlew-cry in space of heaven, and welling of bell-toned streamlet by its shadowy rock . . .'

The passage, ending the chapter called 'The two boyhoods', closes thus:

'So taught, and prepared for his life's labour, sate the boy at last among his fair English hills; and began to paint, with cautious toil, the rocks, and fields, and trickling brooks, and soft white clouds of heaven.'

Index

Figures in italics refer to captions

159